EDWARD ARDIZZONE'S WORLD
THE ETCHINGS AND LITHOGRAPHS
AN INTRODUCTION AND CATALOGUE RAISONNÉ

by Nicholas Ardizzone

with a foreword by Christopher White

and a preface by Paul Coldwell

Unicorn Press and Wolseley Fine Arts

LONDON

Unicorn Press and Wolseley Fine Arts
21 Afghan Road
London SW11 2QD

email: unicorn@tradford.demon.co.uk
website: www.boydell.co.uk

First published 2000 by Unicorn Press and Wolseley Fine Arts in conjunction with the touring exhibition
Edward Ardizzone (1900-79) – Etchings and Lithographs supported by
The London Institute, opening at the Pallant House Gallery, Chichester, 13 October 2000
(For tour details please see p141)

ISBN 0 906290 57 0

Designed by Helen Swansbourne
Printed in China

DEDICATIONS

The Grim Reaper scythed a broad sweep among my friends in 1999
This work is dedicated in memory of:

Lawrence Graves (1922-99)
My father-in-law: kind and gentle man, brave sailor of the Second World War

Jules Sackville (1946-99)
Australian collector: sage of Gulgong, New South Wales, we shared many adventures

Paul Vining (1943-99)
Administrator, Camberwell College of Arts: artist, poet, musicologist,
close friend, my fiercest critic

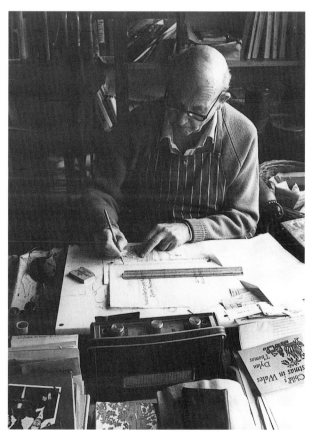

Edward Ardizzone in his studio at Rodmersham Green, detail
Photograph by Nicholas Ardizzone, 1978

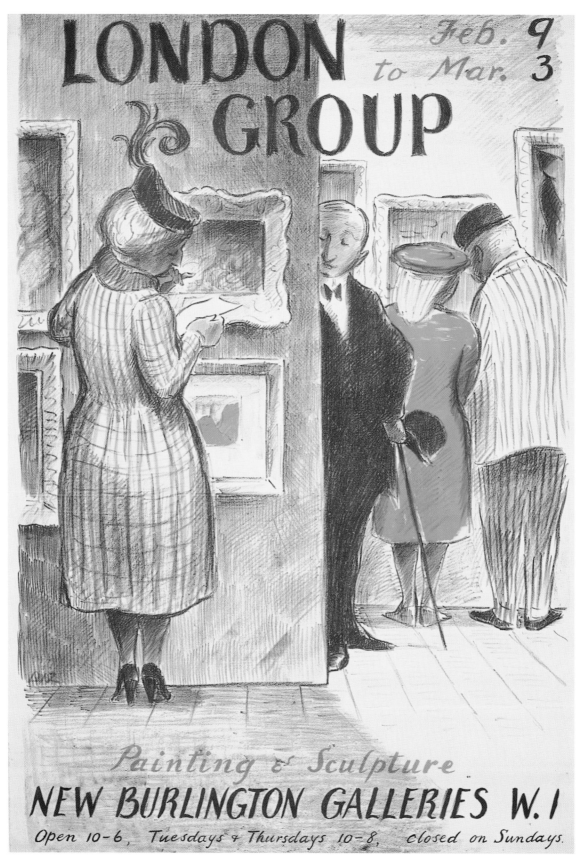

NAP 90
Poster for a London Group exhibition, dated between 1949 and 1954 (see page 134)

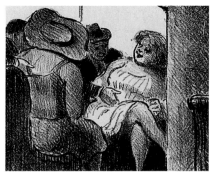

NAP 2
'The Boat to Southend', 1952, detail

CONTENTS

ACKNOWLEDGMENTS

I would like to express my heartfelt thanks to the following:

Brian Alderson, for friendly advice and his erudite and exacting hand-list of my father's illustrated books published to 1973. It is a book of the greatest value

Antoinette, my wife for her constant support, patience and understanding

Charles Bain-Smith, for his help with the intricacies of architectural description

Michael Benson, Director of Marketing at the London Institute for his support for the touring exhibition *Edward Ardizzone (1900-79) – Etchings and Lithographs*. The opening of this first definitive showing of Ardizzone's work as a printmaker coincides with the publication of this book

Professor Roger Breakwell of Camberwell College of Arts for facilities generously given during the research and writing of this book, and for his generous support of past ventures

PDF for permission on behalf of Angus Calder to quote from *The People's War* by Angus Calder first published by Jonathan Cape Copyright © Angus Calder 1969

My sister Christianna Clemence and my sister-in-law Aingelda Ardizzone for their help in this venture and their permission to reproduce the works

Michael Caldwell of the British Film Institute, for information concerning Ardizzone's cinema posters

Laura Cecil, Literary Agent to the Ardizzone Estate, a good friend to the family and a key supporter of the current Ardizzone revival

Paul Coldwell and Frank Tinsley of Camberwell College of Arts, for their constant encouragement and help with the art and technicalities of printmaking

Robin Garton, for permission to quote from *British Printmakers, 1855-1955: A Century of Printmaking from the Etching Revival to St Ives*, and for making available photography he commissioned for a book that was never published

Jonathan Glynne, Course Leader in Art History at Camberwell College of Arts, for friendly encouragement over the years

Brenda Herbert, for editing and correcting my text. That it was her late husband David who published my father's autobiography *The Young Ardizzone, An Autobiographical Fragment* gives me a warm feeling of continuity

The Director-General and Trustees of the the Imperial War Museum for permission to reproduce works made by Ardizzone as an Official War Artist, which are Crown Copyright

Clare Hopkins, Archivist of Trinity College, Oxford, for information about the two Trinity College, Oxford prints

Andrew Murray of the Mayor Gallery, always friendly, knowledgeable and helpful. The family connection with Freddy Mayor and the Mayor Gallery goes back a very long way

Random House Group Ltd for permission to quote from *Edward Ardizzone* by Gabriel White, Bodley Head, 1979 and also Copyright © Schocken Books, a division of Random House Inc.

Rupert Otten and Hanneke Van der Werf of Wolseley Fine Arts, for their backing in this venture, and for the dedicated part they have played in the current Ardizzone revival

Tessa Sidey, Curator of Prints and Drawings at Birmingham Museum and Art Gallery, for sharing generously her research into Editions Alecto and the Public Schools prints

Tate Gallery Publications for permission to quote from *Artists at Curwen* by Pat Gilmour, Tate Gallery, 1977

The Director and Trustees of the Tate Gallery for permission to reproduce *Boating Pond*

Timothy Wilson, Keeper of Western Art at the Ashmolean Museum, Oxford, for interest, research facilities and a warm welcome

PHOTOGRAPHY CREDITS

Most of the photography is © Wolseley Fine Arts except:

NAP 1, 2, 3, 4, 5, 6, 7, 8, 9, 10, 11, 12, 21, 73, 74, 75, 76, 77, 78, 79, 80, 84, 85, 86, 90, 91 photos by and © Nicholas Ardizzone

NAP 72, photo © Austin Desmond Fine Art

NAP 83, 87, 89, photos by and © Angelo Hornak

NAP 70, 71, photos, The Imperial War Museum, Crown Copyright

NAP 20, photo © The Tate Gallery

NAP 82, photo by and © Rodney Todd White & Son

Many kind people have encouraged me and helped with advice and I thank them all. If there is anybody I have neglected to mention or if there is any work I have failed inadvertantly to acknowledge or have mis-attributed, I can but apologise and promise to correct mistakes in future.

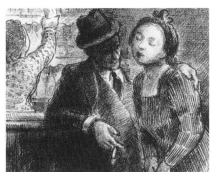

NAP 44
'At the Bar', 1955, detail

FOREWORD

Edward Ardizzone was born in Haiphong, the son of a Frenchman of Italian blood and a largely Scottish woman, who, unusually for a woman in those days, had attended a Paris art school. It was an unconventional marriage linking the Ardizzones of Algiers with the Irvings of Drum. Ardizzone's artistic education was confined to part-time classes at Westminster Art School, which were taught by that fine draughtsman and inspiring teacher, Bernard Meninsky. Ardizzone started life as a clerk in a shipping office in the city, but on the receipt of a small legacy threw up his job, encouraged by his wife but to the horror of his father, and devoted the rest of his life to drawing and painting, initially living as near the 'bread-line' as artists are proverbially supposed to be. During the war he was an Official War Artist.

Although he painted a number of oils in early life, he is best known for his drawings and water-colours, either as works of art in their own right, or as illustrations to books. As one of the most distinctive illustrators, he followed unmistakably in the great English tradition of Charles Keene, Cruikshank and Rowlandson in which the pen was the prime means of communication. In many ways a simple, very direct man, he had a particular gift in writing and illustrating children's stories, some of which have entered into the category of classics. The writer of this Foreword, who was a nephew of the artist living in the same family house in Maida Vale, recalls being, with his two cousins, used as guinea-pigs in the telling and drawing of the first Tim books. He was a sharp observer of life at all social levels – from matronly tarts standing their ground on the streets of Maida Vale, elderly drinkers in Victorian or Edwardian pubs that had seen better days, shivering boat trips down the Thames in blustery weather, the closeted atmosphere of the art-school liferoom with its comfortably rounded models, to bankers and their friends disporting themselves on the beaches at Cannes; he instinctively preferred the fat to the thin. (His world has been eloquently evoked by my father, Gabriel White, in his monograph on the artist.) Whilst he was awake, he was almost always drawing, whatever else he might be doing. At the end of a day spent at his working table in the large bay window of his studio, which also served as the family living-room, he would move to a more comfortable chair and, with a glass of wine beside him and a cigarette dangling from his lips, he would continue, while conversing volubly, to make rapid sketches on dismembered cigarette packets.

Less well known than his drawings are the single prints, mostly executed in lithograph, which form the subject of this book. Often developed from drawings or watercolours, but happily transposed into the medium of printmaking, they cover the full range of Ardizzone iconography. For personal reasons, I would pick out those scenes of elderly customers drinking in the handsome, seedy

Edwardian pub, The Shirland Arms in Maida Vale, whither I, when still living at home, would often accompany the artist and my father for a pint of beer at the end of the day; and, illustrating a very different world, his lithographs of Trinity College, Oxford, with their beautiful rendering of light playing over the local stone. This was a view I saw regularly in recent years, which invariably prompted thoughts of that warm and gregarious man.

Christopher White

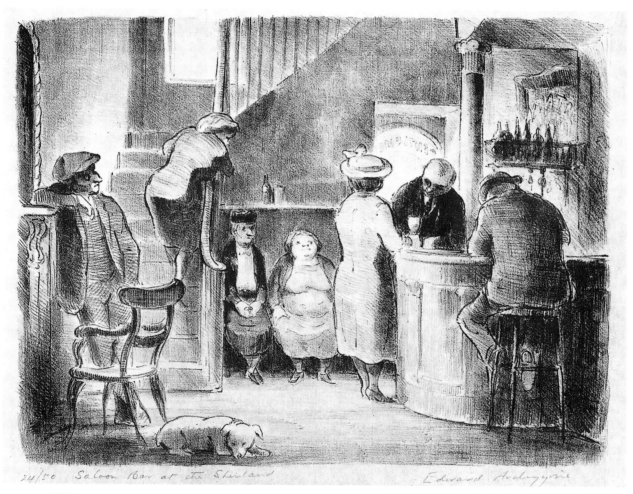

NAP 47
'The Saloon Bar at Shirland', 1955 (see page 86)

NAP 64
'The Dance (Rock & Roll)', 1952, detail

PREFACE

Edward Ardizzone, through his work as an artist and illustrator, displays that rare talent, along with Tenniel and E.H. Shepard, of representing a vision of what it is to be a child that is as intense as the reality experienced. The images created by these illustrators escort the child through childhood into the adult world while also reminding the adult reader of what it was to be a child again. In Ardizzone's case it is a world observed with a gentle eye tuned to character and inflection. It is not a fantasy world, but rather one rooted in daily observed reality, heightened with the intensity of living in the present tense.

While much has been written about Ardizzone's prolific work as an illustrator, very little has been devoted to his output through printmaking. There is a considerable body of work, conceived as individual prints, some ninety in number that show Ardizzone to be a very accomplished printmaker in the tradition of Hogarth, Rowlandson, Cruickshank, Doré and of course Daumier. This catalogue aims to bring together this work for the first time, to enable a reassessment to be made of the particular quality of his work as a printmaker.

ARDIZZONE AS PRINTMAKER

For the artist Ardizzone, the story was always of paramount importance and, most importantly, the story as expressed through drawing. Ardizzone prints are a celebration of those qualities of storytelling combined with an intense passion for drawing. It is therefore only right that he should have been immediately drawn to lithography as a process to make his prints, lithography, of all printmaking processes, being the nearest equivalent to drawing.

A lithograph is made by the simple principle of grease repelling water. The artist draws onto a prepared limestone or zinc plate with greasy materials, lithographic crayons (often referred to as chalks) or with a pen or brush using lithographic ink (tusche). When the drawing is completed, and fixed, the dampened surface is rolled with an ink roller. The ink adheres only to the drawn areas.

An impression is pulled either on a direct press where the paper is laid directly onto the surface before being put through the printing press, reversing the image in the process, or on an offset[1] press where an intermediate stage transfers the image to the paper the same way round as the original drawing.[2]

[1] A more detailed explanation of offset printing is given below, p28

[2] For a more detailed account of lithography, see Stanley Jones's *Lithography for Artists*, Oxford Paperbacks, Handbooks for Artists No. 3, OUP London 1967. Stanley Jones was the manager and master printer at The Curwen Studio, where Ardizzone made, amongst others, the lithographs of Trinity College, Oxford and the Guinness lithograph, *The Fattest Woman in the World* (NAP 86). For further reading on the Curwen Studio, see the excellent *Artists at Curwen* catalogue for the Tate Gallery by Professor Pat Gilmour.

These two ways of printing can be clearly seen in the direct and offset versions of *Hunting for Bait* (NAP 28 & 29). The direct impression, printed first, has a lightness across the surface, which has then been reworked to accommodate the reversal of the image in the offset version. Ardizzone essentially constructs a very different story from each, the direct version having the focus on the boy crouched, exploring the bushes, while the offset version centres on the boy bending. It is interesting to note how the background has been simplified and darkened to create a more dramatic scene.

Ardizzone's lithographs are beautiful examples of the qualities of chalk drawing. There is a sense throughout the prints of the delight in the touch of the crayon onto the surface, whether it be stone or plate. There is very little in the way of experimentation, of combining materials or exploiting the range of effects possible through lithography. Ardizzone is confident in his ability to draw what he has seen or imagined and doesn't intend any effect to disrupt that vision.

It appears that lithography was Ardizzone's preferred medium but he also made a number of etchings. Etching as a process presents very different hurdles for the artist. Whereas in lithography, drawing with crayon on a stone is a similar experience to drawing with pencil on paper, in etching, an etching needle on copper is of a very different order. The plate, generally zinc or copper, is covered with a dark wax ground through which the artist draws (or scratches) the design. The plate is then immersed into generally an acid solution which bites the bright areas of metal exposed by the drawing. The longer the plate is immersed, the deeper the lines become and the darker the resulting print.[3] The plate is then cleaned, inked and printed under great pressure. The different techniques by which tones may be added and the image progressively built up and details of the printing process, are outlined below (p23-28).

For an artist like Ardizzone, with a need for spontaneous and direct drawing, the indirect quality of etching did present problems and indeed his work with etching lacks the evenness of his lithographs. However, where he succeeds as in *The Dance (Rock & Roll)* (NAP 64), which I will discuss later, he shows a control and vitality as strong as in the etchings of his great friend Anthony Gross.[4]

The majority of Ardizzone's prints fall into the following broad headings: beaches and boats; life drawing; street scenes; bars; lovers; schools and colleges and pastimes.

BEACHES AND BOATS

For such a keen observer of life, it is not surprising that Ardizzone should find in pleasure-boats and in families holidaying at the beach, a rich and immediate source for the imagery of his prints. In *The Disembarkation at Southend* (NAP 25), one of the largest and most complex of his etchings, a rather stout lady is blocking the gang plank. The image is classic Ardizzone with intense groupings of figures and the child, to the far right of the picture, alone watching. The etching is directly resolved through line and crosshatching, keeping a vibrancy of mark by deeply engraved lines in the manner of Gross. Each figure is a character remembered, described through line, while an overall sense of warm light illuminates the comic scene. A similarly stout lady performs a knees-up with her two

[3]*The Thames and Hudson Manual of Etching & Engraving* by Walter Chamberlain, T&H London, 1972, offers detailed information on all aspects of intaglio printmaking.

[4]Anthony Gross taught etching at the Slade School of Art, while Ardizzone taught printmaking at both Camberwell and the Royal College of Art. Both artists shared a passion for linear drawing and a direct unpretentious approach to making images. Gross once said to me that he had two landscapes, one when he left his house and turned left, the other when he turned right.

comrades in *The Old Girls Have All the Fun* (NAP 24), with no care for the consequences. In the lithograph *The Boat to Southend* (NAP 23) a more mellow mood pervades. Built up with tonal cross-hatching, it depicts figures sitting on deck dressed for an outing. Ardizzone, like few other artists, is able to suggest the confederacy of conversation and the intensity of listening. The viewer becomes witness to the passing on of secrets, not great momentous secrets but the secrets that bind friendships. This is a recurrent theme in so much of his work.

Two versions of *On the Beach at Cannes* (NAP 26 & 27) offer an opportunity to see how Ardizzone treats the same composition through both lithography and etching. Both compositions are almost identical, with the etching including more foreground, making the format squarer. The drawing in the lithograph has coarsened, making the inside of the umbrella rather flat and the skies darkening. In contrast the etching retains a sense of warm light with delicate rendering of the figures in the sea. But it is the additional space in the foreground of the etching that gives the viewer a polite distance to view the scene with the girl in her striped bikini laid out unaware of being observed. Two states of the etching show how the image has been reworked with cross-hatching to bring out the solidity of the scene and heighten an implied sense of colour.

LIFE DRAWING

Life drawing represented the only formal training Ardizzone received as an artist and his affection for the practice remained with him throughout his life. He taught life drawing at both Camberwell and at the Royal College of Art, evident in so many sketch book drawings of the subject. He fondly remembers in his autobiography *The Young Ardizzone:*[5]

> At home I also continued my practice of drawing more from life. Then I joined Bernard Meninsky's life drawing evening classes at the old Westminster School of Art. This was a turning point in my career.

All the lithographs of life drawing take the whole life room as their subject. These are not studies but small dramas played out by characters seen with intense affection. Gabriel White[6] in his biography of Ardizzone writes:

> The life classes were visited from time to time by the head of the Art School, Walter Bayes. Ardizzone does not mention him in his numerous acknowledgements both in word and writing of the early influence on his work, but it is not without interest that in his own later drawings of models in a life class, a favourite subject for many years, he was carrying out the teaching of Bayes, who for ever tried, without much success, to persuade the students to place the model in the context of the classroom in their drawings, rather than treat it as a figure in a void. This was how Ardizzone depicted his models, within interiors, including students, easels and all the bric-a-brac of an art school. In fact all his figures are to be seen in a setting.

The life room is presented as a theatre, with the characters playing their parts to the full. The models pose, the teachers teach and the students are absorbed in the seriousness of being students. In *The Model and Her Reflection* (NAP 33), Ardizzone himself appears as the teacher gently instructing a young girl at the back of the class. The model is relaxed and self absorbed, surrounded by drawings and reflections of herself, but no one is actually engaged in the act of looking at her. There is a gentle

[5]For details see p104

[6]*op cit* pp22-23

irony in this. The model appears to pose for her own pleasure while all the other figures present are involved in a range of activities which actually ignore her presence.

For me, one of Ardizzone's finest prints is the lithograph entitled *The Model* (NAP 32). Here we are presented with the model behind a screen while on the right, three students examine their drawings. The composition has a simple theatricality, divided in two with both scenes presented frontally. It is worked from a pen and watercolour drawing of the same title but the drawing has been reversed through direct printing. The warmth of the drawing of the model is intensely affectionate. There is a palatable pleasure expressed in the realising of the form, and the softness of tones emerging from the shadows feels close in spirit to the Rembrandt painting, *Woman Bathing in a Stream* and of some of Picasso's etchings from the Vollard Suite of *The Sculptor and his Model*. This single figure, emerging from the shadows of the drawing is contrasted by the group of three the other side of the curtain, absorbed, not as the model is with herself, but deep in conversation. As a lithograph it shows the richness of the medium and the depth of tones possible through the simple use of crayon on stone. As with the majority of his prints, it is resolved through a single printing of black.

In *The Drawing Lesson* (NAP 31), a simple proposition of young girl, teacher and male model becomes an essay in what other things the life room is about. The male model confidently stands exposed

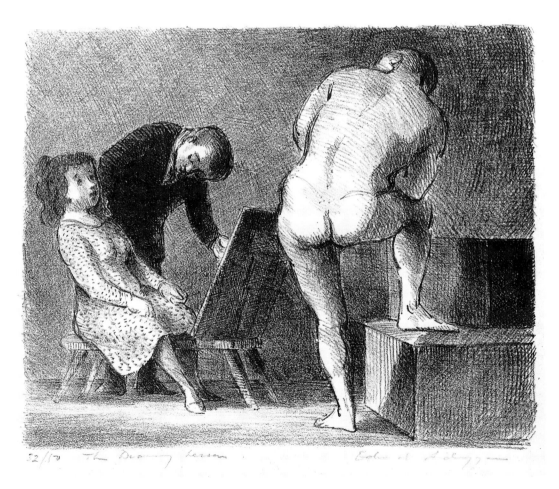

NAP 31, 'The Drawing Lesson', 1952 (see page 66)

and stares at the young girl who in turn sits back as if transfixed by what is in front of her face. The teacher leans over her, staring longingly at the young girl's breasts. There is an inversion of the convention of the life room. The strongest gaze in fact belongs to the male model. A comedy takes place before us, but Ardizzone is not being judgmental. This is not a moral tale but a moment when action becomes a story. When Ardizzone writes in his autobiography about his early experiences with women, there seems to be a similar sense of the human comedy being acted out.

> The Walkers, their rooms being smaller, gave more intimate parties at which we played sardines or, towards morning, strip poker. The girls always cheated at this, as they insisted on regarding some pretty trinket like an earring as an article of clothing, and I do not remember the women ever being reduced to nakedness. The boys on the other hand often lost all.[7]

Street scenes and bars

Ardizzone was drawn to the colourful street and bar life around Maida Vale and Soho. The prostitutes hanging around waiting for clients and the characters in the public houses become intermingled. The act of waiting and of time passing undramatically is the subtext and as such a condition that touches all of us. Ardizzone's ladies of the night are like any group of women at a bus stop, clutching their all-important handbags. In the lithograph *Evening in Maida Vale* (NAP 56), three prostitutes wait at a street corner in shadow, as a car approaches. The wall divides the composition in half, a device Ardizzone frequently uses, leaving a glimpse of an ordinary suburban street visible in sunlight. It is the ordinariness of the scene presented, rendered in fine tones, that actually gives the work an edge and fascination. A more comic, slapstick aspect of Ardizzone is revealed in the etching *The Ambush* (NAP 53), where the rather stout and flirtatious prostitutes wait in a doorway to ambush a frail thin character outside a chemist shop. The women seem overflowing with life while the poor victim appears to be just skin and bones. Even the bottles in the chemist shop seem to be quietly mocking this emaciated impotent figure.

The sense of waiting continues in the interiors. People are either absorbed in themselves or deep in conversation. A lithograph and etching of The Shirland Arms (NAP 47 & 48) both feature a pair of ladies, one thin, one stout, sitting beneath the stairs looking out. Ardizzone fits them into the architecture as if they are part of the fixtures;. they are wedged under a shelf and the angle of the stairs like caryatids. The etching describes the scene with direct, deeply etched lines, building up shadows with crosshatching, giving an overall raw texture to the drama. In contrast, the lithograph bathes the bar in light, while a couple share a drink at the bar. A dog lies asleep on the floor, reassuring the viewer that all is as it should be.

It is always apparent that Ardizzone's sympathy is directed towards the women who, while veering towards the Rubenesque, retain a certain girlishness and sense of fun. The men in contrast often appear slightly scraggy, resigned or pleasantly drunk. This is clearly evident in the etching *The Private Bar* (NAP 46), where two women are approached by a rather birdlike man who seems about to peck them. In the other corner a man looks on drunkenly, unable to move. It is the women, however, who still have the potential to dance!

[7] *The Young Ardizzone* p137, see bibliography p136

LOVERS

Ardizzone's lovers are intense mergings of spirits. The couples seem almost literally to be absorbed in each other and to become part of nature. He often places these lovers as elements in the landscape, as in *The Path to the River* (NAP 16), a rare example of Ardizzone using transfer paper in the preparation of a lithograph. Transfer paper is a prepared paper which permits the artist to draw onto it with lithographic materials and then finally transfer the image onto a plate or stone. The overall texture of this print reveals that the drawing was made with a rough board underneath the paper allowing that texture to become a subtle element in the final print. The landscapes are like theatre sets, framing the emotional drama while also providing details to conceal the figures. While in all these images, the embrace and kiss appears as the consummation of the moment, in *Lovers Among the Rocks* (NAP 19) Ardizzone implies something more carnal. The hand-coloured version of this print with its simple pale wash over the bikini gives the image an even greater sexual charge contrasted against the strong movement across the surface. These freely drawn lovers seem reminiscent of Bonnard's illustrations to Verlaine's *Parallèlement*, where Bonnard's figures share this sense of abandonment to the moment.

SCHOOLS AND COLLEGES

Ardizzone received two architectural commissions, one to record some of the colleges at Oxford, the second to produce a suite of images of English Public Schools. These prints are some of the most ambitious lithographs, in terms of scale, that he produced. The series of Oxford Colleges are topographical in nature with a clear need to get the architecture right. They demonstrate Ardizzone's control over lithography as a medium and the range possible through an understanding of chalk drawing. The architecture overwhelms the human element, producing images of austere backdrops where the buildings have windows which are dark and unyielding. In the print of *New College, Oxford – Quadrangle* (NAP 37) there is an ominous dark cloud combined with rather gothic lighting that gives the whole scene a sense of foreboding. The lines from *The History of Mr Polly* by H.G. Wells that describe finally leaving school as 'when he emerged from the valley of the shadow of education' seem encapsulated by this impressive print.

The later series of public schools reveals a lighter tone with touches that puncture the austerity. In particular in the beautiful print *Charterhouse – The Mulberry Tree* (NAP 39), one teacher is seen urgently lighting up a cigarette while two rather decrepit masters walking away from the school leaning on sticks echo the ancient tree which, Dali-like, is also supported by sticks. But it is in the print of *St Paul's School – the Nets* (NAP 43) that Ardizzone shows his confidence in the human spirit to overcome the seriousness of these institutions. The school is pictured through the cricket nets, which seem to parody the architecture of the fine building. The activity and vitality of the children engaged in play contrasts with the backdrop of the school. This is a finely drawn lithograph, revealing how the artist has scraped into the image to introduce bright clear lines in the netting. There is a vibrancy across the surface of the print, with beautifully graduated tones creating an overall softness.

PASTIMES

Almost all of Ardizzone's prints could be under the heading of pastimes. He so faithfully documents the way we contrive to either fill up our time or simply watch it pass by. Two prints in particular seem to encapsulate these feelings, the etching *The Dance (Rock and Roll)* (NAP 64), and the lithograph *The Cyclists* (NAP 62). Together they show the strength and range of Ardizzone's drawing, one to suggest a moment of stillness, the other to describe a moment of intense excitement and motion. *The Cyclists* has a group of women, their ampleness contrasted by the delicacy of their bicycles, who have stopped on the path to confer. Are they discussing the route or more private matters? They are all turned inwards creating a single form like castle defences. Outside of this group a little boy scowls, like the runt from the litter, excluded. This simple image carries so much about friendship, confederacy and also what it is to be left out. In *The Dance (Rock and Roll)*, Ardizzone shows how direct a medium etching could be for him. In this small print with etching, drypoint and an economical use of aquatint, Ardizzone makes the floor shake and the music swing. The drawing of the dancers is beautifully realised, their energy cut by the light from the stage where the band give it their all. His enthusiasm for dancing is captured in his own words in *The Young Ardizzone* when he writes:

> We were now entering the dancing age, and how we danced! ... Anytime, lunch time, tea time, dinner time, was dancing time. We foxtrotted, onestepped, twinkled, Charlestoned, tangoed and blackbottomed. Should any visitors call, if only for a few minutes, back would go the carpet and we would dance to the gramophone. None of us played instruments but friends did and so we had a Jazz band. We even ran a dance club in a large room above a billiard hall in Westbourne Grove. Our favourite tune was *Limehouse Blues*.

The line itself conjures the sense of rhythm and even in such a small area, he is able to create a feeling of everyone being involved. No dissenters when it comes to dancing.

In many ways a study of Ardizzone's prints without the rest of his work, his published illustrations, his work as a war artist or his sketch books is an artificial separation of what, in the end, is a whole. But that is a vast subject and beyond the limits of this study. Ardizzone is always the storyteller and each medium he used is subordinate to that end. What the viewer comes away with is the world seen and generously shared by the artist. The prints have a substantial part to play in this vision and through his mastery of the process of lithography and etching he has been able to realise images that become locked into the manner of their making. At a time of grandiose statements, there is something in the modesty and directness of these images that seems both refreshing and, most importantly, life affirming.

Paul Coldwell
1999/2000

'Men playing Cribbage', from
Sketchbook 1, 1951 (pen)

NAP 46
'The Private Bar', 1953, detail

INTRODUCTION

Edward Ardizzone, known to almost everybody as Ted, was a very versatile artist, and extremely prolific. He is best remembered as an illustrator of over 180 books and as author of many, but his output in other fields is largely unknown, certainly in terms of scale.

After an early career as a clerk in the City, he began to work as an artist in 1926 aged twenty-six. He exhibited successfully as a painter from 1934. By the outbreak of the Second World War, he had become well established as an artist, and was gaining reputation as an illustrator and author. As an official War Artist he submitted 401 finished works in a little over five years. To this should be added a considerable body of commercial work ranging from illustrated pamphlets to hoarding posters and also a series of some ninety etchings and lithographs. In life he never attracted a bad review and only ever a few lukewarm ones.

It is puzzling that Ardizzone's reputation as a printmaker is not higher. Very few people are aware of this oeuvre, and even among those who are, few realise the scope of it. Notwithstanding this, the edition prints have been regarded by a few as highly collectable, and have commanded consistently high prices over the years, relative to prices for work in other media.

The first mention of Ardizzone concerning lithography appears in *The Story of the AIA*,[8] where James Fitton, quoted, mentions Ardizzone attending a class at the Central School of Art. It is possible that the otherwise-unexplained *Manon Lescaut* lithographs are from this time, as they most certainly are early work, and give an impression of having been done as an exercise rather than a commission.

Although Ardizzone's first activities as a lithographer were in the 1930s, the main body of the work considered here was done between 1948 and 1961. This coincided with periods of teaching in the London art schools. The earlier lithographs were made at Camberwell. Later ones, and all the etchings, were done at the Royal College of Art. Additionally some others were commissioned by and printed at the Curwen Press and, later, the Curwen Studio.

Why Ardizzone became interested in lithography is unknown, but there may be clues within his character. He had always a fascination with printing as a medium. He particularly admired the work of Daumier and Doré but at another level he was awed by the craftsmanship shown by the engravers who interpreted artists' work. He regarded these people, many of whom remain unsung, as being

[8]Morris, Lynda & Radford, Robert, *The Story of the AIA: Artists International Association 1933-1953*, Museum of Modern Art, Oxford, 1983. Ardizzone was only very briefly a member of the Association, in the early days of its tremendous initial enthusiasm. It developed politically and philosophically in a way that was poles apart from Ardizzone's gentle view of life. Nonetheless, he maintained loose links with the Association and remained on the best of terms with almost everybody involved. That he could do this, despite the depth of the contemporaneous ideological divisions within the Left, is another pointer to the affability of his nature.

equal, as interpretative artists, to performing musicians. Apart from this lofty notion, Ted was an affable, friendly man who got on easily with most people. His instinctive admiration of the craftsmen who printed his work communicated itself and was reciprocated, which made them give of their best. He particularly admired the craftsmen at the Curwen Press, and his praise for Ernie Devenish, printer at the Royal College of Art, was fulsome and sincere.

Ascribing influences to an artist is always a tricky pastime, because it is necessarily a very subjective one; however, a study of criticism since the 1930s reveals a consensus, albeit a broad one. Dickie Doyle is mentioned, as are Cruickshank, Daumier, Degas, Doré, Fantin-Latour, Hogarth, Keene and Lautrec. Ardizzone is cast as 'The Modern Rowlandson'. If any of those connections appear far-fetched, we have

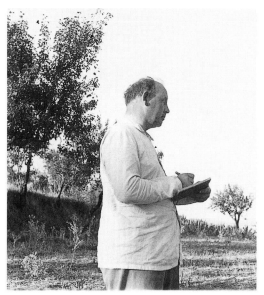

Sicily, July 1943

to remember our standpoint in history. Though to us the nineteenth century seems an aeon away, it would not have seemed so to Ardizzone in 1920, say, when he was beginning to attend his evening classes. The nineteenth century was then recent history and Degas had died only three years previously. Ardizzone would have been discussing the impressionist masters with his fellow students from a similar perspective to that we might use when discussing Picasso or Moore. Also, most unusually for the time, his mother had attended one of the Paris studios, Colorossi's, in the 1890s, and would have had personal tales to tell of Paris and its artists of that time.

Ardizzone was in any case consummately competent and grasped new techniques easily. This was a by-product, perhaps, of his extremely conscientious nature. He loved the texture of the stone and the feel of the chalk as he drew with it. He was fascinated with light and shade, and he found that the subtleties of illumination he could achieve through delicate cross-hatching suited him entirely. Also, as he remarked on occasion, lithography produced in reproduction a replica image uniquely like the original.

It is said within the family that one serious motive for the editions was as a moneymaking venture. However, it is probably of equal importance that when teaching at Camberwell and the Royal College of Art, he had easy access to the means of printing. At Camberwell he taught illustration but, with stone and presses available, he would have been unable to resist using them. Dating the works and establishing where they were done is rendered more difficult here, because some of the works that depict the old life-drawing rooms at Camberwell were in fact printed later at the Royal College. The dated watermarks of the Whatman paper allow no other conclusion, so it is probable that the subjects were worked up from sketchbook drawings made earlier. Again, fashion in clothing is some help here, but it dates the subject rather than its execution.

Ardizzone spent relatively little time at Camberwell. Along with many of his peers and contemporaries, he was poached by Robin Darwin at his newly revitalised Royal College of Art.[9] He was to teach etching which, he freely admitted, he knew nothing about, and he later confessed that he was taught about it by his students. He found etching an unsympathetic medium on the whole. He disliked the reversal of his normal process, of having to draw essentially white on black. He found also that without recourse to aquatint, he could not achieve the lights and darks he so particularly liked. The tedium of inking the plate displeased him too.

Nonetheless he produced some fine and interesting work with this medium. He must have found, too, that the plate was much less prone to damage through mishandling. Whereas he had been able to achieve only quite small editions of some of his lithographs, several of the etching runs were quite large.

[9]Darwin's outrageous poaching from other colleges of staff for his revamped RCA is described (with some asperity) by William Johnstone in his autobiography *Points in Time*, Barrie & Jenkins, London, 1980.

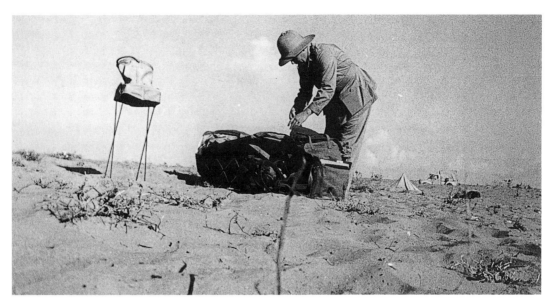

Capt. Edward Ardizzone in the desert, Egypt 1942. Photograph by Bela Zola, Parade Staff

For Ardizzone as an artist, the period 1945 to 1961 was a transitional one. There was no dramatic change but one that, though subtle, was quite marked. His work had matured greatly during the war. Gone were the rather thick lines and quick impressions of the pre-war illustrations, to be replaced with finer line and much greater depth of observation and perception. As an Official War Artist his main output was paintings and although he had done some illustration work during the war, his skill as a pen draftsman had had less opportunity to develop. The post-war period saw his activities change from being mostly a painter to mostly an illustrator. It saw him also developing towards what was arguably his most masterly work – his collaborations with the poets Eleanor Farjeon and James Reeves and the author, Ted's cousin, Christianna Brand. The transition is visible across the edition prints, starting from the earlier style represented in *Lovers and a New Moon* (NAP 12), to the intricate, delicate lines of *The Cribbage Players* (NAP 50), or *The Disembarkation at Southend* (NAP 25). It is argued that the later work lacks some of the vitality of the earlier, but the sheer competence of the line, the subject and his control of light and shade in the later one, is quite astonishing. Gabriel White chooses two examples to illustrate this point, and it seems hard to better his choice – two illustrations, done thirty years apart, of the same incident, from John Bunyan's *The Pilgrim's Progress*.

The achievement of mastery is the result of hard work, experiment and experience. It seems reasonable to propose that the making of prints helped this development of technique and ideas, in that it allowed the artist to do very fine detailed work on a scale that typically was much larger than his normal run of work.

Another transition was occurring during that period: Ted's social and financial circumstances were changing. He had left the Army if not rich, at least solvent. Life for him before the war had been a struggle to support a growing family. The war had helped him to develop a consistency of style but also it had greatly enhanced his reputation among both the public and fellow artists. From the end of the war he virtually never had to worry about being adequately employed. His life moved steadily from precariousness to fame and prosperity.

Some analysis of this oeuvre is called for, some attempt to evaluate it. It must be remembered that

printmaking was never his primary activity, and that he pursued it only spasmodically, as a sideline, during about one third of his working life. He understood the technology perfectly but struggled sometimes with applying it. Not surprisingly, the best examples among the lithographs are those printed by craftsman printers, and it must be remembered that the craft at that time was dying. With the retirement of the best at the RCA and the Curwen Press, he became so dissatisfied with later results that he gave up.[10]

He never achieved the complete mastery of, say, Barnett Freedman. He shied away largely from colour in the edition prints, whilst others, friends such as Anthony Gross, Edwin La Dell, Julian Trevelyan and Alistair Grant were developing colour lithography headlong.[11] The few surviving examples, though meritorious and much admired, show Ardizzone to have little of the control he had with monochrome chalk work.

Consistent with their relative obscurity, very little has been written on Ardizzone's prints.

In his introduction to his book *Edward Ardizzone*,[12] Gabriel White says:

> This book aims to give a pictorial record of Edward Ardizzone's work, both as an artist and an illustrator of books, from his earliest drawings in 1929 to the present day. The selection was made in an effort to show every aspect of his art and to represent his various interests at all stages of his life. It was a formidable undertaking and out of such an enormous output the choice must reflect a personal taste. Others will have their own preferences. Even from an embarrassing quantity of works there are still some pictures which I would have liked to include. They have however, temporarily one hopes, disappeared.

> The text is primarily a commentary on the illustrations, but there is as well an attempt to give a critical appraisal of Ardizzone's style. It is in no way a life of the artist. He has himself covered his early years in his autobiographical sketch *The Young Ardizzone* (Studio Vista, 1970).

> … I first knew Ardizzone at the Westminster School of Art, where we were fellow students. This led to my meeting his sister, Betty, who was keeping house for him at the time; brother and sister had been very close to each other in their childhood. Betty and I married in 1928 and two years later we came to live in the family house in Maida Vale, where I remained until 1963, five years after my wife's death. It is therefore as an old friend, who is also his brother-in-law, that I have written about Ardizzone's work.

White, unlike most other recent critics, did appreciate that by 1939 Ardizzone was well-established as an artist and had only recently been noted as an illustrator. Thus, although he is describing incidents that happened half a century earlier, White was nonetheless one of Ardizzone's close companions during some of the crucial times in his development.

White describes the evenings at Westminster School of Art[13] in the 1920s and the tuition given by Bernard Meninsky and points out, perceptively, that although Ardizzone does not specifically mention the head of the School, Walter Bayes, he appears to have absorbed the latter's teaching – that figures should be in the context of the studio rather than as objects in a void. Further, White

[10] This subject is pursued further in the documentation of *The Last Stand of the Spoons* (NAP 69).

[11] Gabriel White proposed that this may explain why Ardizzone's prints were not immediately popular.

[12] For details see bibliography

[13] I have recently received documentary evidence, kindly brought to my attention by Mr Sydney Gold, which shows that Ardizzone had in fact been enrolled for part-time drawing classes at Reading University in 1918. He never ever mentioned these classes and it is not at present known how many he attended or who taught him. At that time the family were living at Shiplake nearby. Interestingly, Roland Penrose attended the same classes, though it is not known if the two men were aquainted in those days.

relates Ardizzone's meeting at these classes with Augustine Booth-Clibborn, who, being an admirer of the former's work, had much to do eventually with encouraging him to take his chance as a professional artist.

Booth – as he was usually known – was a crucial influence in Ted's life. He was a large character, and as such not universally popular. He was grandson of General Booth, founder of the Salvation Army, and son of the General's daughter, known as *La Maréchale*. Booth was an artist, and in his time had been a friend of Georges Braque and Henri Matisse, and, according to Ted, he had painted with them both in Paris. He was a strong painter, in the *fauve* mould, but

'Female Model standing in a Sculpture Class', from Sketchbook 2, 1949 (pen)

because of his turbulent nature he was seldom exhibited and his work does not now receive the recognition it deserves.

Booth was a noted Fitzrovian, a group of artists who based themselves in the 1920s on The Fitzroy Tavern in Charlotte Street. He was married to Nora, the sister of the painter Nina Hamnet. He was a classic example of a son rejecting his background, and enjoyed the lowlife with gusto. He was a close friend of Aleister Crowley, a fashionable Satanist of the period, and Ted recalled being introduced to him.

Augustine Booth, c 1965

I remember well Booth's post-war visits to the house in Elgin Avenue. With his forceful presence and his thunderous, French-accented voice, he both enthralled and terrified me, yet he was ever courteous and never patronising. When driving him back to Victoria Station to catch his train, he used to regale me with advice upon some of which I still draw. In retrospect, I can quite understand the mixture of reverence and awe in which the young Ted must have held him.

Young wives, often jealous of premarital friendships and notably protective of their new spouses, tend to treat obstropilous characters such as Booth with the greatest suspicion, regarding them as a 'bad influence'. However, the friendship survived, and when Booth was old, Ted paid at least an annual pilgrimage to see the old man at his home in Broadstairs on the Kent coast.

Around this time he re-met his school friend Freddy Mayor, a flamboyant character with tremendous social flair. His importance and that of the Mayor Gallery in the advancement of Modern Art is well recorded. Mayor introduced Ted to the Chelseaites. The Chelseaites and the Fitzrovians were sworn enemies, but it is an indication of Ted's nature that he was able to move freely within the two cliques. Through the influence of Booth and Mayor he

became more sure of himself and began to lose his juvenile shyness and stammer. Through them also, he met many of the established artists of the time. Through Mayor he met Kenneth Clark who became a firm admirer of Ted as an artist, and though the latter was never to know it, papers I have seen recently show that Clark did much to enhance and protect his career.

White emphasises the importance of Maida Vale, the area of London where Ardizzone lived: and he observes correctly that 'it was as a town artist that Ardizzone first made his name', before continuing with a useful description of his early progress as an illustrator.

White's book is comprehensive and attempts with some success to present Ardizzone's enormous range of activities and styles. It is still the most serious work published on him. Even recalled so long after the event, White's memories of Ardizzone as a young man and of the time at Westminster School of Art are the only written record of this period. Unless compelling new evidence appears, in these matters White must be accepted as the authority.

On one hand the book fulfils admirably its avowed intent of giving a pictorial account with the text as commentary, and White states frankly that he is writing as an old friend and brother-in-law. On the other hand I recall with affection much of the research for the book being conducted over a bottle of wine or two, whilst the two old boys tried to remember quite what happened when. By this time Ardizzone was in declining health and his memory was beginning to wander a little. There are, therefore, factual and chronological inaccuracies. Unfortunately the chapter in which the prints are discussed is particularly misleading, particularly as to dating of the works.

I do not intend to dwell on this, but it is important to realise that, apart from the *Manon Lescaut* suite, none of the edition lithographs were done before the war, so the dating of *Evening in Soho, Lovers Surprised* and *The Model* as *c* 1935 is untenable. Even were the 1950s watermarks or the fact that Ernie Devenish worked with Ardizzone after the war insufficient evidence, the fashion of the womens' clothes place the works firmly post war.

NAP 69
'The Last Stand of the Spoons', 1968, detail

TECHNIQUES OF PRINTMAKING BY ETCHING AND LITHOGRAPHY

Every catalogue of prints seems to have very detailed descriptions of the techniques used in lithography and etching, so it becomes difficult to find different ways of describing the same things. Here only a brief description of the techniques and a little of their history will be given. The underlying principles and some of the steps of execution are described. In both cases the former are very simple, but the latter very much less so. In both technologies the beauty of result relies heavily on craftsmanship. The many variations of the procedures developed by artists are limited only by the boundaries of human ingenuity. For those wishing to delve further, *Artists at Curwen*[14] and *Julian Trevelyan, a Catalogue Raisonné of his Prints*[15] are highly recommended for their extensive technical notes and glossaries.

ETCHING

HISTORY

Etching is an ancient technique. Unlike lithography it does not have a known inventor but it does have a long history which is so full it is difficult to summarise. Artists mentioned below are those who used etching to produce finished work, rather than some who used it as a preliminary to engraving. Because exponents are so numerous, those mentioned are the most significant, who appear to form a coherent chain from the earliest to the present in the development of both etching and of European art.

Etching is thought to have evolved in super-Alpine Europe from the decoration of armour, and to date from the middle of the fifteenth century.

[14]Gilmour, Pat, Tate Gallery, 1977, ISBN 0 905005 759

[15]Turner, Sylvie, Scolar Press and Bohun Gallery 1998, ISBN 1-84014-292-8

The first etchings were made with iron plates, and the earliest one to which a date has been given is by Daniel Hopfer, the artist son of a family of armourers in Augsburg. His portrait of Kunz van der Rosen is put at 1504 or earlier. The earliest work bearing a date is one of 1512 by Urs Graff, a Swiss soldier, draftsman and goldsmith, which suggests another connection between etching and armoury. Albrecht Dürer produced a coherent body of work but gave up etching in favour of engraving after making a few prints. The technique was cumbersome at the time: the iron plates proved incapable of producing a fine line.

Altdorfer and Lucas Van der Leyden both developed the technique of etching. The latter combined etching with engraving, and the first use of copper plates is ascribed to him. The idea of etching, grasped widely, achieved a popularity among artists that has never waned and it spread quickly. Francesco Mazzuoli[16] (Parmigianino) was producing etchings in Italy after 1520. The list and dates of the artists who developed the craft over the centuries is too long to expand here, but the pivotal exponent in its development was Rembrandt van Rijn, who raised it to a high art form. Again, the list of followers is long, but certain milestones on the way to the present stand out. Giovanni Battista Tiepolo and his contemporary Antonio Canale (Canaletto) distinguished the form in Venice, the latter's prints being then considered equal artistically to his paintings.

Another pivotal character in this history is Francisco de Goya y Lucientes, who carries etching forward to the more-or-less accepted beginning of modern art. Development in the early part of the nineteenth century was slow, but James McNeill Whistler, Alphonse Legros and Théodore Rousell were enormously important in re-establishing it. Rousell's lifespan intrudes sufficiently into that of Ardizzone's for the latter to have been influenced by him. He died in the year Ardizzone became an artist. Later exponents such as Walter Sickert, Augustus John and Frank Brangwyn lived well into Ardizzone's artistic career.

Differences between etching and engraving

The term 'etching' applies both to the method and the product. Etching is a form of engraving which uses lines corrosively bitten into a metal plate. It is an *intaglio* process: in common with metal engraving, the incised line is filled with ink to print to paper, as opposed to wood engraving, where the relief surfaces are inked.

In engraving lines are cut into the plate by pushing a sharp point – called a burin – into and out of the metal. The burin is like a thick needle with a point the shape of a lozenge or an inverted teardrop. The burin must sink into the metal and then rise up out of it, which produces a line that swells and tapers at each end. This can be used to produce wonderful rhyming lines and halftones but it tends to look formal, quite unlike freehand drawing. Etching, however, is drawn directly to a plate that has been covered with a waxy ground. The drawing can be made with a needle with any shape of point, or with any object of sufficient hardness to displace the ground. Because the plate can be pre-prepared, many artists, notably Rembrandt, have used etching plates as a form of notebook, by sketching into the ground whilst in the field and processing the plate later. However, for the artist, etching has a great disadvantage: it is a reversal of the normally-accepted method of drawing, because the artist has to work on a black ground with a needle rather than pencil or brush, on a rather non-tactile surface, to leave a metal-coloured line.

[16]Various spellings and forms of the name are found: Mazzola also is common

THE TECHNIQUE OF ETCHING

A sheet of metal – most commonly copper or zinc – is prepared with a ground through which the artist scratches the drawing. The ground, usually these days a hard mixture of beeswax, Egyptian asphaltum and resin, is dabbed and then spread with a roller onto the heated plate. This coating must have sufficient integrity to protect the undrawn areas from acid, and be dark enough to make the drawing visible. To aid this, sometimes the ground is blackened with smoke from a taper. The edges and verso of the plate are treated with an acid-resistant stopping-out varnish.

When the design has been drawn into the ground, the plate is immersed in acid, which attacks the exposed surface of the metal where the ground has been scratched away. By careful timing, and according to the formula and concentration of the reagent, very fine or very coarse lines and areas of bite may be achieved. Nitric acid is mostly used for zinc plates, and Dutch mordant – a mixture of hydrochloric acid and potassium chlorate – for copper ones.

The plate may be removed successively from the acid to allow some lines to be stopped out so that they will be bitten no further. New lines may be drawn as well, which will be bitten less in progressive baths than the ones there beforehand. Proofs or printing runs may be made at any stage from the plate, which may then be worked further to produce successive 'states'.

SOFTGROUND

Using a formula that contains grease, a soft ground may be applied. This allows broad lines and smears to be drawn with blunter tools, or textures may be applied by such means as pressing fabric into the ground.

DRYPOINT

Lines may be scratched into the ungrounded plate using a needle tipped with steel or diamond. Though less fluent than working through the ground, drypoint can give warm vigorous lines.

AQUATINT

A form of halftone may be added to an etching with aquatint. Carefully controlled, this technique can provide tones from near white to near solid black. The desired part of the bare plate is covered with a different kind of ground, a fine and ideally even coating of rosin particles which are then fused to the surface of the metal by heating on a hotplate. The rosin is applied in a dust-box or by muslin dust bags. The dust box is a cupboard within which the plate is placed on a rack; at the turn of a handle internal paddles stir up a dust of rosin which settles on the plate. In this way a very even coating may be applied. With the dust bag, however, the artist can watch and control the process. Areas where the aquatint is not required are then stopped out.

When placed in the bath, acid attacks the areas between the melted rosin granules, giving a fine and surprisingly regular tone, a little reminiscent of photographic grain.

PRINTING AN ETCHING

After the ground has been removed using spirit, the plate is inked. In etching the whole plate is inked – with typically a mixture of Frankfurt or French black powder and burnt linseed oil[17] – before the surplus is removed from the relief areas by wiping with muslin, leaving ink in the lines. This

[17]Umber or sepia frequently are added to give a warmer tone

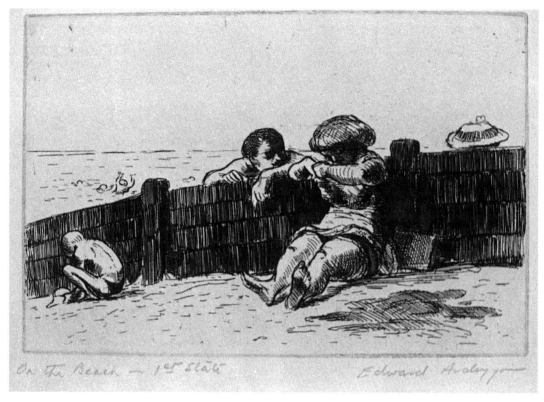

NAP 51, 'On the Beach (Sheerness)', 1953, 1st state

cleaning is the most expert part of the inking process. If it is not done well the whites will be unsatisfactory. If it is overdone the ink will be removed from the lines. In either case, constant quality from print to print will not be achieved.

Next, dampened paper is laid on the plate, then layers of blotting paper, then printer's blanket. The plate is then fed through a roller pinch press resembling somewhat a domestic mangle. The press must be well made with precision-finished rollers. Printing is done under great pressure, so there is usually a gear train between motive handle and rollers. The pressure must be even and adjustable. Pinching the plate too hard will greatly shorten its printing potential, causing fine lines to disappear and heavy-bitten relief areas to collapse.

The covers and paper are peeled away to reveal the image transferred in reverse to the paper with a slightly raised, tactile line and a deep impression in the shape of the plate. The print is left to dry, after which it can be pressed flat, but not to such an extent that the platemark is obliterated.

However, for the artist, etching always has its two inherent drawbacks: drawing onto a dark ground and reversal of the image in printing. The advent of lithography, eventually, brought solutions to both these problems.

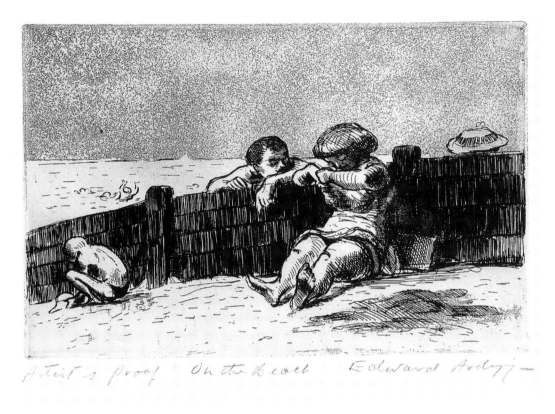

NAP 51, 'On the Beach (Sheerness)', 1953, artist's proof (see page 90)

LITHOGRAPHY

HISTORY

Lithography is the art of drawing, for the purposes of reproduction, on a prepared stone or plate. Its history is brief relative to that of etching. The process was invented in 1798 by Aloys Senefelder, a writer, who saw lithography as a cheap method of printing his plays. Although this technology is based on the delightfully simple principle that oil and water do not mix, making it work is more problematic. For this reason extensive experimentation occurred before he published his invention. Quickly seeing commercial possibilities, he proposed them in *Vollsraendiges Lehrbuch der Stiendrukerey* in 1819. The English translation was called *A Complete Course in Lithography*.[18] The essential discovery was that an image could be printed planographically – that is from a flat surface – without recourse to etching or engraving. Despite the comparative brevity of its existence, lithography has attracted a huge number of exponents, so again it will be possible to mention only the most significant people and events.

[18]*The Oxford Dictionary of Art*, new edition 1997, p514

Lithography was adopted enthusiastically by artists at first as a means of reproducing the masters, which, considering that photography was not available, was often accomplished with a mastery of its own. In England, despite initially successful attempts by André and Hullmandel to filch his patents and the limelight, Senefelder was honoured by the Society of Arts and the interest of artists began to be engaged: both Blake and Bewick experimented, so did John Sell Cotman and John Linnell the younger.

It was in France that lithography achieved immediate popularity among both professional and amateur artists. A great deal of the work produced concerned itself with depicting Napoleon's war, which established lithography as a household commonplace. Géricault produced work of horses and boxers which, among early lithographs, achieve a very high standard. Daumier and Gavrani excelled themselves. Of Goya, Elizabeth Pennell wrote:[19]

> Manet with paint and canvas, did not get more life and colour out of the bull-ring than did Goya with greasy chalk on stone.

After its spectacular early success lithography suffered a great decline. By the 1840s the public's interest had become saturated with it. Also, the advent of photography dealt it a great blow, the new technology becoming the medium of choice for magazine illustration. As Elizabeth Pennell put it:[20]

> The horrors of Chromo-lithography demoralized the public. A mystery was made of the actual printing. Artists were not allowed near the press – and few had presses of their own – [and] were kept in an outer room waiting for proofs.

By the 1860s there was a revival. Manet, Legros and Fantin Latour in France and Whistler in England produced notable work. Momentum picked up. The 1891 exhibition at the École des Beaux Arts reaffirmed the status of lithography. Eugène Carrière and Pierre Puvis de Chavannes were among those notable in this period, as were Henri de Toulouse-Lautrec and Odilon Redon. Paris and Düsseldorf held centenary exhibitions in 1895 and there was another in London 1898.

Compared to what was happening all over northern Europe, and compared to what was to happen later, there were relatively few artists practising lithography in England at this time, and English contributions to the centenaries had been minimal. Nonetheless a few notables stand out, among them Whistler, William Rothenstein, William Strang and Joseph Pennell.

Importantly, despite the partial eclipse of lithography, it had developed commercially in its first century, in the making of all manner of products such as posters, packages, labels, book illustrations, music and even containers. It was the commercial printing technology of its day, and would remain so until it began to be threatened by the introduction of photogravure and silk-screen printing. In consequence a significant craft tradition was formed among printers, many of whom became capable of producing the finest work reliably.

Pennell, an expatriate American, played a leading part in the resurgence of lithography in England, one that was to be long lasting and to establish this country as being more active than anywhere else in the early twentieth century. In 1909, together with A.S. Hartick, F. Ernest Jackson and J. Kerr Lawson, he was instrumental in setting up the Senefelder Club of which he was made president, and which was to remain the pivot of the art in England for the remainder of the century. Most of the

[19]*Encyclopaedia Britannica*, 14th ed., vol. 14, 1929, p210

[20]Ditto

distinguished lithographers of the day became members. This leads us into Ardizzone's lifetime, and members such as J. McLure Hamilton, C.H. Shannon, John Copeley, E.J. Sullivan, G. Spencer Pryce, Ethel Gabain and Frank Brangwyn were not only Ardizzone's influences, but also his contemporaries.

THE TECHNIQUE OF LITHOGRAPHY

Lithography is the art of of drawing with a greasy crayon[21] or ink (tusche) on a specially prepared textured stone or metal plate. Unlike etching, the artist draws a black line onto a pale surface. The chalk and ink are much more like those used in normal drawing. Although the structure of the stone or plate may be unforgiving, the grain of the surface and the texture of the crayon give a satisfactory tactile feedback. The technique is based on the fact that the greasy image will repel water but not printing ink. The stone or plate is dampened with water, thus when ink is applied it will adhere only to the drawn lines. The inked image can then be transferred onto the paper under pressure.

It is a most satisfactory medium for a master of line and shading like Ardizzone because it is as near the creation of a repeatable drawing as it is possible to achieve. For all practical purposes, if well executed, what is drawn is what will be reproduced. The possibilities for tonal nuance far excel that of etching.

The best material is Kellheim stone. It is not naturally textured, the surface is prepared by rubbing with carborundum or flint powder. By varying the grade of the powder, the texture may be varied. The surface must be completely flat to achieve even printing. Zinc plates are an alternative. These are less favoured by artists, but highly satisfactory results are possible. For printing on a rotary press, only plates can be used.

The crayon and tusche may be applied to the stone or plate, or to a special transfer paper, from which the image can be transferred mechanically to plate or stone. This overcomes the inherent characteristic of direct work common to etching and lithography, that the image will be printed mirror fashion. In lithography this can also be overcome by offset printing (see below p30). A separate plate, stone or transfer paper must be drawn for each colour to be printed

As the subsequent processes are essentially the same, only the use of a stone will be described. The drawing must be made carefully with the hands gloved or resting on paper, because body grease such as a fingerprint will take ink and be printed. When the drawing is complete the stone is treated chemically with a combination of nitric acid and gum Arabic – named confusingly, an 'etch' – which helps desensitise the undrawn area and remove unwanted specks of grease.

PRINTING A LITHOGRAPH

DIRECT PRINTING

An essential difference between lithography and etching is that in lithography only the drawn areas, not the whole plate or stone is inked. After placing it on the bed of the press and adjusting it for height using paper as shims, the stone is swabbed with a sponge and then the ink is applied by roller. This requires great skill. Too little and the pull will be pale and thin, too much and detail areas or cross-hatching will fill in.

[21]Lithographic crayon frequently is referred to as 'chalk'

A moistened sheet of paper is laid over the stone, then a backing. The impression is made by sliding pressure applied by a scraper – a bar of blunt-finished hardwood or modern nylonic compounds – through a membrane called a tympan, a metal alloyed specially to be flexible whilst resisting distortion.

OFFSET PRINTING

In offset printing the wetting and inking of the print may be done manually or automatically. The stone and the paper are placed side by side on the bed of the press, at a distance relevant to the circumference of the cylinder. The cylinder, which has a rubber coating, is passed over the plate and the paper, picking up the image from the former to deposit on the latter. Because of the intermediate stage, the image has been reversed twice, so the image on the paper is seen the same way round as that on the stone. Despite sounding cumbersome, offset printing can produce quality difficult to tell from direct work.

WHAT CAN GO WRONG

In etching it is possible to achieve a visually pleasing result even if mistakes are made but lithography is an exacting process, with pitfalls at every stage. The image on the stone may be damaged or irrevocably destroyed by carelessness or incompetence during drawing, chemical treatment, inking or making the pull. Nonetheless, in the hands of a master craftsman, whether the artist or a printer, the results can be as sublime as they may be disappointing when done by a tyro.

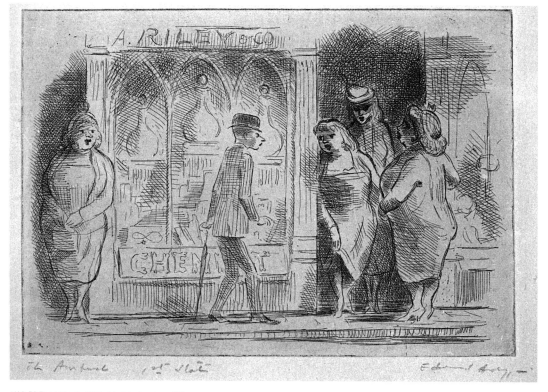

NAP 53, The Ambush, 1956, 1st state (see page 93)

NAP 25
'The Disembarkation at Southend', c 1952, detail

THE PRINTS

DEFINITIONS

This catalogue documents the following types of work:

Editioned lithographs

Some lithographs that are similar to editioned lithographs

Etchings

Overtons and Hatchetts menus

Commercial works originated either wholly or partly by lithographic techniques, such as cinema posters, the School Prints, J. Lyons prints and Guinness prints.

Posters which owe nothing to lithography in their origination have been excluded. For example, the 1938 Shell advertisement of a lifeboat crew *These Men Use Shell – You Can be Sure of Shell* was originated in oil paint so does not fit within my present definition of a print. I have left out also, with considerable regret, the most unusual poster Ardizzone made for Catholic Book Week 1960, *Read to Know – Know to Love,* because it originates from a watercolour drawing. For similar reasons I have not included the 1950s Guinness hoarding poster of a man carrying a piano on his shoulder.

Published books where the illustrations have been made directly to stone, plate or transfer paper have not been included. These are examples of illustration rather than of printmaking; also, they are the subject of work in progress by another author.

(BA8) refers to the numbers given to Ardizzone's books in:

Alderson, Brian, *Edward Ardizzone, a Preliminary Hand-List of his Illustrated Books,* The Private Libraries Association, Pinner, 1974

Books illustrated with lithographs by Ardizzone but not catalogued here are:

Great Expectations by Charles Dickens (BA8), published in New York for members of the Heritage Club, 1939

The Local by Maurice Gorham (BA9), Cassell and Co. Ltd., La Belle Sauvage, London, 1939

The Poems of François Villon, translated by H.B. McCaskie (BA16), The Cresset Press, 1946

Hey Nonny Yes: Passions and Conceits from Shakespeare, Assembled by Hallam Fordham (BA17). Produced by S. John Woods[22] for The Saturn Press, 1947.

Nicholas and the Fast Moving Diesel, Written and illustrated by Edward Ardizzone (BA18), Eyre and Spottiswoode, London, 1947. This first edition was drawn directly to the plate. As an aside, this is the publication of a story made up by my father and told to me when he was home on leave in 1944. The later, smaller format edition was completely redrawn and produced by line-separation photolithography.

The Tale of Ali Baba and the Forty Thieves: Being literally translated from the Arabic into French by C. Mardrus; and then translated into modern English by E. Powys Mathers (BA29) the Limited Editions Club, New York, I949.

The Newcomes: Memoirs of a Most Respectable Family, edited by Arthur Pendennis Esq. by William Makepeace Thackeray (BA42). Printed for the members of Limited Editions Club at the University Press, Cambridge, 1954. This book was produced in an unusual fashion, the illustrations being done in pen and later hand-coloured by stencilling. Only the cloth of the front board was illustrated lithographically.

Ardizzone's personal lithographed Christmas cards. These are the subject of an earlier book.[23]

There are in circulation a number of hand-tinted and signed page proofs from *Great Expectations*. They are thought to be pre-publication proofs signed-off for the printer. Again these have been regarded as falling outside the present definition.

Although Ardizzone spent a year in India teaching silkscreen printing, there are no known surviving works by him in that medium.

ARDIZZONE'S SKETCHBOOKS

The 'Notebook' references given in the catalogue refer to Ardizzone's personal sketchbooks. More than sixty of these survive, covering a period from just before the Second World War until the end of his life. Most of them are housed at the Ashmolean Museum, Oxford.[24]

Deborah Ardizzone started the work of cataloguing them in the 1960s, completing Nos.1-47.

I nearly finished the task, documenting Nos. 49 to 65 shortly after my father's death in 1979. There remain about three uncatalogued.

The sketchbook numbers were accorded in an arbitrary fashion and have no chronological significance.

'NOTEBOOK: SB02:47b' indicates Sketchbook No. 2, page 47, image b

Normally, Ardizzone used only the recto of the pages in his sketchbooks. Where there is a reference to a drawing on the verso it is indicated so: 'NOTEBOOK: SB05:74v'

It was Ardizzone's habit to draw constantly, wherever he was, on whatever came to hand. Many of the sketchbooks have such drawings as inclusions, referred to thus: 'SB17: inclusion d'

[22]John Woods is described below (pp116-17, 122)

[23]*My Father and Edward Ardizzone* by Edward Booth-Clibborn, Patrick Hardy, London 1983

[24]Ardizzone's war notebooks, in which he recorded an almost daily illustrated diary, are at the Imperial War Museum. These cover the period from just before the Invasion of Sicily until the end of the war in Germany. A published version, *Diary of a War Artist,* published by The Bodley Head appeared in 1974.

METHOD

DATES

In order to leave the text more readable, the lifespan dates of individuals have not been included but may be found in the index.

DATING THE WORKS – THE LEDGERS

Surprisingly, for a man who had spent many years as a clerk and who was by nature orderly, Ardizzone seldom kept records of his work. However, three print ledgers exist. The ledgers 'A' and 'B' are single sheets of paper divided into rows and columns, recording title, edition size, number printed, number of pulls remaining, and technical details. Ledger 'C' is a school exercise book and appears to be a fair copy of the first two, though with rather more details.

The three ledgers appear to be an attempt to analyse where the stones, plates and pulls were that he had done while teaching at the RCA. The ledgers only record 12 prints but they are useful in giving details of whether the prints were from stone or plate; the numbers printed to date and the types of paper used. Ledger 'C' also reports certain pulls being sent to the Zwemmer and the AIA Galleries.

STONE OR PLATE?

Where there is no documentary evidence this has been determined by my best judgement of shape of the impression left in the paper. A stone seldom has a straight edge, whereas a plate nearly always does.

PAPER

The paper types I have indicated are those that I believe all or most of the pulls were made on; however, Ardizzone did experiment with different paper types when proofing or even, sometimes, during the run.

WATERMARKS

'None seen' indicates that none of the prints I have examined have borne a watermark. Because large sheets of paper may be cut into quite small divisions, it is possible that some prints under a given title that I have not seen may bear a mark, or part of one. 'None' indicates that the given type of paper is not watermarked during manufacture.

DESCRIPTIONS

I have heard it said that a description of a work of art should be written so accurately as to evoke it to a blind person or someone on the end of a telephone. I find this far-fetched. The descriptions in this catalogue are given to help the reader see elements in the works that otherwise might be missed, or where I have particular knowledge of location or circumstance. For this reason the length of the descriptions will vary according to the complexity, as I perceive them, of the elements within each work.

DIMENSIONS

All measurements are measured in millimetres, height before width, taken to the mean edge of the image, excluding inscriptions. Measurements have been made to a tolerance of plus or minus two millimetres, however it is important to realise that paper is not dimensionally stable. Factors such as humidity and storage may cause the area of one print to vary from others by as much one or two centimetres.

THE ART SCHOOL AT CAMBERWELL

When Edward Ardizzone taught at Camberwell it was a college of the superseded London County Council and was called Camberwell School of Art and Crafts. Now, as a constituent college of the London Institute Higher Education Corporation it is called The London Institute, Camberwell College of Arts, and there have been several small tinkerings with the name between times. To avoid confusion, I shall normally refer to the college simply as Camberwell, except where there seems to be some reason to use the name applying at a particular date.

REFERENCES TO EXHIBITIONS

Exhibitions are recorded where they have been reported, but have not been specifically researched. The codes used for the exhibitions are as follows:

V&A *Edward Ardizzone – A retrospective Exhibition*, London, Victoria & Albert Museum (13 December 1973-13 January 1974). Curator and catalogue: Gabriel White

AAC *Artists at Curwen*, prints from the Curwen Gift, London, Tate Gallery (23 February-11 April 1997). Curator and catalogue: Pat Gilmour

SAC *Edward Ardizzone*, second (posthumous) retrospective exhibition given by the Scottish Arts Council 1979 at the SAC Gallery, Charlotte Square, Edinburgh (8 December 1979-27 January 1980), touring: Aberdeen, Museum and Art Gallery (9 February-9 March); Stirling, Mc Robert Arts Centre Gallery (18 March-18 April); Orkney, Pier Arts Centre, Stromness (12 April-10 May 1980); Manchester, Gallery of Modern Art, (24 May-22 June) and London, Imperial War Museum (6 July-3 August 1980) Curator and catalogue: Andrew Murray

NG81 *Edward Ardizzone 1900 – 1979*, London, New Grafton Gallery, (19 February – 18 March 1981). Curator and Catalogue: David Wolfers

MG *Edward Ardizzone Lithographs and Etchings*, London, The Mayor Gallery, 1981, (10-20 December). Curator and catalogue: Andrew Murray

ABS *Ardizzone by the Sea*, Middlesbrough Art Gallery Exhibition, 1982 (4 September-2 October). Touring: York Art Gallery (9 October-7 November) and the D.L.I. Museum and Arts Centre, Aykeley Heads, Durham (20 November-12 December). Curator and catalogue: Andrew Murray

MBA *The Modern British Artist as Printmaker – 20th Century Images on Paper*, Ascot, Austin Desmond Contemporary Books

SSC *The Spirit of the Staircase, 100 Years of Printmaking at the RCA, 1896-1996*, London, Victoria & Albert Museum (7 November 1996-30 March 1997). Curators and catalogue: Tim Mara and Sylvie Turner

WFA *The World of Edward Ardizzone*, London, Wolseley Fine Arts (4-22 February 1998). Curator and catalogue: Rupert Otten

RAS *Running Away to Sea,* London, Camberwell College of Arts (26 October-11 November 1999).
Curators: Nicholas Ardizzone and Francis Tinsley.

WCE *Edward Ardizzone – A Centenary Exhibition,* London, Wolseley Fine Arts (2-26 February 2000).
Curator and catalogue: Rupert Otten.

E.g. EXHIBITED: SAC(125:AP) indicates:
Scottish Arts Council exhibition 1979-1980, catalogue No. 125, artist's proof

REFERENCES TO LITERATURE

GW(160) indicates:
White, Gabriel, *Edward Ardizzone,* The Bodley Head, London 1979 & Schocken Books, New York, 1979 p160

AAC(160) indicates:
Gilmour, Pat, *Artists at Curwen,* Tate Gallery, London 1977, ISBN 0 905005 75 9, p160

SSC indicates:
The Spirit of the Staircase exhibition foldout, 1996 (see SSC above, p32)

G&Co indicates:
Garton, Robin, *British Printmakers, 1855-1955: A Century of Printmaking from the Etching Revival to St Ives,* Garton & Co (ISBN 0 906030 24 2), with Scolar Press (ISBN 0 85967 968 3), London 1992

CATALOGUE ORDER

The works are numbered NAP 1-91: the prefix stands for 'Nicholas Ardizzone Prints Catalogue' and has been chosen to differentiate this catalogue from an earlier one in which I used the suffix 'NA'.

I have ordered the works generally but not rigidly as follows:

By theme, e.g. *Village Life*
By sub theme, e.g. *Rodmersham Green, Gloucestershire, Suffolk*
By apparent date or sequence of events
By date of printing

NAP 88
Overtons menu, c 1956, detail

SUITE I
L'HISTOIRE DU CHEVALIER DES GRIEUX ET DE MANON LESCAUT

by Antoine-François (called *l'abbé*) Prévost, (1697-1763)

There is no record of when, where or why these lithographs were made. It is certain that they are very early work and almost certainly the artist's earliest surviving works in this medium. It is possible that they were done as an exercise, or for a publication that foundered. The fact that Ardizzone has illustrated only part of Part I of the book, not attempting to cover Part II (the sojourn of the couple in America and the conclusion), might support either idea.

The first documentary record of Ardizzone practising lithography is his attendance at evening classes given by James Fitton at the Central School of Art, connected with the inaugural meetings of the Artist's International Association in 1932. It is possible to speculate that these lithographs were an output of those classes.

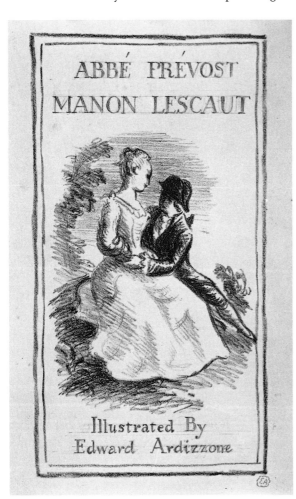

Prévost's tale – of the powerless state of man blinded by passion and of a life of ease and virtue abandoned in the face of love – reflects a bizarre facet of human nature: we praise virtue but seem unable to pursue it. The moral issues the book raises are similar to those that exercised Ardizzone from time to time. Human frailty and foibles fascinated him, and resonated nicely with his sideways glance at life.

To stray into a critical analysis of the book here, though tempting, would be inappropriate, but a skeletal commentary is given to help to set the illustrations in context.[25]

[25]Prévost's prose is exacting: it allows the translator little leeway. For this reason I have made my own translations without reference to any other English text, so any similarity to any other translations is coincidental.

NAP I

Manon Lescaut – Title page

Lithograph from a stone DATE: *c* 1932
DIMENSIONS: 245 x 138 EDITION: Only a few proof pulls made
PAPER: Heavy cartridge WATERMARK: None
INSCRIBED: One sample lettered with title and credit by Edward Ardizzone in pencil

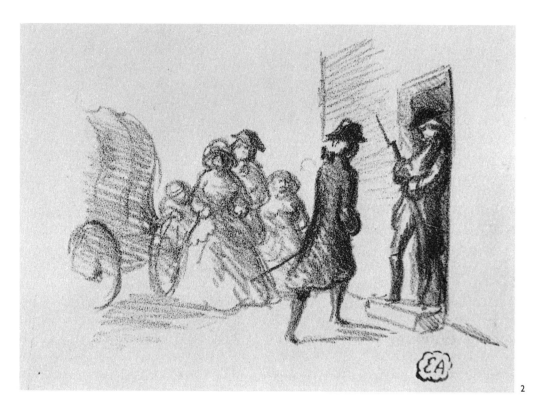

2

NAP 2

Manon Lescaut – ... *le Sujet de ce Désordre*

Lithograph from a stone DATE: *c* 1932
DIMENSIONS: 65 x 95 EDITION: Only a few proof pulls made
PAPER: Heavy cartridge WATERMARK: None

The book begins in the middle of the story. It is narrated by M. de Renoncour, a nobleman, who is returning from attending to family affairs in Rouen. On stopping at the small town of Pacy he finds the citizens in uproar about something happening in a nearby inn.

A guard appears at the door of the inn. De Renoncour calls him over to explain.

> *Enfin, un archer revêtu d'une bandoulière, et le mousquet sur l'épaule, ayant paru à la porte, je lui fis signe de la main de venir à moi. Je le priai de m'apprendre le sujet de ce désordre.*
>
> Eventually, a watchman with a bandoleer, and musket on shoulder, appeared at the door. I beckoned him to me. I asked him to tell me the cause of the disorder.

EXHIBITED: WCE(50)

NAP 3

Manon Lescaut — Une Douzaine de Filles de Joie

Lithograph from a stone

DIMENSIONS: 192 x 121

PAPER: Heavy cartridge

DATE: *c* 1932

EDITION: Only a few proof pulls made

WATERMARK: None

INSCRIBED: Some samples lettered with title by Edward Ardizzone in pencil

«... c'est une douzaine de filles de joie que je conduis, avec mes compagnons, jusqu'au Le Havre-de-Grâce, où nous les ferons embarquer pour l'Amérique.»

'... it is a dozen tarts who me and my mates are taking to Le Havre-de-Grâce, where we shall ship them off to America.'

EXHIBITED: WCE(49)

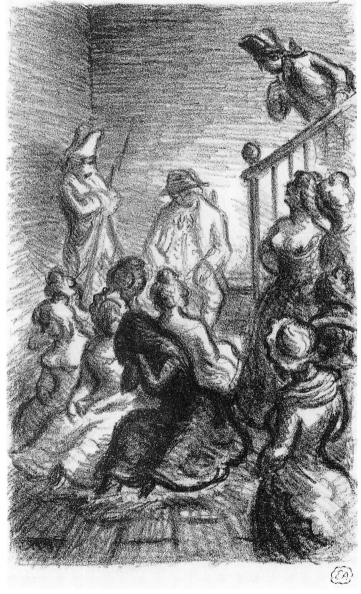

3

Renoncour enters the hostelry to see a sorry troupe of women imprisoned there. One of them, however, is so outstandingly beautiful, and emanates such a presence, that her being there seems completely inappropriate, as if a mistake must have occurred. She is Manon Lescaut.

All, in fact, are disturbed by Manon's plight, but as one of the watch points out, it is not to be supposed that she is there because of the good she has done and in any case, it is by order of the *Lieutenant Général de Police*. The officer points out a young man in the corner of the hall, explaining that he has accompanied the escort from Paris, and insists always on being near Manon. He suggests that he might best explain the circumstances to Renoncour.

Renoncour is drawn immediately to des Grieux, seeing in him great quality. He is able to help him with some money, and to threaten the watch with sanctions should they attempt to cheat on the arrangements he makes with them. He moves on then, and puts the incident out of mind.

Two years later, however, he encounters des Grieux at Calais, where he has just completed the return journey from America. Renoncour invites him to an inn, where des Grieux recounts the whole story.

NAP 4

Manon Lescaut – Il n'Attendit Point …

Lithograph from a stone
DIMENSIONS: 67 x 90
PAPER: Heavy cartridge
INSCRIBED: Some samples lettered with title by Edward Ardizzone in pencil
EXHIBITED: WCE(51)

DATE: *c* 1932
EDITION: Only a few proof pulls made
WATERMARK: None

> *Il n'attendit point que je le pressasse de me raconter l'histoire de sa vie. «Monsieur», me dit-il, «vous en usez si noblement avec moi, que je me reprocherais, comme une basse ingratitude, d'avoir quelque chose de réservé pour vous. Je veux vous apprendre, non seulement mes malheurs et mes peines, mais encore mes désordres et mes plus honteuses faiblesses. Je suis sûr qu'en me condamnant, vous ne pourrez pas vous empêcher de me plaindre.»*
> He minded not at all that I urged him to tell me the story of his life. 'Sir,' he said to me, 'you have treated me so nobly, that I would reproach myself as deeply ungrateful, if I were to show you the slightest reserve. I want to tell you not only of my misfortunes and sufferings, but also my misdeeds and my most shameful weaknesses. I feel sure that while you condemn me, you will not refuse me sympathy.'

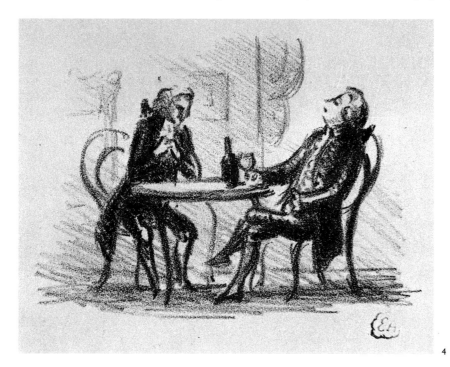

4

The Chevalier des Grieux is a young man of excellent character and learning. Because of this it has been decided that he should enter Holy Orders. He has been studying in Amiens and there on the eve of his return home, by chance, he meets Manon. She is a girl of astounding beauty and presence but of no family. She is about to be forced to take the veil because of waywardness. Des Grieux falls madly in love with her and, despite his reputation for level-headedness, and having tricked his best friend and mentor Tiberge, the couple contrive to flee to Paris. They spend their first night together at Saint-Denis.

NAP 5

Manon Lescaut – Nous Fraudâmes les Droits de l'Église

Lithograph from a stone DATE: *c* 1932
DIMENSIONS: 194 x 123 EDITION: Only a few proof pulls made
PAPER: Heavy cartridge WATERMARK: None
INSCRIBED: Some samples lettered with title by Edward Ardizzone in pencil

> «Nos projets de mariage furent oubliés à Saint-Denis; nous fraudâmes les droits de l'Eglise, et nous nous trouvâmes époux sans y avoir fait réflexion.»
>
> 'Our marriage plans were forgotten at Saint-Denis. We cheated the church of her rights and found ourselves married without a second thought.'

After a few weeks of blissful cohabitation, Manon betrays des Grieux by taking a rich protector. Also, she informs the young man's family where he is. Servants are sent to capture and return him home.

With the good guidance of his family and that of his saintly friend Tiberge, des Grieux begins the difficult climb back to wisdom and virtue. He and Tiberge decide to complete their theological studies at Saint-Sulpice.

For a year all goes well for the young abbé des Grieux, until he has to give a public dissertation which has been well advertised throughout Paris. Because of this Manon discovers where he is, and she, having attended the lecture in secret, later presents herself to him at the seminary.

NAP 6

Manon Lescaut – Je Demeurai Debout, le Corps à Demi Tourné

Lithograph from a stone DATE: *c* 1932
DIMENSIONS: 195 x 123 EDITION: Not known
PAPER: Heavy cartridge WATERMARK: None
EXHIBITED: WCE(48)

> «Elle s'assit. Je demeurai debout, le corps à demi tourné, n'osant l'envisager directement. Je commençai plusieurs fois une réponse, que je n'eus pas la force d'achever. Enfin, je fis un effort pour m'écrier douloureusement: Perfide Manon! Ah! perfide! perfide! Elle me répéta, en pleurant à chaudes larmes, qu'elle ne prétendait point justifier sa perfidie.»
>
> 'She sat herself down. I remained standing, half turned away, not daring to look at her directly. I tried several times to respond, but did not have the strength to do it. At last I made the effort to cry out sadly "Faithless Manon! Oh! Faithless!" She echoed me, whilst crying hot tears, making no pretence to justify her perfidy'.

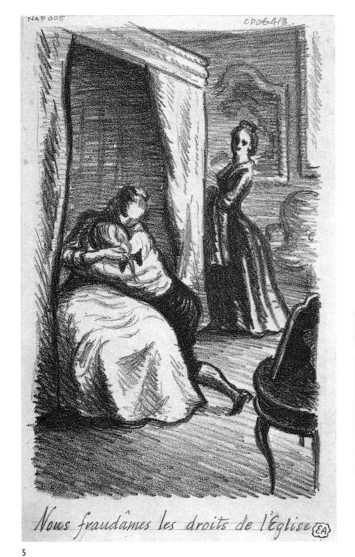

Nous fraudâmes les droits de l'Eglise

5

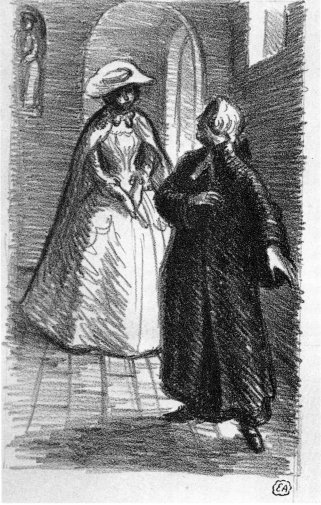

6

Des Grieux abandons his noviciate and falls once again into errant ways. He, Manon and later her brother M. Lescaut take to a life of card-sharping, confidence trickery and genteel pimping. A series of events leads them to cheat the wrong person, a powerful man, who has them arrested and sees des Grieux sent to the house of correction at Saint-Lazare and Manon to a house for fallen women, 'less for their crimes than for their debauchery'.

Eventually des Grieux makes his escape and begins to plan that of Manon. He is able to contrive to visit her at the convent.

NAP 7

Manon Lescaut — Nous Nous Embrassâmes avec cette Effusion de Tendresse

Lithograph from a stone DATE: *c* 1932
DIMENSIONS: 200 x 193 EDITION: Only a few proof pulls made
PAPER: Heavy cartridge WATERMARK: None

«*Elle comprit que j'étais à la porte. J'entrai, nous nous embrassâmes avec cette effusion de tendresse lorsqu'elle y accourait avec précipitation, qu'une absence de trois mois fait trouver si charmante à de parfaits amants.*»
'She at once understood that I was at the door; as she was rushing towards it, I entered. We embraced each other with that outburst of tenderness, which an absence of many months makes so delicious to those who truly love.'

Manon escapes by using a disguise. Shortly after there is a street incident which concludes with Manon's brother being shot dead. The couple flee to Chaillot, where they sink deeper into a life of immorality and crime. Once again, a confidence trick backfires and the couple are recognised and arrested.

NAP 8

Manon Lescaut — Ils m'ôterent tous les Moyens de me Défendre

Lithograph from a stone DATE: *c* 1932
DIMENSIONS: 195 x 127 EDITION: Only a few proof pulls made
PAPER: Heavy cartridge WATERMARK: None
INSCRIBED: Some samples lettered with title by Edward Ardizzone in pencil

«*Je saute sur mon épée; elle était malheureusement embarrassée dans mon ceinturon. Les archers, qui virent mon mouvement, s'approchèrent aussitôt pour me la saisir. Un homme en chemise est sans résistance. Ils m'ôtèrent tous les moyens de me défendre.*»
'I jumped for my sword; but unhappily it was entangled in my belt. The watchmen, who saw me start, at once came to seize it from me. A man in his shirttails can offer no resistance. They deprived me of all means of defending myself.'

After this arrest, Des Grieux and Manon are parted again and returned to prison. The authorities and the family determine that, provided they can keep the lovers apart, the young man is capable of reform, repentance and salvation. Manon (whose family is of no consequence) is treated as a common prostitute and sentenced to transportation to the American Colonies.

Des Grieux accompanies her into exile. Later, because of a fatal fight, the couple are forced to flee the colony. The exertion proves too much for Manon and she dies. The constant Tiberge comes to des Grieux's rescue and the Chevalier's family prove willing to receive him back.

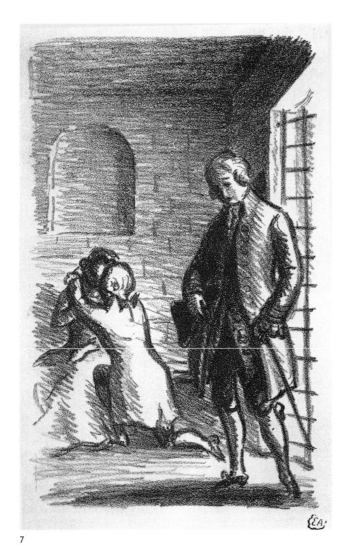

7

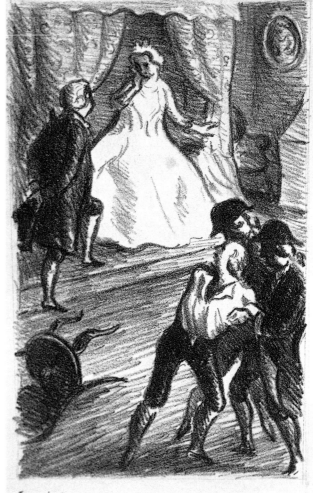

8

Ils m'ôtèrent tous les moyens de me défendre

SUITE II
BRITTANY

I n 1949 Ardizzone and his brother David took their families to Brittany for a holiday. They stayed at the Hôtel Beau Rivage at Benodet on the mouth of the river Loden. Most of the holiday was spent on the beach near a bar called *Sans Souci* which still exists. David had a car, which allowed him and Ted to do some exploring in the neighbourhood.

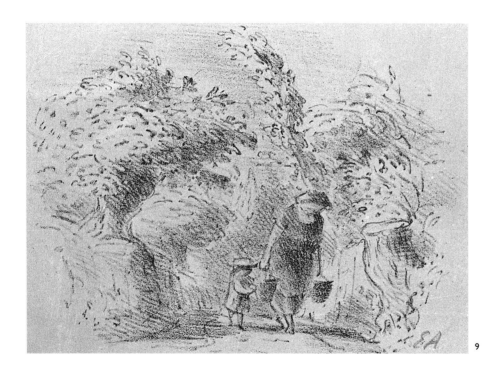

9

NAP 9

A Lane in Brittany

Lithograph from a stone
DIMENSIONS: 94 x 127
PAPER: off-white light cartridge
NOTEBOOK: SB02:47b

DATE: 1949
EDITION: Not known, but probably fewer than 10
WATERMARK: None

DESCRIPTION: The scene is a lane in an oak forest. A woman carrying two pails approaches, moving slightly left to right. There is a little girl in a broad-brimmed hat at her right hand.

PRINTED: Probably at Camberwell

NAP 10

Benodet

Lithograph
DIMENSIONS: 105 x 180
PAPER: Various, some cartridge type, some off white Japanese
WATERMARK: None
INSCRIBED: Some samples titled and signed by Edward Ardizzone in pencil

DATE: 1949
EDITION: Not known, but probably fewer than 10

NOTEBOOK: SB02:27

DESCRIPTION: In the distance, at the edge of the dunes, there are trees and the outline of two barns.

The shore is to the left and a few distant figures can be seen playing in the surf. In foreground there is a row of striped beach tents running across picture. In front of the leftmost one a couple are seated on the sand under an awning, before and to left of them a woman is sitting on a deckchair. To the right in foreground two figures are lying sunbathing. The wind is blowing the tents into curved shapes, giving the row a strangely balletic quality.

PRINTED: Probably at Camberwell

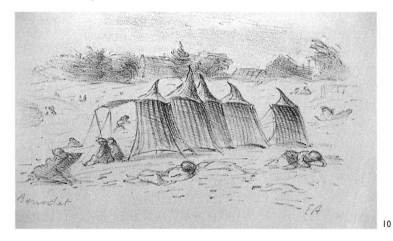

10

NAP 11

On the Beach, Benodet

Lithograph from a plate
DATE: 1949
DIMENSIONS: 60 x 152
EDITION: Not known, but probably fewer than 10
PAPER: Various
WATERMARK: None
NOTEBOOK: SB02:26
INSCRIBED: Titled and signed by Edward Ardizzone in pencil

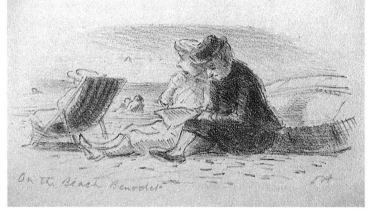

11

DESCRIPTION: In foreground right there is a small upturned boat against which two figures are seated on the sand. The one nearest, a woman in her late middle age, is wearing a hat and long dress both in widow's black. She is stooped forward slightly reading a newspaper. To the left in midground, seen rear view another figure is sitting in a striped deck chair. In the distance bathers can be seen in the sea.

PRINTED: Probably at Camberwell

SUITE III
LOVERS

Edward Ardizzone's lovers are for the most part tender creatures. Only in *Lovers among the Rocks* (NAP 19) is there any strong lustful charge. All the others are faced with one of the eternal problems of lovers, that of having nowhere to go, so that this most powerful of emotions must be expressed wherever it can, be it on the park bench, in a country pub or by the canal bridge.

NAP 12

Lovers and a New Moon

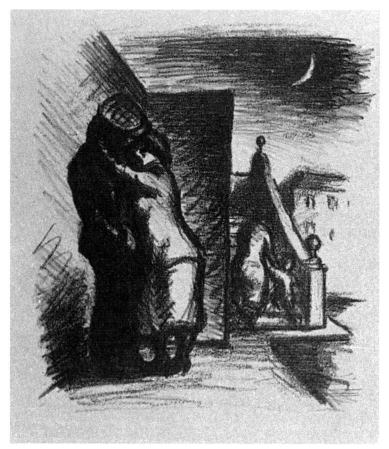

12

Lithograph from a stone
DATE: *c* 1948
DIMENSIONS: 200 x 178
EDITION: Not known, but probably fewer
than 10
PAPER: Cream Ingres
WATERMARK: None seen
NOTEBOOK: SB17: inclusion 'd', pencil sketch
of a similar scene at the same location
INSCRIBED: One pull inscribed with title by
Edward Ardizzone in pencil

DESCRIPTION: Two lovers huddle by a wall
near the canal bridge. This is early work,
probably the first post-war lithograph. The
chalk work is fairly crude compared to the
fine crosshatching seen later.

Ardizzone did several works on this
theme in other media, White reproduces a
pen and watercolour drawing, *Lovers by a
Canal Bridge,* in GW(184)

The setting is the base of the steps of a
footbridge that spans the Grand Union
Canal, connecting Formosa Street and
Delamere Terrace in London W9. Quite
near to the family house in Elgin Avenue,
the bridge is just around the corner from
The Bristol Arms in Bristol Gardens. The
Warwick Avenue area contained most of
Ardizzone's favourite pubs.

NOTE: Very few pulls are thought to exist
EXHIBITED: MG(17)

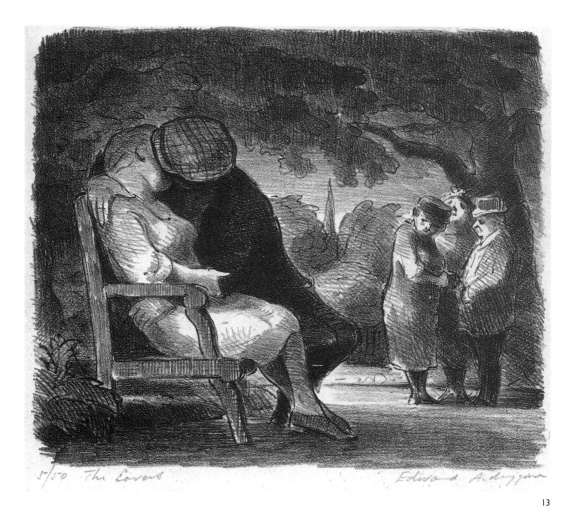

13

NAP 13

The Lovers

Lithograph from a plate DATE: 1955

DIMENSIONS: 190 x 225

EDITION: Ledger 'B' states an intended edition of 50, but only 22 printed, 7 on heavy paper, 15 on light paper.
'Plate damaged, not more than 22 prints'

PAPER: Whatman white wove WATERMARK: Whatman mark on some samples

INSCRIBED: Numbered, titled and signed by Edward Ardizzone in pencil

DESCRIPTION: The setting is a leafy park with a surrounding canopy of trees through which a church steeple may be seen in the distance

In foreground left there is a park bench facing right, on which a couple sit embracing. The woman sits nearest us, while the man at her side leans over her to kiss her. His face and head are completely obscured by the top of his flat cap. His left hand holds her by the waist whilst her right hand holds him at the elbow.

Further away to the right a group of three middle-aged figures, two women and a man, stand talking. One of the women turns to look at the lovers disapprovingly.

EXHIBITED: V&A(66)

NAP 14

Lovers Surprised

Lithograph from a plate DATE: 1955

DIMENSIONS: 184 x 230

EDITION: Ledger 'A' states: 'Plate here (probably oxidised)'. Intended edition 50, printed 19

PAPER: Off-white wove WATERMARK: None seen

NOTEBOOK: SB05:15,16,17

INSCRIBED: Numbered, titled and signed by Edward Ardizzone in pencil

DESCRIPTION: A couple embrace at the head of the stairs right. An older woman on her way upstairs left throws up her hands in horror at the scene. This is a subject that Ardizzone worked in several media.

 Fine in execution, excellent printing, beautiful controlled darks and fine chalk work

NOTE: Titles vary slightly between pulls

PRINTED: RCA

EXHIBITED: V&A(72); MG(08)

REPRODUCED: GW(165)

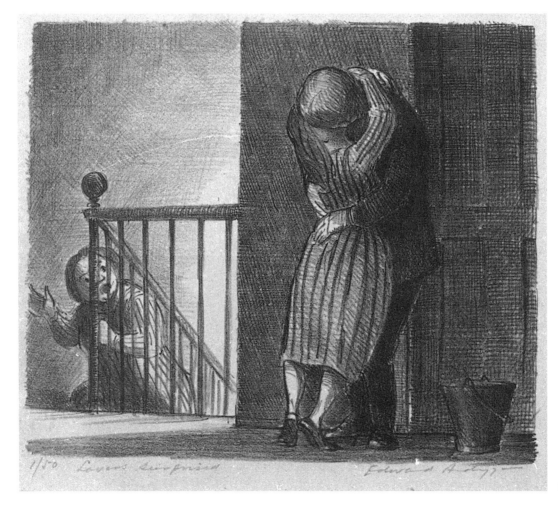

14

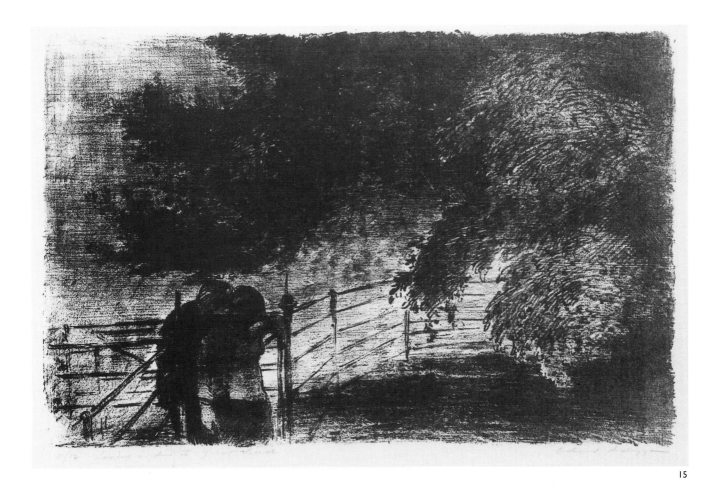

15

NAP 15

Lovers Under the Great Beech

Lithograph from a stone
DIMENSIONS: 292 x 463
PAPER: Whatman white wove
INSCRIBED: Numbered, titled and signed by Edward Ardizzone in pencil

DATE: 1956
EDITION: 12
WATERMARK: Whatman mark on some samples

DESCRIPTION: The texture of the printing suggests that this image was made on a transfer paper backed with a rough surface or that the image on the stone has been scarified with some form of comb.

The setting is park land with ornamental iron fencing all seen under the spreading boughs of a giant beech. To the left a man stoops across a kissing gate to kiss a girl.

The image is atmospheric, but only partially successful because the dark tones have filled up considerably. The printing quality of some samples is decidedly uneven.

PRINTED: RCA
EXHIBITED: MG(22)

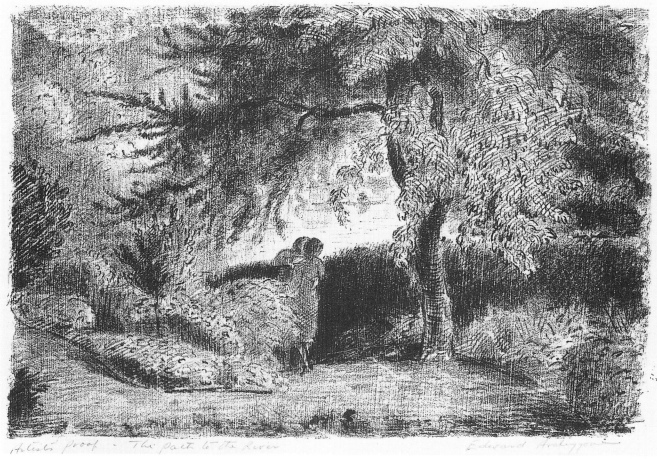

Artist's proof — The path to the River *Edward Ardizzone*

16

NAP 16

The Path to the River

Lithograph from a plate DATE: 1956
DIMENSIONS: 290 x 440 EDITION: 20
PAPER: Whatman white wove WATERMARK: Whatman mark on some samples
INSCRIBED: Numbered, titled and signed by Edward Ardizzone in pencil

DESCRIPTION: The texture of this work suggests that it was done on transfer paper, possibly over a rough surface.

 The scene is a wood in summer with the river seen below through carefully-drawn trees. The atmosphere is both lush and romantic. The viewpoint is the apex of a hairpin bend in a path, with the right hand leg descending away from us to the river. There are trees in midground, to the right a willow and to the left the overhanging branch of a yew, beneath which stands a woman seen rear view who is embracing a man partly obscured by her.

SEE ALSO: Paul Coldwell's preface (p14)
EXHIBITED: MG(24); WCE(56:10/20)

NAP 17

Lovers by the Cattle Bridge

Etching DATE: 1950

DIMENSIONS: 133 x 205 EDITION: Not known

PAPER: Off-white wove WATERMARK: None seen

NOTEBOOK: SB16:3, very rough pencil sketch

INSCRIBED: Titled and signed by Edward Ardizzone in pencil

DESCRIPTION: The hump of the stone bridge, framed by the branches of trees behind, fills the foreground. Just beyond the bridge a couple stand embracing.

PRINTED: RCA

EXHIBITED: V&A(065); SAC(122:02/30); MG(16)

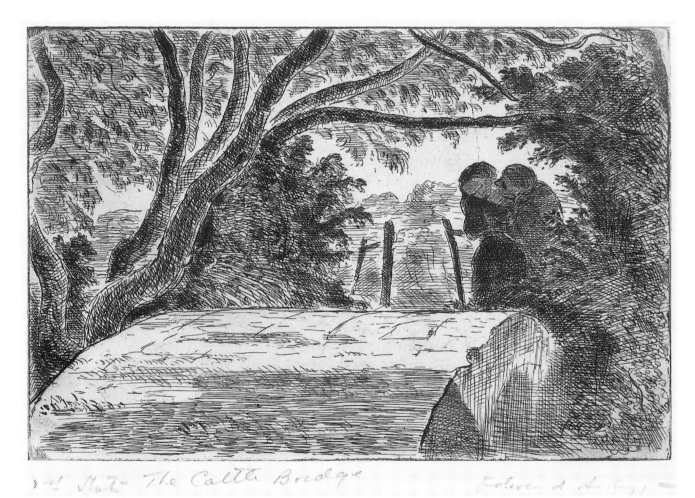

17

NAP 18

The Young Lovers

Lithograph from a plate DATE: 1955

DIMENSIONS: 170 x 220 EDITION: Ledger 'A' reports an intended edition of 30

PAPER: Some Whatman white wove, some cream Japanese

WATERMARK: Whatman mark seen on some samples

INSCRIBED: Numbered, titled and signed by Edward Ardizzone in pencil

DESCRIPTION: Again this is a setting with two separate scenes, where we become accidental voyeurs in a private situation. It is as though we view the scene from another room whose dividing wall has suddenly vanished. The setting is a pub, almost certainly a country pub, sparse with bare boards. It is, however, popular, as witnessed by the cheerful group of people sitting in the background to the right.

Isolated by a partition and shadow; separated from the others but not hidden; facing but oblivious to us and the other drinkers, a young couple sit on a bench behind a table. He has his arm round her with his left hand resting on her shoulder. They sit leaning towards each other with their heads touching. There is no passion in this scene: the couple are, quite simply, painfully and tenderly in love.

PRINTED: RCA

EXHIBITED: MG(08); WFA(28:10/30,AP)

REPRODUCED: GW(p167)

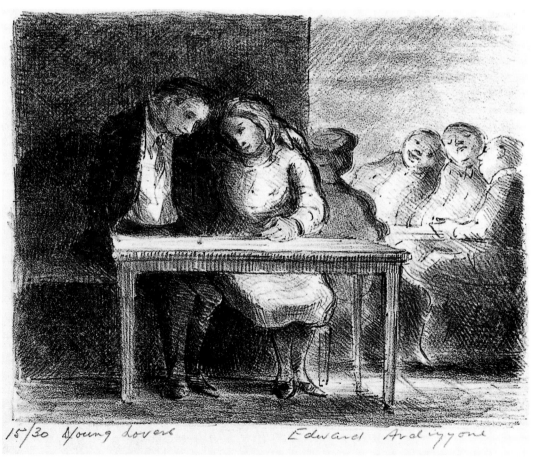

15/30 Young Lovers Edward Ardizzone

18

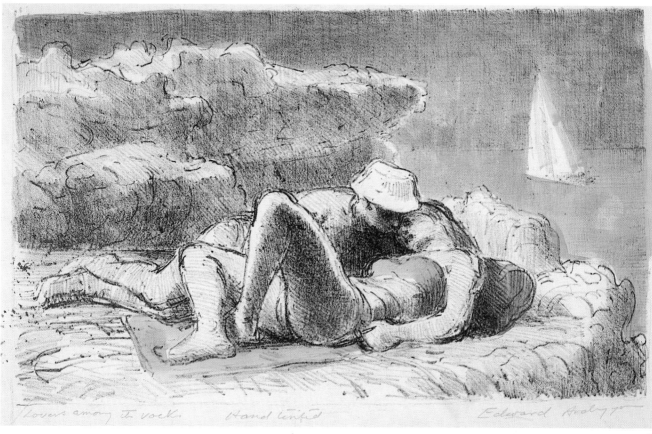

19

NAP 19

Lovers Among the Rocks

Lithograph from a stone
DIMENSIONS: 210 x 357
WATERMARK: CHRISBROOK

DATE: *c* 1958
PAPER: Off-white wove
EDITION: Not known

NOTEBOOK: SB11:51, possible sketch; SB32:32, possible pencil sketch

INSCRIBED: Tinted pulls: 'Lovers among the Rocks – Hand tinted' and signed by Edward Ardizzone in pencil.
 Untinted pulls: numbered, titled and signed by Edward Ardizzone in pencil

DESCRIPTION: A couple lie sunbathing on a rock in a Mediterranean setting. Behind them is a large rocky outcrop. The couple, she in the foreground, are lying heads to the right. The man, wearing a white cotton sun hat, is bending forward to kiss her. She has her knees drawn up and slightly parted. In the background a Bermuda-rigged yacht is passing right to left.
 As opposed to the other works in this series, which tend to depict tender young love, the scene is quite pronouncedly erotic.

SEE ALSO: Paul Coldwell's preface (p14)
COLLECTION: Tate Gallery (P06011, not titled or signed. Titled by the Tate as *Lovers by the Sea*)
EXHIBITED: V&A(73)
PRINTED: The Curwen Studio, proofed by Stanley Jones

SUITE IV
BOATING, BOATS AND THE RIVER THAMES

NAP 20

Boating Pond

For image see next page

Lithograph (offset) DATE: *c* 1953
PUBLISHED: Commissioned by and printed for British Transport Hotels
DIMENSIONS: 340 x 483 EDITION: Unknown
PAPER: Heavy cartridge type WATERMARK: None seen
INSCRIBED: Signed 'E. Ardizzone' on the red plate in the drawing area, in chalk, bottom right

DESCRIPTION: Colours: 7, cerulean, yellow ochre, vermilion, grey, raw umber, black chalk and tusche.

Much of the line is brushed in tusche, but chalk is used here and there to add detail and to enhance modelling.

The setting is the boating lake at Regent's Park in central London. It is dug in the course of and fed by one stream of the river Fleet, London's largest underground river. The family often visited the lake in summer. There are islands in the middle where one tied up to eat picnics. For hire were sailing dinghies, punts, sculling skiffs, and larger rowing boats which could, at a pinch, carry about six people with two rowing double oars. In these boats, there was a seat astern with a wicker back where the cox sat to steer the boat by means of two ropes attached to a quadrant atop the rudder. The lake became very crowded from time to time, and the clutter and the collision shown in the print are not overly fanciful.

The scene is a lively one of summer. To the left is the hut where money was taken and oars, rowlocks, punt poles and sails were issued.

Before the hut floats a pontoon; behind and partly obscured by it is a sailing dingy in which stands a young man who is hauling up the sail while another, standing on the pontoon, is steadying the mast. In the left corner, seen facing us, are a small boy and a little girl. The boy is squatting down pulling on the painter of a boat out of picture. To the right of the pontoon is moored a large rowing boat. Behind that, a young man in a sculling skiff has collided with a large rowing boat, which has been struck abeam and looks in danger of capsizing. One man attempts to shove the skiff off with an oar and the woman in the steering seat, seen rear view, throws up her hands in alarm. In the background there is much activity with people getting into boats and on the bank there are people giving advice to those afloat. A courting couple lie on the bank, oblivious to all the bustle around them. To the right edge there is a large weeping willow behind which a metal fence and the trees of the park are visible. The whole scene is watched, from a bridge to the left edge, by two women and a child who is staring through the railings.

PRINTED: The Curwen Press
LITERATURE: AAC(93)
COLLECTION: Tate Gallery (P06012)

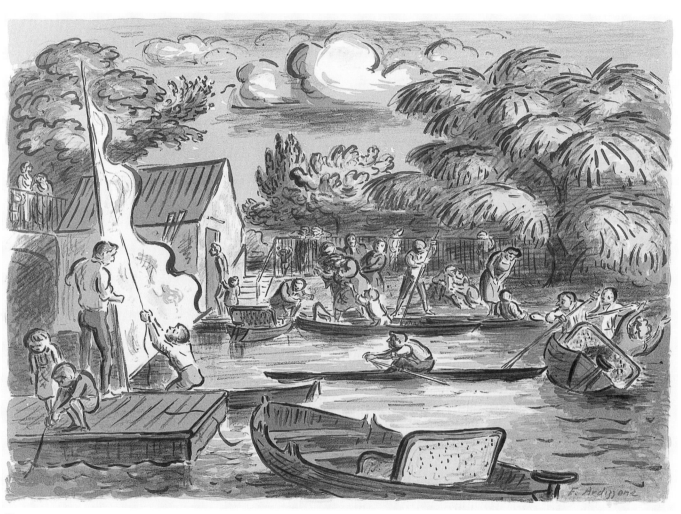

20

BOATS TO GREENWICH

Ted made occasional visits to Greenwich. The journey was made in the open topped, canopied motor launches shown which, having left Cherry Garden Pier, made their way down the Thames through the still busy Port of London, through a fascinating prospect of moored vessels and dockland landscapes. Ted liked to draw there, both in the park and in the vast industrial hinterland nearby. He had a favourite pub nearby, The Union in Lassell Street SE10. This was a bargees' pub, where I, then aged thirteen, would wait outside sipping orange squash while watching the men moor up some of the few still-working, red-sailed barges to a buoy, before coming ashore in a dingy for a pint or two.

Now the London Docks are closed and the pub, renamed The Cutty Sark, is a tourist haunt surrounded by much-desired housing.

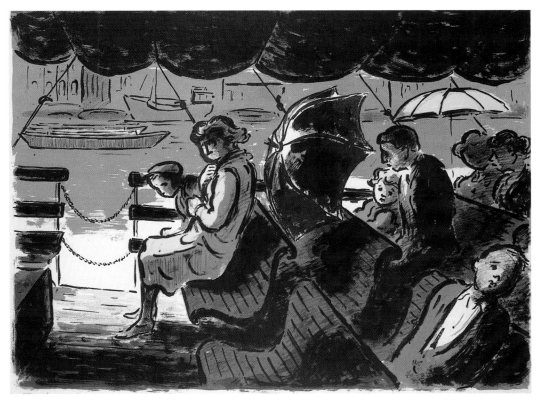

21

NAP 21

The Boat to Greenwich

Four-colour lithograph from plates DATE: 1952
DIMENSIONS: 340 x 477 EDITION: Only one pull thought to exist
PAPER: RCA off-white wove WATERMARK: RCA crown
INSCRIBED: Titled and signed by Edward Ardizzone, on the plate

DESCRIPTION: Colours: red, grey, yellow, black line
We see the covered section of a river boat with passengers seated on slatted wooden benches. There is a strong wind and driving rain and despite an awning overhead a woman, left, is clutching her coat around her and

other people have raised umbrellas. The boat is moving right to left down river and there are barges moored to buoys and behind can be seen a ship moored up before warehouses. Something has engaged the attention of all three children aboard but only them. They are staring out towards us almost as if we were pointing a camera at them. The boy in the right hand bottom corner has a strangely detached expression as he gazes out of picture, a little reminiscent of the woman with the green-lit face in Lautrec's *Au Moulin Rouge* (1892).

NOTE: Believed to be the only colour lithograph Ardizzone made at the RCA
PRINTED: RCA
EXHIBITED: MG(12); RAS(41)

NAP 22

The Boat to Greenwich (in Rain)

Etching with aquatint
DIMENSIONS: 207 x 330
PAPER: Off-white wove
INSCRIBED: Signed and some pulls titled by Edward
　　Ardizzone in pencil.

DATE: 1952
EDITION: Not known
WATERMARK: None seen

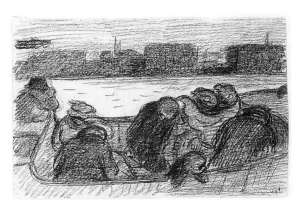

NAP 22, working drawing, 200 x 300

DESCRIPTION: This, apparently, is the same voyage as the previous work. Here we see the forward, uncovered, section of the boat as it moves right to left down river. It is a dull day and all six adults are huddled against the strong wind and driving rain whilst a man in the covered section of the boat is holding onto the brim of his hat. The eighth passenger is a small boy in foreground, who appears to be the only happy person aboard, as he leans his head and elbows over the gunwale towards us whilst studying something at water level.

At this phase of the journey the whole scene is one of extraordinary bleakness. Here the river looks deserted of other traffic (perhaps it is a Sunday), and in the background the docks present a desolate-looking landscape of warehouses, cranes, chimneys and a water tower. On this site now stands the Millennium Dome!

PRINTED: RCA
EXHIBITED: SAC(128:05/10); ABS(73); RAS(47)

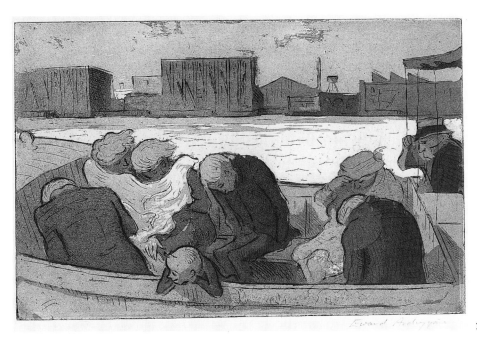

22

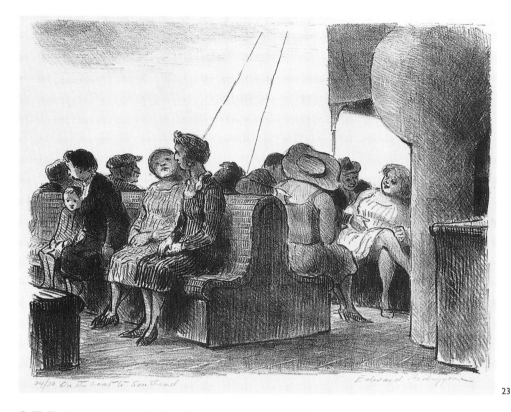

23

STEAMERS TO SOUTHEND

Southend-on-Sea is a noted fun resort on the northern bank of the Thames estuary. It has a pier with a funfair on it, and many similar attractions in the town. It is within easy reach of London, from where a day trip by steamer was popular. There were two paddle steamers serving the route in the 1950s, *Royal Sovereign* and *Royal Daffodil*.

NAP 23

The Boat to Southend

Lithograph from a stone
DIMENSIONS: 230 x 315
PAPER: Whatman white wove
NOTEBOOK: SB16:8, pencil sketch
INSCRIBED: Numbered, titled and signed by Edward Ardizzone in pencil

DATE: *c* 1952
EDITION: 30
WATERMARK: Whatman mark on some samples

DESCRIPTION: The scene is the deck of a steamer, with groups of passengers seated on back-to-back wooden slatted benches. Most of the right hand edge of picture is taken up with a large ventilator. Seen to the left of that is a woman in happily animated conversation with the rest of her group. To the left in foreground two women sit chatting quietly and beyond them sits a woman with a bored-looking child. The work has two quite distinct emotional zones, that to the left is sombre and somehow quite formal whereas on the right the atmosphere is sunny and relaxed.

SEE ALSO: Paul Coldwell's preface (p11)
PRINTED: RCA
EXHIBITED: SAC(113); ABS(065:24/30); MG(01)

NAP 24

The Old Girls Have All the Fun

Etching with drypoint

DATE: *c* 1952

DIMENSIONS: 147 x 252

EDITION: 30

PAPER: Whatman white wove

WATERMARK: Whatman 1952 mark on some samples

INSCRIBED: Numbered, titled and signed by Edward Ardizzone in pencil

DESCRIPTION: Three elderly women dance together on the deck of a steamer. To the right of them other passengers are seated on slatted benches and in background can be seen the sea. To the left there is a lifeboat in its davits.

SEE ALSO: Paul Coldwell's preface (p11)

PRINTED: RCA

EXHIBITED: SAC(126:03/30); ABS(070:08/30); MG(10); WFA(29:08/30); RAS(46)

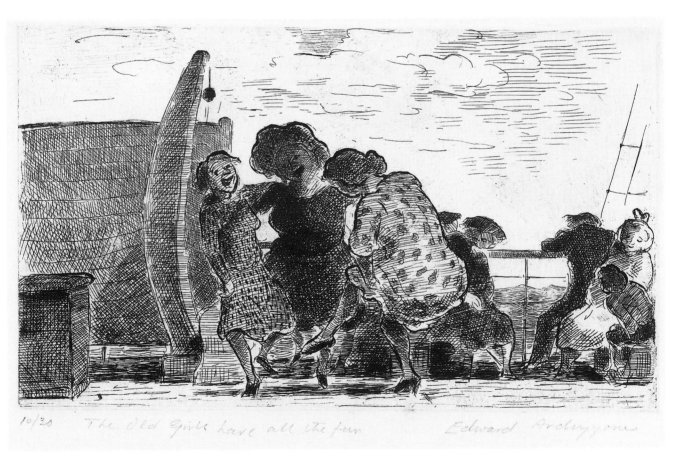

24

NAP 25

The Disembarkation at Southend

Etching DATE: *c* 1952

DIMENSIONS: 230 x 325 EDITION: 30

PAPER: Whatman white wove

WATERMARK: Whatman mark on some samples, some 1952 and some 1939

INSCRIBED: Numbered, titled and signed by Edward Ardizzone in pencil

DESCRIPTION: We see the after section of the ship moored stern left against Southend Pier. To the left is a large lifeboat, prominent in its davits, and left of that a couple are embracing by the rail. To the right of the lifeboat the public are coming ashore down a double-channelled gangway. A family group have already descended and are hurrying away eagerly to the left. Some are in a hurry to come ashore and others are not. The right hand side of the gangway is blocked by an enormously fat woman who has stopped to ask something of one of the ship's officers. She is wearing a 'Kiss Me Quick' hat. On deck right, leaning on the rail a man and a woman are in conversation. A small girl is leaning dangerously forward through the rail, gripping the one above and behind her as if about to swing from it. Below decks a man can be seen through the window finishing up his pint. On the pier a solitary small boy is walking away diagonally left to right, glancing back at the scene on the gangway.

SEE ALSO: Paul Coldwell's preface (p10)

NOTE: One pull hand-tinted by the artist exists

PRINTED: RCA

EXHIBITED: ABS(072:24/30); MG(02); WFA(30:19/30)

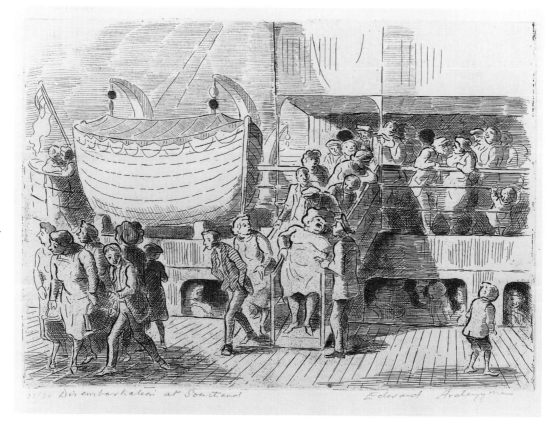

SUITE V
THE SOUTH OF FRANCE

In the middle of the 1950s Ted and Catherine's social situation was changing. They became particular friends with the banker Michael Behrens and his wife Felicity, who had a grand house on the Thames near Henley where Ted and Catherine went to stay frequently.

The Behrens also had a house in Hanover Terrace at the edge of Regents Park near Baker Street. A circle of friends lived there into which the Ardizzones mingled quite happily. These included José and Michael Baird, Ralph and Ursula Vaughan-Williams and Feliks Topolski (whom Ted had known in the war). He also became friends with the judge Harry Leon and his wife Barbara. Ted illustrated several books for Harry, who wrote under the name Henry Cecil.[26]

Catherine was far more socially ambitious than Ted, she both dreamed of luxury and craved respectability. She wanted Ted to mix with 'the right sort of people'. The pattern of visitors to the house at Elgin Avenue changed. Less was seen of fellow artists and friends from the past and much more of bankers, barristers and chartered accountants.

The Behrens would each year take a villa in the south of France, Italy or the Balearics, to which they would invite a large party. Ted and Catherine accompanied them almost annually. Being lionised, and mixing in different circles, appears for a period to have influenced Ted's choice of subject. Although he never lost his ability to see life with a sideways glance, his perception seems sometimes to have lost some of its habitual Rowlandsonian acuity. We see less portrayal of the low life and human foibles. This trend may be seen in some of the subjects from the south of France.

It may be, too, that removed from his normal setting of London with its streets, pubs, children, dogs and tarts, he found little by way of subjects to draw. Luxurious villas, swimming pools and sunny beaches may not have done much to stimulate him. Whereas he was by no means averse to a little luxury he found too much of it confining. He himself often referred to this time as being 'in the gilded cage'.

'Bathers in a Pool, Cap Ferrat', from Sketchbook 8, 1961 (pen)

[26]The best-known book is probably *Brief to Counsel* (BA62), Michael Joseph, London 1958

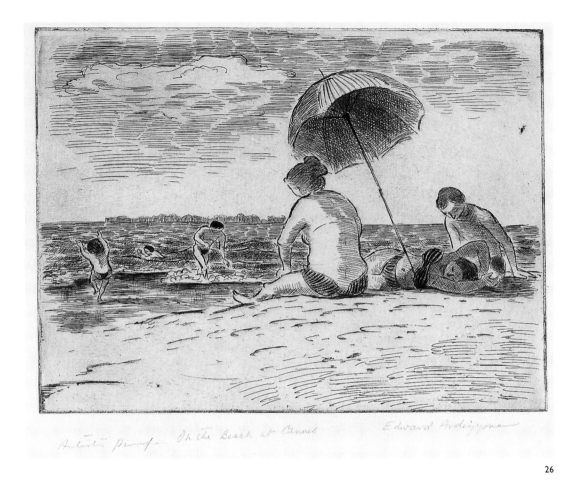

Artist Proof — On the Beach at Cannes Edward Ardizzone

26

NAP 26

On the Beach at Cannes

Etching with drypoint	DATE: 1955
DIMENSIONS: 187 x 253	EDITION: 30
PAPER: Whatman white wove	WATERMARK: Whatman mark on some samples

NOTEBOOK: SB11: numerous *On the Beach at Cannes* subjects; SB16:35,36, pencil sketches
INSCRIBED: Numbered, titled and signed by Edward Ardizzone in pencil

DESCRIPTION: A woman, seen three-quarter rear view is seated on the beach. To her right is a beach umbrella, in whose shade a young woman lies on her back, head to right facing us. Behind and partly obscured by her a man is sitting looking down at her. At the water's edge a child is frolicking, and to his right a man is leaving the water, while further out a woman is swimming. The scene is pleasant, but all but the gambolling child seem subdued and detached, as if lost in their own thoughts.

SEE ALSO: Paul Coldwell's preface (p11)
PRINTED: RCA
EXHIBITED: ABS(071:08/30); MG(20); WFA(35:AP)

NAP 27

On the Beach at Cannes

Lithograph from a plate DATE: 1955

DIMENSIONS: 190 x 360 EDITION: 20

EDITION: Ledger 'A' reports an intended edition of 50 and 24 printed, 'Plate at College'.

PAPER: Various, some heavy cartridge type and some light off-white Japanese

WATERMARK: None seen

NOTEBOOK: SB11: numerous *On the Beach at Cannes* subjects; SB16:35,36, pencil sketches

INSCRIBED: Most pulls numbered, titled and signed by Edward Ardizzone in pencil. Some pulls just signed and titled.

DESCRIPTION: Essentially the same scene as NAP 26

SEE ALSO: Paul Coldwell's preface (p11)

PRINTED: RCA

EXHIBITED: SAC(119:02/20); ABS(066:09/20); MG(14)

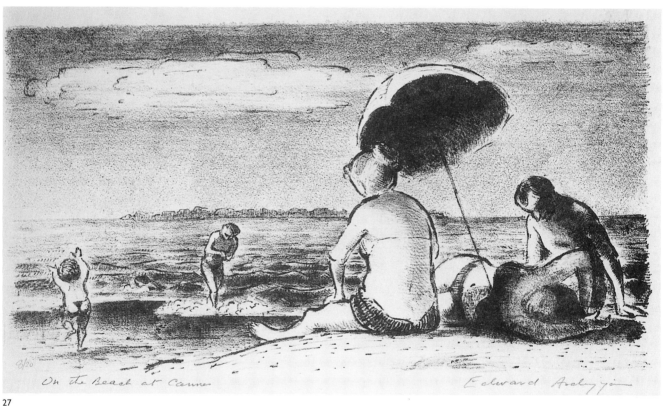

27

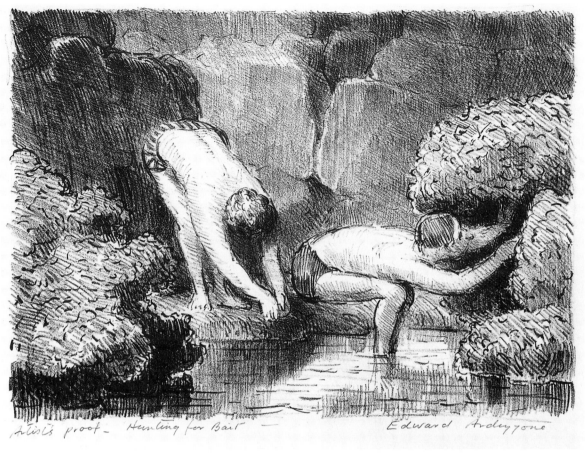

Artist's proof - Hunting for Bait - *Edward Ardizzone*

28

NAP 28

Hunting for Bait (direct)

Lithograph from a plate
DIMENSIONS: 226 x 320
PAPER: Whatman white wove
NOTEBOOK: SB32:10v,11, pencil sketches
INSCRIBED: 'Artist's Proof' and signed be Edward Ardizzone in pencil

DATE: 1958
EDITION: Only artist's proofs are thought to exist
WATERMARK: Whatman 1958 mark on some samples

DESCRIPTION: Two men, dressed in swimming trunks, are searching in a rock pool. There are large rocks behind and seaweed-covered ones in the foreground right and left. To the left a man, standing towards us three-quarters left to right, is bent over double while searching with his hands for something at the edge of the pool. To the right and slightly forward of his companion, another man, in profile left to right, is standing bent double, torso to thighs, while he feels with his hands up under a cleft in the rocks.

SEE ALSO: Paul Coldwell's preface (p10)
PRINTED: RCA

NAP 29

Hunting for Bait (offset)

Lithograph (offset)
DIMENSIONS: 226 x 320
PAPER: Whatman white wove

DATE: 1958
EDITION: 25
WATERMARK: Whatman mark on some samples

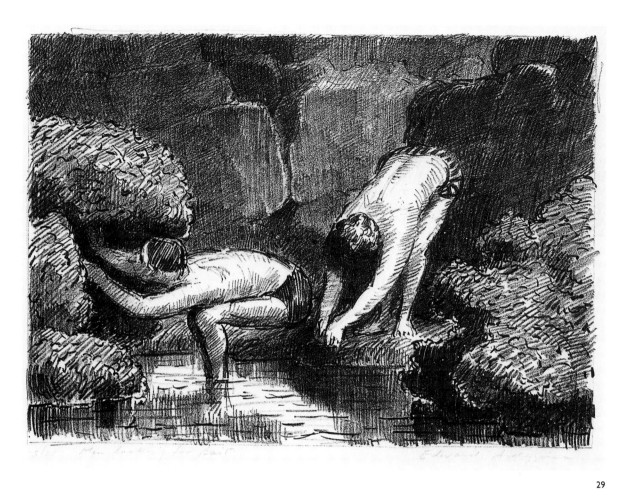

NOTEBOOK: SB32:10v,11, pencil sketches
INSCRIBED: Titled and signed with initials by Edward Ardizzone in pencil

DESCRIPTION: The plate has been considerably reworked after the direct pulls were taken, making for a much fuller image with a greatly increased tonal range. Being an offset of NAP 28, the image is reversed.

NOTE: 16/25 inscribed 'Men Looking for Bait'
SEE ALSO: Paul Coldwell's preface (p10)
PRINTED: RCA
EXHIBITED: SAC(120:11/25); ABS(067:17/25); MG(21); RAS(43); WCE(59:3/25)

NAP 30

Oiling on the Rocks

No image available

Lithograph from a stone	DATE: 1955
DIMENSIONS: 202 x 225	EDITION: Not known
PAPER: Cartridge type	WATERMARK: None seen

NOTEBOOK: SB13:24,37v,38, sketches for a terracotta figure of the same subject
DESCRIPTION: A man wearing a fez is rubbing oil into the back of a woman
PRINTED: Not known
NOTE: Although it is known to exist, it has not been possible to find either a pull or an image of this
 lithograph. The details given here are those recorded in my database made after my mother died in 1992.

SUITE VI
DRAWING FROM LIFE

To the general public the life room is something of a mystery, analogous perhaps to the dissecting room for doctors. Each concerns one of the most powerful taboos in western society: the external and the internal privacy of our bodies. To artists the life room is something unique and strangely sacramental, a private place where a bond, a trust exits between artist and model. Ted, as we have seen, received his only training as an artist at evening life classes and it was an environment in which he was particularly happy.

Later, as a tutor, he still adored the clutter of chairs, couches, easels, donkeys, drapes and props that always makes for the unique atmosphere of the life room and, as well as drawing the model, he could amuse himself drawing his students.

An anecdote told me by a former student is both typical and illuminating. After a considerable binge in the Junior Common Room, the student felt unable to make the journey home. Being friendly with the wardens, he was able to sneak into one of the RCA Cromwell Road life rooms, where he fell asleep on a couch. Having overslept, he awoke to hear Ted and his class entering the room. Fearing trouble, he was at a loss as to what to do, so he decided to do nothing and feign sleep. The next thing he heard was Ted telling his students 'How simply splendid! My dear girls and boys, now *that's* the sort of thing you should be drawing!'

NAP 31

The Drawing Lesson

For image see page 12

Lithograph from a stone DATE: 1952
DIMENSIONS: 188 x 234
EDITION: 30, ledger 'A' reports an intended edition of 50 with 30 printed, though the pulls are signed as being out of 50
PAPER: Whatman white wove WATERMARK: Whatman 1952 mark on some samples
INSCRIBED: Numbered, titled and signed by Edward Ardizzone in pencil

DESCRIPTION: A male model, seen back view, holds a standing pose with his right foot resting on a dais. To the left and a little further back a girl student is seated on a donkey with her drawing board before her. The teacher is bending over her left shoulder, pointing to some detail in her drawing and offering her some advice while gazing at her breasts.

SEE ALSO: Paul Coldwell's preface (pp12-13)

The stone

In 1979 I was teaching at Canterbury College of Art. A colleague there related that he had, a few years previously, seen the stone for this lithograph. It had crossed the road from the old Royal College of Art in Cromwell Road to the basement of the Natural History Museum, where it was being used as a door stop.

PRINTED: RCA
EXHIBITED: SAC(110)

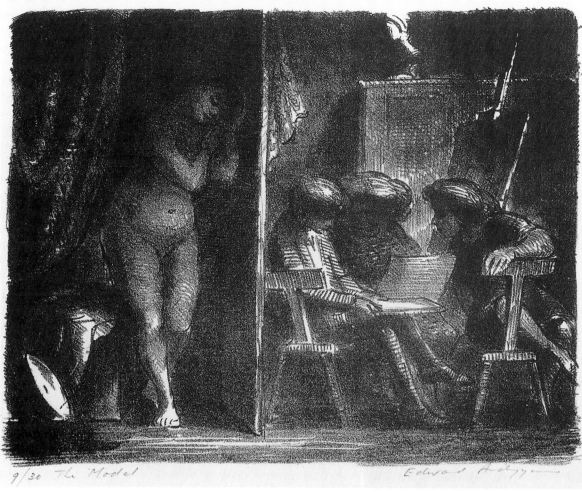

9/30 The Model Edward Ardizzone

32

NAP 32

The Model

Lithograph from a stone DATE: 1953
DIMENSIONS: 210 by 270
EDITION: 30, ledger 'A' reports an intended edition of 30
 with that number printed, 'Stone – unequal prints'
PAPER: Off-white wove WATERMARK: None
 seen
INSCRIBED: Numbered, titled and signed by Edward
 Ardizzone in pencil

DESCRIPTION: This is arguably Ardizzone's finest lithograph
in terms both of technique and observation. As in many
other works, he uses two subjects which are related to
but secret from each other. It is not so much that the
observer is forced into voyeurism, but more that we are
being let into two sides of a secret, because both subjects
are quite intimate and we are privileged to see both.

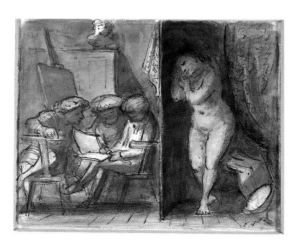

The Model, watercolour, 1953, 210 × 275
Private collection, London

The setting is the old life rooms at Camberwell. To the left there is a cubicle. The curtain is drawn aside and up, to reveal the model, standing, preparing herself. She faces us almost directly, leaning slightly to her left while she arranges her hair with both hands. She is pretty and slightly plump at the waist. She is lit only by the rays of a small dish-type electric fire which rests on the floor bottom left.

To the right of the cubicle wall can be seen three students, a man and two women. They sit on donkeys facing us, but they are looking down, completely absorbed in discussing a drawing that one holds in her hands. There is a drape hanging on the wall left background, and a cupboard on top of which stands a cast of a bust. The students seem relaxed, indeed there seems to be no hostility or tension anywhere in the work. The observation, drawing, chalk work and printing are exceptional in almost all the pulls.

SEE ALSO: Paul Coldwell's preface (p12)
PRINTED: RCA
EXHIBITED: V&A(068); SAC(108); MG(19; WFA(31:17/30); WCE(60:17/30)
NOTE: A watercolour of the same subject exists
REPRODUCED: GW(166)

NAP 33

The Model and Her Reflection

Lithograph from a stone DATE: 1955
DIMENSIONS: 250 x 360
EDITION: 25(1st), 75(2nd). A few unauthorised prints exist; see below (p69)
PAPER: Japanese white laid WATERMARK: None
NOTEBOOK: SB22:14, pen study; SB22: inclusion 'd', pencil sketch
INSCRIBED: Numbered, titled and signed by Edward Ardizzone in pencil

DESCRIPTION: This is certainly one of the best drawn and executed of Ardizzone's lithographs. The quality of the printing is outstanding.

The alert glance of the girl seated on the donkey left announces firmly that we have come upon the scene by opening the door. Her expression is friendly, suggesting that we are known to her and are not completely unexpected. Behind her is a self portrait of the artist instructing a girl standing at her easel. Foreground left a male student, seen rear view, sits on his donkey with his drawing propped before him.

The model holds her pose a little right of centre. She has an attractive face, long blond hair, and a rather full figure with heavy hips. She is standing, leaning to her left, supporting herself with her elbow on the cross-bar of an easel.

The right two thirds of the far wall is taken up with a mirror. In this we see to the left the reflection of a drawing of the model and to the right can be seen the reflection of the model's buttocks and legs. In the top right corner of the print, a drape hanging over a flat or a canvas gives compositional balance to the girl first mentioned. The bottom right corner is occupied by an unoccupied donkey on which rests another drawing of the model. Although the space depicted is quite cluttered, the artist has successfully captured the illusion of a greater space caused by the mirror.

SEE ALSO: Paul Coldwell's preface (pp11-12)
LITERATURE: AAC(930)
NOTE: A watercolour exists, University of Hull collection

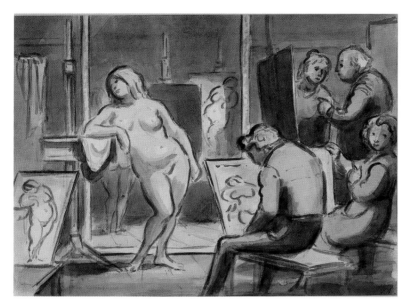

The Model and Her Reflection
Watercolour, 1953
355 × 559
Private collection, London

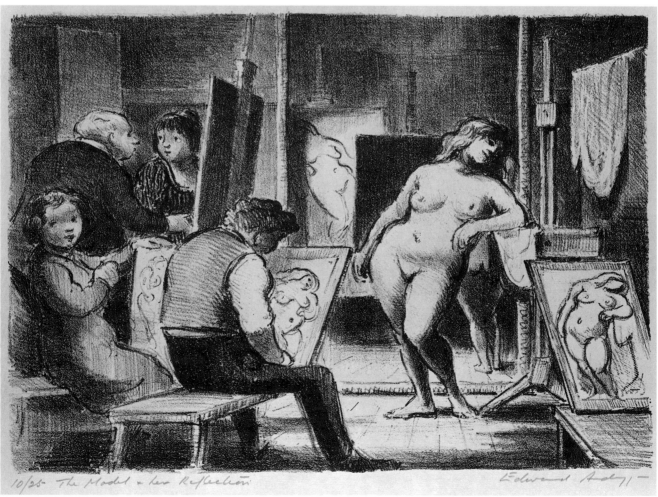

10/25 The Model & her Reflection Edward Ardy 71

33

The stone

The stone of this work survives and has an interesting history. After the death of Ardizzone in 1979, the stone was taken to Camberwell from the Curwen Studio where it was printed originally. The plan was to strike a second run with the intention of selling the prints as a benefit for the artist's widow Catherine. For some reason the project never came to fruition, but the stone remained on the premises, just sitting in a drawer, or being used occasionally as a pressing weight. Fortunately the image had been competently gummed up so the chalk impression was preserved.

That is how matters stood until October 1989, when some students – enterprising but shamefully ill-taught about copyright issues – ungummed the stone and printed off some pirate pulls.

This might never have been discovered save for an extraordinary coincidence. I joined Camberwell as a student in the autumn of 1989. On attending the annual college print sale, I discovered the unauthorised prints on offer at £5 each! Had this not been discovered, it is not hard to imagine the puzzlement that would have ensued had any of the prints appeared in the market!

It should be pointed out that these prints are easily identifiable because they are of inferior quality, the image being decidedly pale. It is thought that not more than about ten prints leaked into the public domain.

The new edition

After some tussling between the Ardizzone estate and the then authorities at Camberwell a stand-off came about, where the college kept possession of the stone but promised not to make any further unauthorised prints. Time, circumstances and people having moved on and the matter remaining unresolved, the artist Francis Tinsley[27] became concerned about the long-term safety of the stone and approached the Ardizzone Estate with the solution that has been agreed.

A new edition of seventy-five prints has been struck. These were first offered for sale at the 1999 exhibition of works by Edward Ardizzone, *Running Away to Sea*.[28] The money raised through the sale of the new edition will be used to set up a trust to enable an Edward Ardizzone Printmaking Prize to be established, to be awarded annually to a student at CCA. The stone is to be returned to the Ardizzone Estate.

The new edition prints have been made by Mike Taylor[29] and Francis Tinsley, using off-white BFK Rives paper. The stone has proved remarkably robust and printable, the only difference between the new run and the original being a slight filling up of some of the darker areas of cross-hatching.

To validate them and differentiate them from the original edition and the pirated prints, the new edition prints will be embossed with the seal of the Camberwell Press and will be accompanied by a letter of authentication.

NOTE: 1st edition variously reported as printed at RCA; GW(74) and (correctly) The Curwen Studio, AAC(77)
LITERATURE: AAC(93, titled as *Life Class*)
COLLECTION: Tate Gallery (P06010, titled as *Life Class*)
EXHIBITED: V&A(70); SAC(117:11/25); MG(28);WFA(31); RAS(10:2nd ed); WCE(58:5/25)
REPRODUCED: AAC(80, titled as *Life Class*)
PRINTED: (1st) The Curwen Studio, proofed by Stanley Jones. (2nd) Camberwell

[27]Senior Lecturer in Printmaking, Camberwell

[28]For details see p32

[29]Visiting Senior Lecturer in Printmaking at Camberwell and Director of the Pauper Press, London

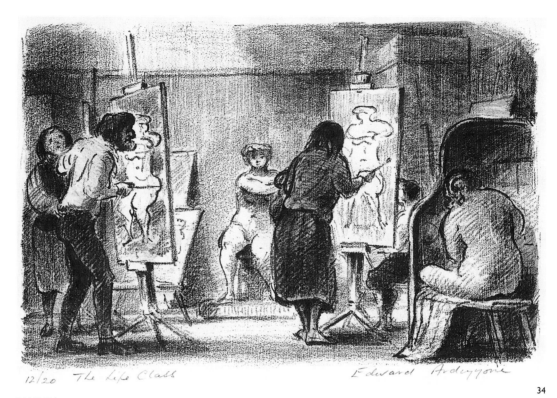

12/20 The Life Class Edward Ardizzone

34

NAP 34

The Life Class

Lithograph from a stone DATE: *c* 1958
DIMENSIONS: 195 x 300 EDITION: 20
PAPER: Whatman white wove WATERMARK: Whatman mark on some samples
NOTEBOOK: SB10:1, possible sketch (same model); SB11:100,101v,102, pencil sketches; SB29:56,59 pen sketches
 of similar subjects and figures
INSCRIBED: Numbered, titled and signed by Edward Ardizzone in pencil

DESCRIPTION: This life room scene is less finely executed than some of the others but it has some unique and
interesting features, not least among them that a second colour, pale yellow, has been printed on, but has
been made to appear as a hand-tinted wash.

 Again, the device of separate actions within the picture has been used, but in a quite different fashion to
some of the other works. Here the main action is in the larger division of the frame. Three students stand at
easels painting the model. Another student, partially obscured by the right-hand canvas in foreground, sits on
a donkey drawing. To the right, almost to be missed, the secondary action takes place. Before a small
shoulder-high partition, a second model sits cross-legged on a donkey with her back to us.

 Another significant difference in this work, compared to others in the same category, is that time and
fashion have moved on. Depicted here are the old life rooms of the Royal College of Art at Cromwell Road.
The RCA is a postgraduate college, so generally the students depicted are older. John Osborne's play *Look Back
in Anger* had appeared in 1956. 'Kitchen Sink' had arrived. The post-war contract between the generations was
over and all conventional mores were open to question.

 The Bohemian fashion for art students had started. Scruffiness was now the vogue, with an apparent
disregard for clothing or convention. This was the way of things for some five years until it crumbled before
the strident *chic* of Swinging London and the 1960s. The female student seen rear view right is working
barefoot.

PRINTED: RCA
EXHIBITED: MG(30); WFA(33:10/20)

SUITE VII
OXFORD

NAP 35

Trinity College, Oxford – The Porter's Lodge

Lithograph (offset) DATE: 1954
DIMENSIONS: 295 x 455 EDITION: *c* 50
PAPER: Hay white wove WATERMARK: HAY
INSCRIBED: Titled and signed by Edward Ardizzone in chalk, on the plate

DESCRIPTION: The viewpoint is the lawn, looking towards Broad Street, with roofs and a spire seen in the distance. The coatless figures and the state of the trees suggest early summer. The trees are very finely drawn, birches and a willow to the left and a fine cedar of Lebanon to the right.

There is little activity: to the right two gowned figures stand chatting to each other, another man is walking away towards the open gate while a third is seen making enquiries at the lodge. To the left, another gowned figure is walking right to left past a row of bicycles.

There are many complex compositional elements in this work, and the perspectives are cleverly controlled by the use of contrasts achieved through exceptionally fine chalk work.

LITERATURE:
AAC, p93:

> By 1960, when he drew at the Press the two specially commissioned finely graduated lithographs of Trinity College, Oxford in his favourite black and white, the Curwen Studio had opened. A number of subsequent prints, including 'Life Class' and a typical boating scene were thus the product of this special establishment for artists' lithographs that had grown naturally from Harold Curwen's pioneering.

GW(166):

> In the sixties, he was asked by Sir Arthur Norrington, President of Trinity College, Oxford, to make two plates, printed at the Curwen Press, of the Chapel Quad and of the Porter's Lodge and gates leading into Broad Street. The first was a particularly beautiful print in its use of greys and in its delicate tonal contrasts.

Excerpt from an E-mail, 2 February 2000, from Clare Hopkins, Archivist, Trinity College:

> It has proved surprisingly difficult to discover anything concrete about your father's two prints of Trinity College. The reason I fear is that the project was organised by undergraduates!
> However, it seems that the idea was conceived at the time of the establishment of the JCR Art Club (also known as the Art Scheme), in 1954, which coincided with the establishment of the Trinity Society (Old Members' organisation) the same year. The Trinity Society made a donation towards the cost, and "about 50 copies" of each lithograph were made available for purchase by undergraduates at a cost of 15 shillings each.

REPRODUCED: AAC(231)

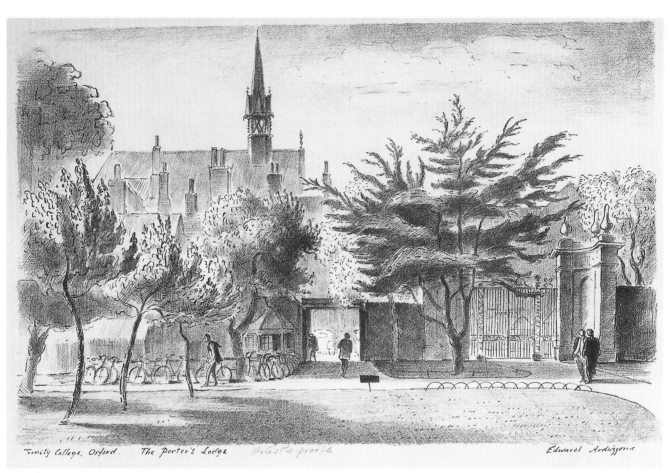

Trinity College. Oxford. The Porter's Lodge artist's proofs Edward Ardizzone

35

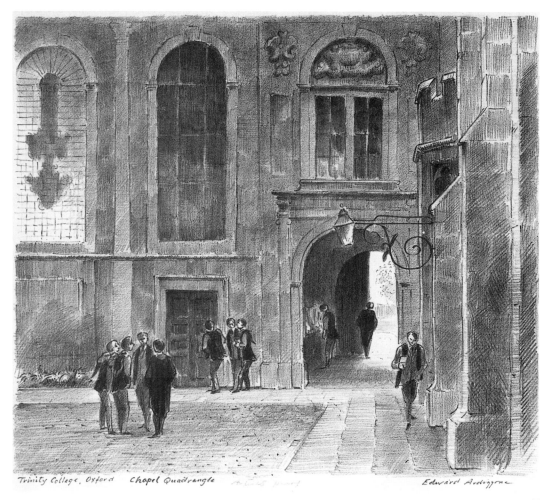

Trinity College, Oxford Chapel Quadrangle Edward Ardizzone

36

NAP 36

Trinity College, Oxford – Chapel Quadrangle

Lithograph (offset) DATE: 1954
DIMENSIONS: 292 x 342 EDITION: c 50
PAPER: Off-white wove Hay hand made WATERMARK: HAY
INSCRIBED: Numbered, titled and signed by the artist on the plate

DESCRIPTION: Ahead of us is an archway leading away to a sunlit area beyond where a faint suggestion of trees can be seen. At the far side of the arch the left hand door is being opened or closed by a man standing with his back to us and, to the left, another man, seen left profile, is standing reading notices.

 In the quadrangle itself two groups of undergraduates stand chatting, while another, solitary man approaches us along the right hand wall.

PRINTED: The Curwen Press
LITERATURE: AAC, p93, see also quote under Literature entry for NAP 35
EXHIBITED: V&A(75); WCE(63:AP)
REPRODUCED: AAC(231, titled as *The Inner Quad*)

NAP 37

New College, Oxford – Quadrangle

Lithograph (offset)
DIMENSIONS: 265 x 380
PAPER: Whatman white wove
NOTEBOOK: SB13:5-7, pencil sketches
INSCRIBED: Signed by Edward Ardizzone in pencil

DATE: 1954
EDITION: Not known
WATERMARK: Whatman mark on some samples

DESCRIPTION: We are looking across the central lawn. There is an archway through the building at the other side through which a figure is walking away. At the left, by the chapel wall, a group of undergraduates is standing in conversation. Much nearer a man is walking towards us, whilst another walks away left towards him. In the foreground right three workmen are engaged in tending the edge of the lawn. Except for these last three, all figures are wearing gowns. In the sky there is much piled white cloud, with one threatening dark patch to the right.

SEE ALSO: Paul Coldwell's preface (p14)
PRINTED: The Curwen Press?
EXHIBITED: WCE(62:AP)

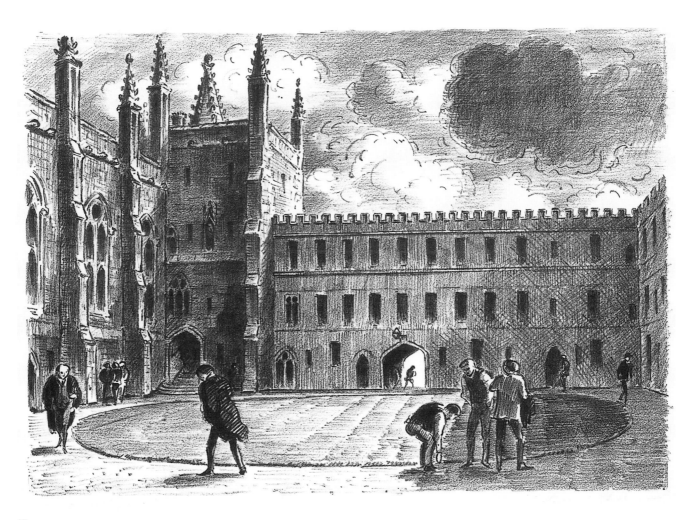

37

SUITE VIII
PUBLIC SCHOOLS

These prints were commissioned by Paul Cornwall-Jones at Editions Alecto. Ardizzone enjoyed doing the work. He found the business of making an occasional formal drawing, rather than an illustration, a challenge and a useful exercise. He was unhappy with the printed results; he had hoped for a a fuller range of tones than eventually were achieved.

He went to Paris to supervise the printing but having seen the proofs, he allowed himself to be persuaded into signing the blanks, and the printers let him down.

38

NAP 38

Charterhouse – The Courtyard

Lithograph (offset)
DIMENSIONS: 380 x 535
PAPER: Rives off-white wove

DATE: *c* 1964
EDITION: 100
WATERMARK: B F K RIVES

NOTEBOOK: SB08:85, pencil sketch; SB08:86-89, Charterhouse, architectural details; SB08:87, pencil sketch
INSCRIBED: Signed by Edward Ardizzone in pencil

DESCRIPTION: The viewpoint is the centre of a path leading to the well and thence to the corner of the cloisters behind. A boy is walking away from us passing to the left of the well whilst a man is walking towards it from the path to the right. In the cloisters boys can be seen passing to and fro.

To the left of centre behind the cloisters the chapel and its spire are visible, with other school buildings to the right.

PRINTED: Desjobert, Paris

NAP 39

Charterhouse – The Mulberry Tree

Lithograph (offset)
DIMENSIONS: 382 x 537
PAPER: Rives off-white wove
NOTEBOOK: SB08:72, 73, Pencil sketches; SB08:86-89, Charterhouse, architectural details
INSCRIBED: Signed by Edward Ardizzone in pencil

DATE: *c* 1964
EDITION: 100
WATERMARK: B F K RIVES

DESCRIPTION: The ancient mulberry tree, in the middle of its lawn with its many props, stands leaning over to the left. In the left hand bottom corner there is a pot of tulips and at the edge of the cental lawn other bulbs are in flower.

This, and the wearing of overcoats by all the three figures seen, indicates springtime. Finely drawn buildings can be seen behind. In the foreground a middle-aged master, wearing a homberg hat, who has just emerged from an ogee arch in the building behind him, pauses to light a cigarette. The spring sky is cloudy-bright with some patches of darker cloud.

SEE ALSO: Paul Coldwell's preface (p14)
PRINTED: Desjobert, Paris

39

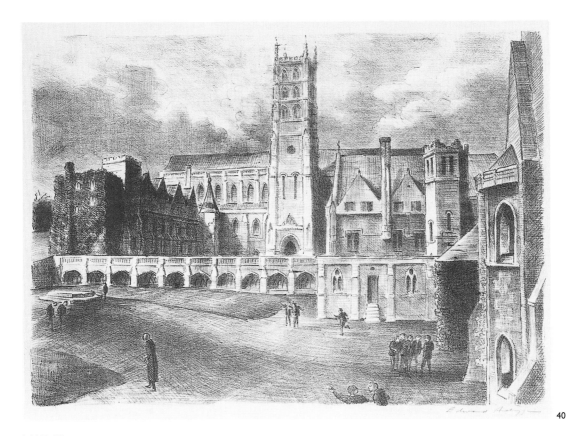

40

NAP 40

Downside Abbey – The Tower

Lithograph (offset)
DIMENSIONS: 370 x 530
PAPER: Rives off-white wove
INSCRIBED: Signed by Edward Ardizzone in pencil

DATE: *c* 1964
EDITION: 100
WATERMARK: B F K RIVES

DESCRIPTION: Downside Abbey was built in the nineteenth century but not completed until 1935. The scheme incorporated an existing Jacobean farmhouse which is now part of the school. The general architectural style is Old English, with a fine Perpendicular tower.

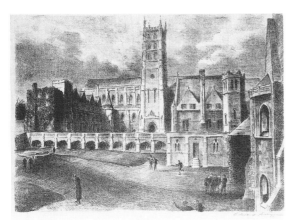

The drawing and the chalk work are finely done and the perspectives are carefully controlled in intent, but somehow, perhaps because of a certain paleness in the printing, this work gives an overall impression of flatness. The composition is interesting but slightly disturbing, relying perhaps too heavily on the figure of the monk walking left in foreground.

NOTE: Working drawings exist
PRINTED: Desjobert, Paris

NAP 40, working drawing, 290 x 445
Private collection, London

NAP 41

Downside School – The Quad

Lithograph (offset)
DIMENSIONS: 345 x 540
PAPER: Rives off-white wove
NOTEBOOK: SB08:74, pencil sketch
INSCRIBED: Numbered, titled and signed by Edward Ardizzone in pencil

DATE: *c* 1964
EDITION: 100
WATERMARK: B F K RIVES

DESCRIPTION: The buildings with their eccentricities and distortions are finely rendered, but again there is a certain flatness, perhaps in the printing, that gives an impression of flattened perspectives. Despite there being considerable activity within the picture, the overall impression is very subdued.

PRINTED: Desjobert, Paris
EXHIBITED: WCE(65:AP)
NOTE: Working drawing exists

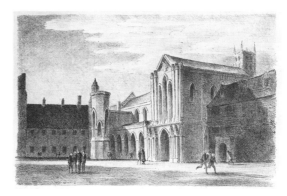

NAP 41, working drawing,
290 x 445
Private collection, London

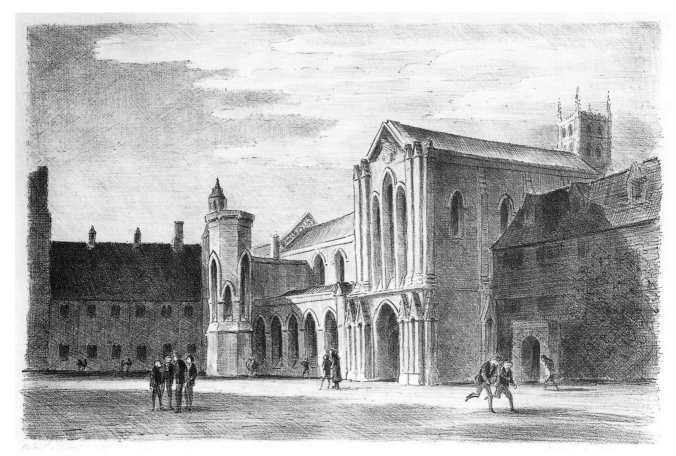

41

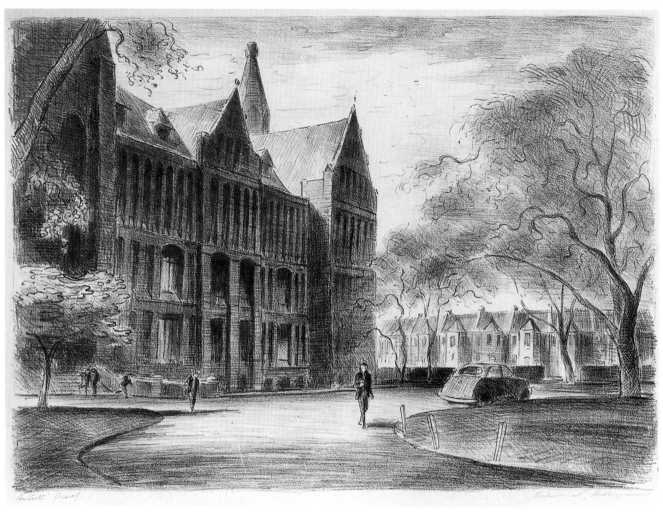

42

NAP 42

St Paul's School – The Front

Lithograph (offset) DATE: *c* 1964
DIMENSIONS: 382 x 535 EDITION: 100
PAPER: Rives off-white wove WATERMARK: B F K RIVES
INSCRIBED: Numbered, titled and signed by Edward Ardizzone in pencil

DESCRIPTION: The front of the school is to our left. To the right in background is a row of houses. Before that a broad drive embraces a central lawn in the middle of which stands a plane tree. In midground facing left to right, there is a car parked by the lawn. There are several figures in the composition, the most prominent one is walking towards us round the drive.

PRINTED: Desjobert, Paris
NOTE: Working drawing exists

NAP 43

St Paul's School – The Nets

Lithograph (offset) DATE: *c* 1964
DIMENSIONS: 350 x 535 EDITION: 100
PAPER: Rives off-white wove WATERMARK: B F K RIVES
NOTEBOOK: SB08:75, 76, pencil sketches
INSCRIBED: Signed by Edward Ardizzone in pencil

DESCRIPTION: The right background is taken up with the school building. To the left we see the side of a cricket pavilion, behind that there is a flagpole, a row of sheds, and in background an elm tree. In foreground, boys are practising in the nets, the second closest to us is bowling right to left. To the right another boy watches and awaits his turn. In the left hand corner a trolley with tyred wheels is parked.

SEE ALSO: Paul Coldwell's preface (p14)
PRINTED: Desjobert, Paris
EXHIBITED: V&A(76)

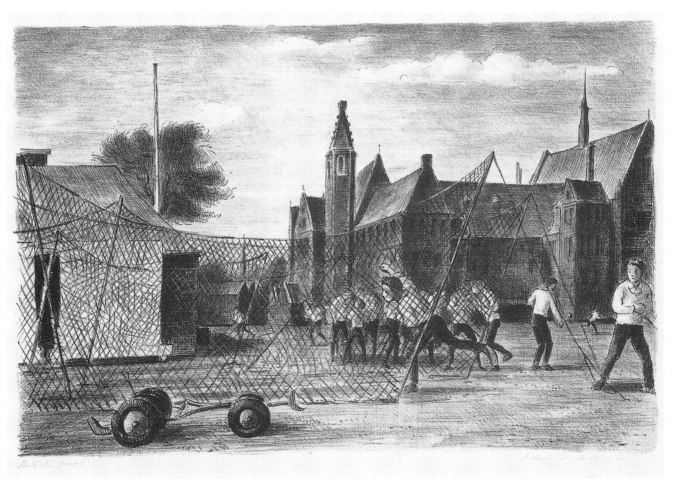

43

SUITE IX
PUBS

Through Augustine Booth,[30] Ted learnt to love pubs and drink. The atmosphere of the pub and the behaviour of people in it fascinated him, and he gained many subjects from there. He had a fine taste for drink, and regarded a pint of bitter in good condition as equal to fine wine, of which he became a connoisseur. Pubs and drink were a kind of punctuation to his life. He drank copiously, and occasionally to excess, but never desperately.

He had a round of about a dozen pubs that he favoured in the Maida Vale area of London and some of them, like The Alfred in Formosa Street with its renowned joinery and splendid etched glass, were remarkable both visually and architecturally.

The pub was absolutely his favourite leisure occupation. He would relax and do much of his thinking over a pint or two of beer. He would draw there constantly on anything to hand, a cigarette packet, a beer mat, or even a bus ticket. It was in pubs he found the humanity that fascinated him, the flawed, fallible humanity for which he had such a keen visual sense.

His second favourite occupation perhaps, was walking, which combined well with pub visiting. He would often take Jock, the family Jack Russell terrier, with him. Ted took snuff, and when he had taken a pinch, the dog, walking behind, would start sneezing a few seconds later.

NAP 44

At the Bar

Lithograph from a plate DATE: 1955
DIMENSIONS: 204 x 272 EDITION: Not known
PAPER: Off-white wove WATERMARK: None seen
INSCRIBED: Numbered, titled and signed by Edward Ardizzone in pencil

DESCRIPTION: A couple are seen front view in medium close up. The middle-aged man, smartly dressed in the fashion of the 1950s and wearing a hat, stands leaning back on his right elbow against the bar, a lighted cigarette in his hand. To the right, in front of and partially obscuring him is a younger woman, smartly dressed in a striped dress. She has her eyes closed, her hands clasped before her waist and is offering him a cheek to be kissed. He has his arm around her, with his hand on her left shoulder. Left, seen rear view behind the bar, a woman in a flower-print dress is replacing a bottle on a shelf.

PRINTED: RCA
EXHIBITED: SAC(112); MG(26)

[30]Booth is described on p20

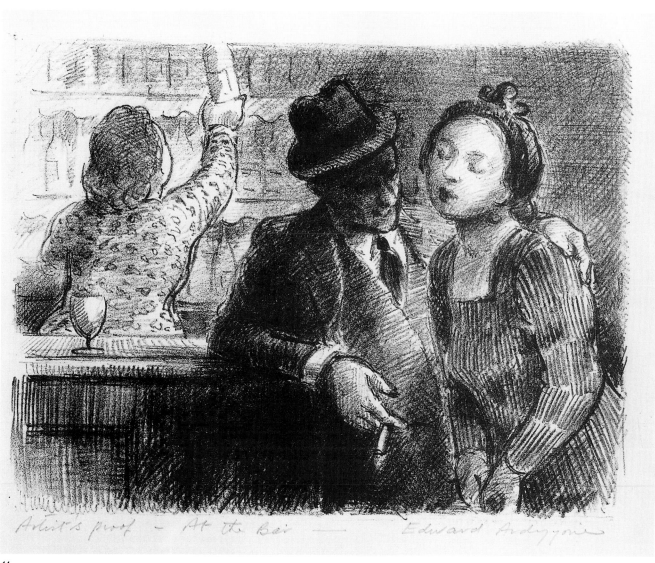

Artist's proof — At the Bar — Edward Ardizzone

44

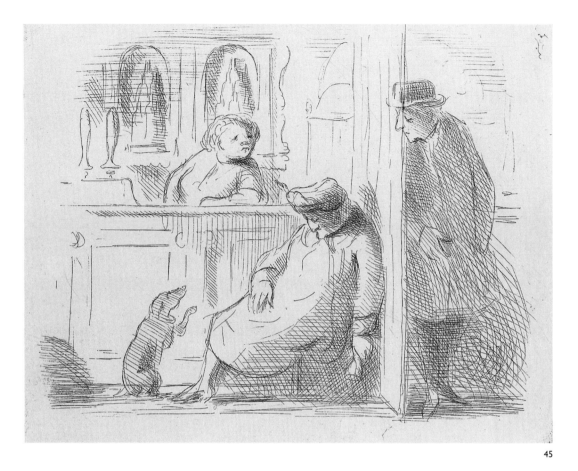

45

NAP 45

One for the Road

Etching

DIMENSIONS: 120 x 153

PAPER: Whatman white wove

NOTEBOOK: SB49:18, 2 pencil sketches on a similar theme

INSCRIBED: With title, state where appropriate, and signed by Edward Ardizzone in pencil

DATE: *c* 1955

EDITION: Not known

WATERMARK: None seen

DESCRIPTION: An elderly woman, seen left profile, sits slumped asleep on a bench in a pub. Her left hand is hanging down but still grips an upturned glass. She is being nagged for attention by her nondescript but worried-looking dog. She is watched by the barmaid who is standing behind the bar and by a man standing to the right, who is looking around the partition from another bar. They both regard her with a mixture of sympathy and disdain. The subject is one that Ardizzone worked in several media, under such titles as *Time to Go Home* and *She May Have a Lot to Forget, Poor Thing.*

This is a powerful illustration of Ardizzone's view. Having witnessed the scene at a glance, it became fixed in his memory, later to be recalled with devastating accuracy but totally without cruelty.

NOTE: At least two states exist

PRINTED: RCA

LITERATURE: GW(157)

REPRODUCED: A pen illustration of the same subject appeared in *The London Magazine* Vol. 1, No.6, 1954 and is reproduced in GW(157)

NAP 46

The Private Bar

Etching

DIMENSIONS: 153 x 208

PAPER: Whatman white wove

INSCRIBED: Titled and signed by Edward Ardizzone in pencil

DATE: 1953

EDITION: Not known

WATERMARK: Whatman mark on some samples

DESCRIPTION: The setting is a Victorian pub interior, possibly The Hero of Alma in Carlton Terrace. In midground is the bar behind which a woman, seen three-quarters back view, is working. Behind her an ornate shelving tower reaches to the ceiling. In front of the bar two middle-aged women are seated. They have turned slightly towards us to speak to a tall slim man who has recently entered though a door left background. To the right, facing the two women, a man is seated with his left leg crossed over his right knee and his right elbow propped on the bar. He looks lost in his own thoughts.

SEE ALSO: Paul Coldwell's preface (p13)

PRINTED: RCA

EXHIBITED: SAC(127:02/30)

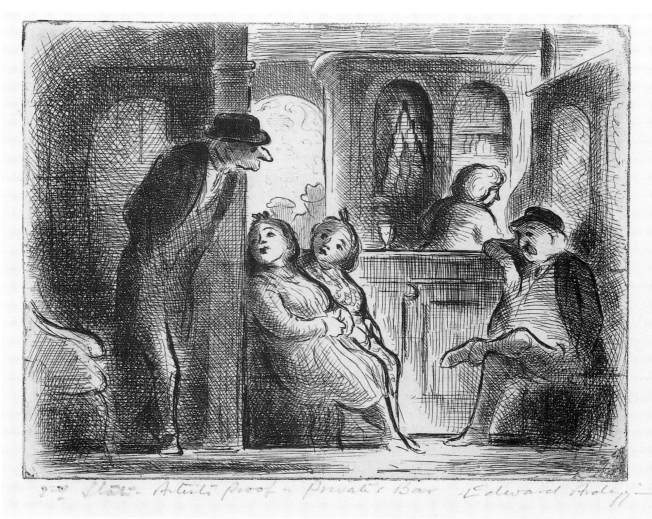

46

NAP 47

The Saloon Bar at the Shirland

For image see page 8

Lithograph from a stone DATE: 1955
DIMENSIONS: 280 x 375
EDITION: 50, ledger 'A' reports an intended edition of 50. Additionally, a few artist's proofs exist
PAPER: Believed 20 off-white Japanese, remainder Whatman white wove
WATERMARK: None seen
NOTEBOOK: SB16:90, pencil sketch; SB16:92, pen sketch
INSCRIBED: Numbered, titled and signed by Edward Ardizzone in pencil

DESCRIPTION: The Shirland Arms, Shirland Road, London W9, was by no means Ardizzone's favourite pub, but it was the closest to home, being some 350 metres from his front door. He depicts it in many works in several media. Deceptively, it was quite large, having four bars and an off-licence. The quality of the original fittings and joinery spoke of finer days gone by. However, except for St Patrick's Night, or just before closing time, there were seldom more than half a dozen customers present in the entire pub. It was a rather bleak pub in atmosphere, though here, the man standing leaning against the mantle shelf and the dog lying in foreground suggest the warmth of an open fire.

The lithograph is exceptional in the quality of its chalk work and its handling of light and shade, especially in the area of the two seated women. Here the bar room is shown in reverse image.

SEE ALSO: Christopher White's foreword (p8) and Paul Coldwell's preface (p13)
PRINTED: RCA
EXHIBITED: SAC(111)
COLLECTION: British Museum (1945-12-8-67; PRN: PPA2879)

NAP 48

The Stairs at the Shirland

Etching with aquatint DATE: 1955
DIMENSIONS: 137 x 210 EDITION: Unknown
PAPER: Whatman white wove WATERMARK: Whatman mark on some samples
NOTEBOOK: SB16:90, pencil sketch; SB16:92, pen sketch
INSCRIBED: With title and signed by Edward Ardizzone in pencil

DESCRIPTION: This etching depicts essentially the same scene as the lithograph NAP 47, except that there are fewer figures in the composition, and the atmosphere imparted is less cosy. The glass door behind the bar is marked 'Ladies', where in the lithograph it is marked 'Gentlemen'. Here the bar room is seen the right way round, bar to the left. This could suggest that Ardizzone had drawn the etching plate from a pull of the lithograph.

SEE ALSO: Christopher White's foreword (p8) and Paul Coldwell's preface (p13)
PRINTED: RCA
EXHIBITED: MG(05)

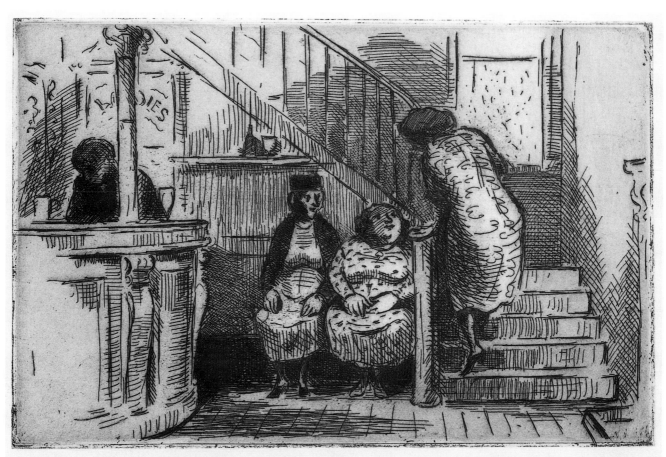

The Stairs at the Shirland Edward Ardizzone

48

NAP 49

The Drinkers

Lithograph from a stone
DIMENSIONS: 265 x 410
PAPER: Whatman white wove
INSCRIBED: Numbered, 'The Drinkers – coloured by hand' signed by Edward Ardizzone
NOTE: Some untinted pulls exist

DATE: 1958
EDITION: Not known
WATERMARK: Whatman mark on some samples

DESCRIPTION: Three men, all formally dressed, all in their late middle age, sit round a table drinking wine. The table, quite small, is dressed with a table cloth, suggesting a restaurant or perhaps a club dining room. On the left is a tall, slim man with a long nose with which he is testing the wine in a glass held in his left hand. In the middle sits a thickset man with a glass in his right hand. He has his left arm around the shoulder of another man seated to his left at the right of the table, with whom he is sharing an earnest confidence. This man has a long hooked nose which he is using to assess the wine.

The folds of the table cloth show delicate chalkwork. The background is taken up completely with crosshatching of varying tonal range.

PRINTED: RCA

49

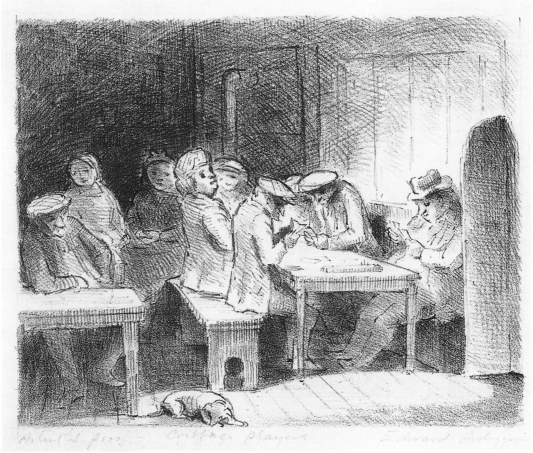

50

NAP 50

The Cribbage Players

Lithograph from a plate DATE: 1955
DIMENSIONS: 174 x 220
EDITION: 50, ledger 'A' reports an intended edition of 50 'plate at college'. About 10 artist's proofs exist
PAPER: Some Whatman white wove and some cream Japanese
WATERMARK: Whatman mark on some samples
NOTEBOOK: SB01:82; SB06:134, ink sketch
INSCRIBED: Titled and signed by Edward Ardizzone in pencil

DESCRIPTION: This lithograph is exceptionally fine in observation, composition and execution and is excellently printed. To the right, a group of men play cribbage round a table in the public bar of an old pub. The stove pipe on the rear wall and the wearing of overcoats suggest winter but also warmth. Two women and an old man sit at an adjacent table. A small dog sleeps on the floor in foreground.

The glance of the man sitting on the left bench lets us know we are strangers, but the others continue their game unperturbed. The division between primary and secondary subjects here relies not, as in other works, on physical things such as partitions, but on one simple fact: the men round the table are in the game but the women and the old man are not.

PRINTED: RCA
EXHIBITED: WCE(37:AP)

SUITE X
THE BEACH

The beach at Sheerness on the Isle of Sheppey in Kent was the nearest seaside to Rodmersham Green where Ted's mother Margaret lived, and to the village of Bredgar where his youngest brother David had a house. In summer, frequent outings with children from both families were made to Sheerness.

NAP 51

On the Beach (Sheerness)

For image see page 27

Etching with aquatint
DATE: 1953
DIMENSIONS: 135 x 209
EDITION: Not known
PAPER: Whatman white wove
WATERMARK: Whatman mark on some samples
INSCRIBED: Titled and signed by Edward Ardizzone in pencil. States are indicated where appropriate

DESCRIPTION: A wooden groyne stretches down the beach across the whole picture width. Behind left, the sea can be seen to the horizon, with a few bathers in the near distance. Facing us, sitting legs towards us, a young woman, attempting to change modestly, is arranging the torso of her swimming costume under her dress.

Behind and to the left of her, behind the groyne, a young man, facing us, is leaning across it, trying to catch a glimpse of her breasts. To the right, behind and protruding above the groyne, the top of a woman's hat can be seen, suggesting that the man has a female companion.

Near the left of picture a small boy is squatting with his back to the other characters playing in the sand, seemingly completely detached from the little incident playing itself out behind him.

NOTE: Two states exist of this plate, the later one having a hand aquatint added to the sky area.
LITERATURE: Gabriel White discussed and reproduced a pen and watercolour drawing of the same title and subject
GW(65):

> The quality that really distinguishes the work of this period however is the greater sensitivity Ardizzone shows to the psychological drama underlying the little events of daily life. Quentin Bell, in a penetrating analysis of 'On the Beach' (no. 69) in *The Studio* (May 1955), shows how much is to be learnt from so small a drawing and how it can become 'the narration of a transient scene in the human comedy.'

NOTE: A few 1st state pulls exist, which are lighter and have no aquatint in the sky area
EXHIBITED: ABS(074); RAS(44)

NAP 52

On the Beach

Lithograph from a stone DATE: 1953
DIMENSIONS: 135 x 210 EDITION: Not known
PAPER: Off-white wove WATERMARK: Whatman mark on some samples
INSCRIBED: Titled and signed by Edward Ardizzone in pencil

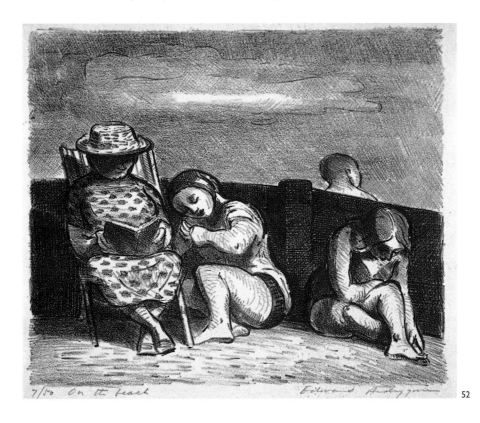

52

DESCRIPTION: The location is probably the same as that for the etching NAP 51, except here only one groyne is seen, as if from the other side, that is sloping away down the beach to the right.

To the left an elderly woman, facing us, sits in a deckchair reading a book. She is fully clothed, wearing a floral dress and a straw hat. She has her feet crossed.

To the right, a young woman, facing us, is seated on the beach. She is wearing a swimming cap and she has her head inclined towards the older woman. She is wearing also a swimming costume with a vest or shirt covering the torso and is adjusting something, maybe the strap of her cap or the bodice of her costume, with her hands held up under her face. Further to the right another young woman, dressed in a single-piece swimming costume, sits looking down at her feet. Her left leg is crossed over the other with her left knee raised whilst she explores her foot with her left hand. Between the two younger women, at the other side of the groyne and protruding above it, the back of the head and shoulders of a man can be seen.

There is fine chalk work here, notably in the sky and the groyne. The very regular cross-hatching is suggestive, almost, of mezzotint in its regularity and graduation of tone. However, there is a marked difference in the tonal contrast between pulls which alters the mood of the work considerably. In the crisper pulls the atmosphere is of a sunny day whereas the flatter pulls give a sombre effect.

PRINTED: RCA
EXHIBITED: MG(23); RAS(42)

SUITE XI
THE TARTS

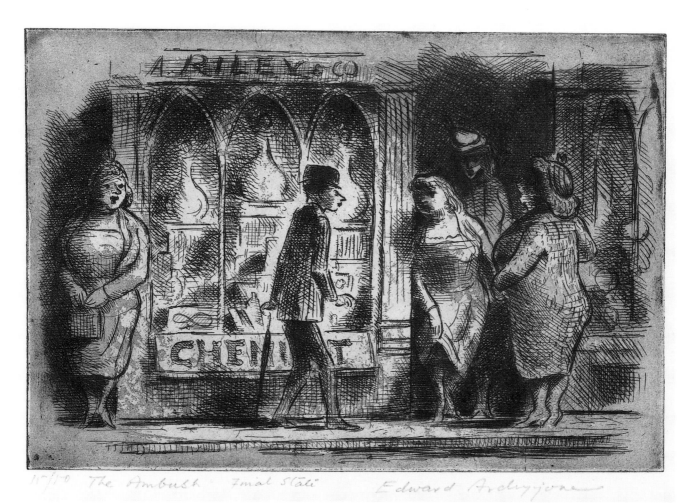

53

From the early days of his career Ardizzone did many works depicting London prostitutes. In the 1950s prostitution in London had become a serious nuisance. It was difficult for a man to walk anywhere without constant harassment, and women, even when just standing at bus stops, were often presumed by passing men to be prostitutes. In the end the matter became such a scandal that the government passed the Street Offences Act of 1958. It was not so foolhardy as to attempt a prohibition of prostitution – it was simply made illegal to loiter or to solicit custom, either by speech or gesture.[31]

[31]Quaintly, this Act proscribes also sliding on ice or snow; blowing horns, ringing doorbells and making bonfires.

SOHO

The area depicted is Soho, a 'square mile' in central London. It has always had a raffish reputation, but in the 1950s it was notorious for squalor, vice, and the gangsterism that attends the latter. Though partially deserved, this reputation obscured the lively and intensely cosmopolitan nature of Soho, as well as its somewhat decayed Victorian grandeur. This social mixture provided ample visual fare for a lively observer.

The current notion of prostitutes as victims of society was not widely fashionable at that time. Ardizzone regarded them – quite without malice – more as victims of their own innate stupidity in being unable to make a living any other way. This is expressed in the stances and expressions of the women he drew.

None of the prostitutes Ardizzone depicts are – in any conventional sense – beautiful, but neither are they hideous. He does not visually savage them. There is no unkindness in his observation of them, but even a certain sympathy with their plight. His view is very much less corrosive than that of Degas in his *Three Prostitutes on a Sofa*,[32] but still he does not spare them the reflection of their own absurdity.

NAP 53

The Ambush

Etching with aquatint	DATE: 1956
DIMENSIONS: 148 x 217	EDITION: Not known
PAPER: Various	WATERMARK: ENGLAND

INSCRIBED: Titled, signed Edward Ardizzone in pencil
NOTE: 3 states exist

DESCRIPTION: The setting is night time in front of an ornate chemist's shop which has in the window the large, decorative flagons of coloured liquid that were usual at that time. A callow young man wearing a bowler hat and carrying an umbrella is passing left to right. Three prostitutes gathered right in the doorway tease him. The youngest woman is lifting the edge of her skirt to show a knee. Another woman leans against the corner of the building left.

SEE ALSO: Paul Coldwell's preface (p13)
PRINTED: RCA
EXHIBITED: SAC(124a:1st state & 124b:AP 1/5); MG(27 & 27a – different states); WFA(34:AP1/5)

[32]*Trois Filles Assise, de Face*, in the Rijksmuseum, Amsterdam

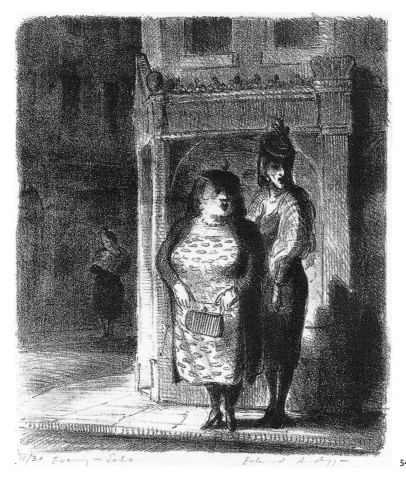

54

NAP 54

Evening in Soho

Lithograph from a stone DATE: 1956
DIMENSIONS: 257 x 230
EDITION: 30, ledger 'A' reports an intended edition of 30 and 30 printed, 'stone'
PAPER: Unbleached Arnold off-white laid WATERMARK: Unbleached Arnold
INSCRIBED: Numbered, titled and signed by Edward Ardizzone in pencil

DESCRIPTION: Two prostitutes stand in front of a shop window at a street corner. It is dark, the only
illumination being street light. Another woman is seen rear view on the opposite pavement of the adjacent
street. Of the foremost pair, the nearer one is decidedly stout. She is wearing a flower-print dress; a coat
unbuttoned, which is held wide open by the swell of her ample bust; a little flat hat with a feather; and she is
carrying a small handbag held by both hands in front of her. She partially obscures the other woman to her
left who is the opposite in physique, being taller by a head than her companion and slender with a gaunt,
thin face and a rather beaky nose. She wears a hat cocked forward on her head and a dark dress under a fur
stole. Both women have fiercely painted lips.

 This work is distinguished by fine chalk work and clever observation of light on the two women and the
pavement.

PRINTED: RCA
LITERATURE: GW(163)
EXHIBITED: V&A(069); SAC(109:18/30); NG81(78:11/30)

NAP 55

Street Corner

Lithograph from a plate

DIMENSIONS: 240 x 262

PAPER: Whatman white wove

DATE: 1956

EDITION: 30

WATERMARK: Whatman mark on some samples

NOTEBOOK: SB11:162,163, pencil sketches for a similar scene, this has three figures; SB11:165, similar but with red line; SB23:11, pen sketch of similar figures

INSCRIBED: Numbered, titled and signed by Edward Ardizzone in pencil

DESCRIPTION: Three prostitutes stand chatting in a doorway left. The centre one facing us, a black woman, is enormously stout. Her two slimmer companions stand facing each other on either side of her. To the right, other women can be seen waiting on the opposite pavement of the adjacent street.

This image has filled up considerably during printing which has detracted from the fineness of the chalk work. Nonetheless, it shows clever use of light, with strong back light showing from the street lighting round the corner right.

PRINTED: RCA

EXHIBITED: MG(25)

REPRODUCED: GW(163)

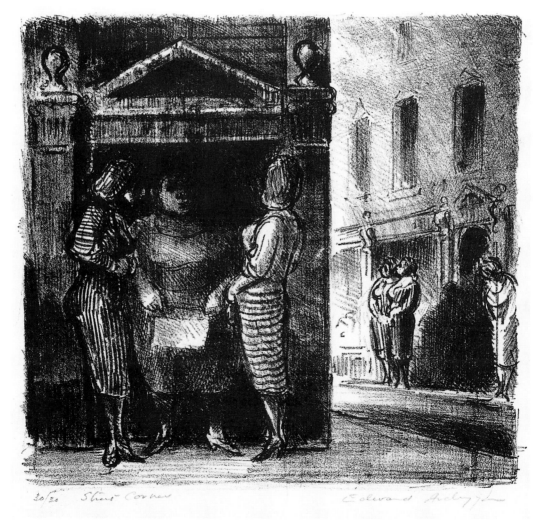

55

The car tarts

A result of the Street Offences Act of 1958 was a vast increase in prostitution involving motor cars. The 'car tarts' would wait alongside the main commuter routes in the evening, waiting to be picked up by clients. By this means they avoided not only any accusation of soliciting, but also the overhead cost of paying extortionate rents to landlords. The part of Maida Vale shown here is a prosperous inner-city suburb next to and west of central London. The area is named after the eponymous road, where lived Ted's cousin and childhood friend Mary Lewis.[33] A frequent visitor to the house, Ardizzone would enjoy watching from the drawing room window as the 'girls' awaited trade.

There being no action without reaction, car prostitution led to innocent women being accosted by drivers, residents being put out and general annoyance which, in turn, became scandalous to such an extent as to cause eventually, the 1985 legislation against 'kerb crawling'.

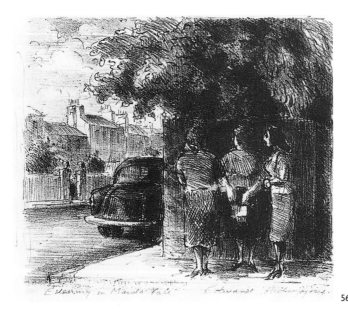

56

NAP 56

Evening in Maida Vale

Lithograph from a plate
DIMENSIONS: 185 x 230
PAPER: Whatman white wove

DATE: 1958
EDITION: 30
WATERMARK: Whatman marks visible on some samples

NOTEBOOK: SB23:11, pen sketch of a similar scene with one girl talking to a man in a car; SB23:75, ditto, from a different viewpoint
INSCRIBED: Numbered, titled and signed by Edward Ardizzone in pencil

DESCRIPTION: Three women wait in a side street at the corner of a main thoroughfare in a prosperous residential area. Just around the corner in the main road, a car has drawn up.

SEE ALSO: Paul Coldwell's preface (p13)
EXHIBITED: SAC(115:12/30); MG(13)

[33]Mary Lewis wrote as Christianna Brand. Best known as a crime writer, she also had a notable collaboration with Ardizzone with such books as the *Nurse Matilda* stories and *Naughty Children*.

SUITE XII
VILLAGE LIFE

RODMERSHAM GREEN

In 1926 Edward Ardizzone's father Auguste bought a house at Rodmersham Green, in the orchard country on the downs above Sittingbourne in Kent. He lived there until his death in 1942. It was to the same village that Ted and Catherine retired when, in 1972, they gave up the house at 130 Elgin Avenue, London W9.

Though now the area is a commuter dormitory for London, and the countryside has been stripped of its fruit trees and hedges to be put under the plough, it used to be an area of pretty, secret villages with a certain untidy intimacy.

NAP 57

Old Ladies on the Green

Lithograph from a stone
DATE: 1955
DIMENSIONS: 200 x 255
EDITION: 30, Ledger 'A' reports an intended edition of 30 and 30 printed
PAPER: Various, some off-white laid and off-white wove
WATERMARK: Some marked 'Unbleached Arnold'
NOTEBOOK: SB22:98, possible blue pen sketch
INSCRIBED: Numbered, titled and signed by Edward Ardizzone in pencil

Artist proofs – Old Ladies on the Green Edward Ardizzone

57

DESCRIPTION: The setting is Rodmersham Green. Two old ladies stand talking to each other in the middle of the road. Notwithstanding the trees being fully in leaf, both are wearing winter coats and hats. The one nearest stands back to us. She is wearing a light-coloured coat. The other, facing us in semi-profile left to right, has a dark coat. The weather appears overcast with some piled cloud in the sky, but there is sufficient sunlight to cast long shadows suggesting evening.

The depiction of Rodmersham Green is just as it looked then. The gates of Orsett House are in left foreground, and behind them the giant ilex tree that used to grow there. Beyond that is seen the old chapel. Down the slope can be seen the roof of Holly Tree Lodge, to the right of which two children are playing on the green.

PRINTED: RCA
LITERATURE: GW(164)
EXHIBITED: V&A(71); MG(06)
REPRODUCED: GW(164)

58

NAP 58

The Bullies

Lithograph from a stone DATE: *c* 1958
DIMENSIONS: 245 x 350 EDITION: 30
PAPER: Barcham Green off-white wove WATERMARK: CHRISBROOK
INSCRIBED: Numbered, titled and signed by Edward Ardizzone in pencil

DESCRIPTION: The scene is a village green with a house seen at the bottom of a slope to the right. Beyond the house rolling orchard country leads into the distance.

A party of teenage boys have ambushed a younger one. Whilst one of them holds the victim by the collar of his jacket, the other four have taken a shopping basket from him and are running away right with it down the slope. The incident takes place before a wooden fence behind which are seen trees, some of which are in blossom. Standing at the gate of the house below, a woman looks on. This work is distinguished not only by its exceptionally fine chalk work and printing, but also by its sheer vitality and exuberance.

EXHIBITED: SAC(118:15/20); MG(30)-RAS(45:20/20)
REPRODUCED: GW(45). White reproduces a pen and watercolour drawing which shows a similar group of boys
 playing in a very similar setting, though there the action is entirely innocent.
PRINTED: The Curwen Studio, proofed by Stanley Jones

GLOUCESTERSHIRE

In the middle of the 1950s Ted and Catherine shared a rented country cottage with Michael and José Baird who were part of the Hanover Terrace circle.[34] The cottage was in the village of Aston Subedge, which is tucked in just below the escarpment of the Vale of Evesham, near the town of Chipping Camden. The countryside there was very different from that of Kent, but it appealed to Ardizzone who used it as the subject for two of his only four known softground etchings.

NAP 59

The Country Lane (The Road to the Village)

Softground etching DATE: 1953
DIMENSIONS: 147 x 214 EDITION: Not known
PAPER: Whatman white wove WATERMARK: Whatman 1952 mark on some samples
INSCRIBED: Some titled *The Country Lane,* others titled *The Road to the Village,* and signed by Edward Ardizzone
 in pencil

DESCRIPTION: The viewpoint is the middle of a country road that curves away right into a leafy village. In the right corner there is a rock or high bank topped with a high, wild hedge. In left foreground two women gossip over a garden fence. The fence follows the curve of the road away as far as can be seen and further along it a man, seen rear view, is walking or running away along the pavement. In the middle distance right, houses and roofs can be seen and behind them, in the distance, is the spire of a church.

PRINTED: RCA

59

[34]See p61

NAP 60

A Romantic Corner

Softground etching

DIMENSIONS: 147 x 214

PAPER: Whatman white wove

INSCRIBED: Titled and signed by Edward Ardizzone in pencil.

DATE: 1953

EDITION: Not known

WATERMARK: Whatman 1952 mark on some samples

DESCRIPTION: This is similar to NAP 59 in intent and setting. The viewpoint could be further along the same road. There is a large rock in foreground left and behind it a large willow tree. The same church spire is seen in the distance right. In midground right a couple, arm in arm, walk away from us. Further away on the same side of the road is seen the same shadowy, running figure, but this time it is approaching us.

PRINTED: RCA

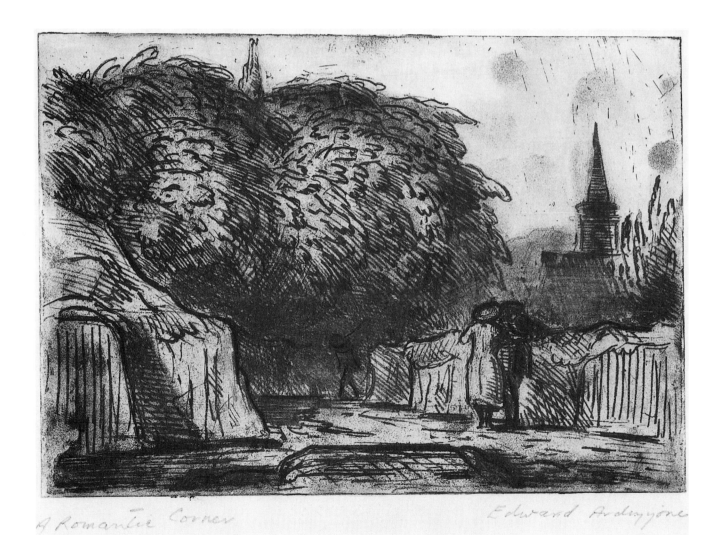

60

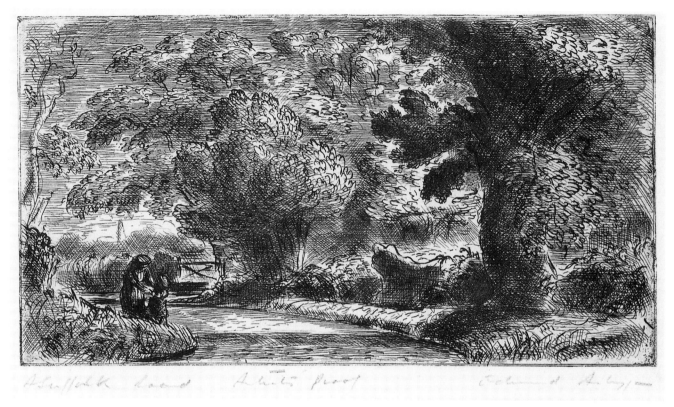

A Suffolk Road Artist's proof Edward Ardizzone

61

SUFFOLK

Other than the artist's inscription, there is no evidence to indicate the location of the following print.

NAP 61

A Suffolk Road

Etching DATE: *c* 1953
DIMENSIONS: 116 x 218
EDITION: Unknown, maybe only artist's proofs were pulled. One pull, not signed or titled exists, which has
 been extensively overdrawn in pencil by Edward Ardizzone.
PAPER: Whatman white wove WATERMARK: Whatman mark on some samples
INSCRIBED: 'Artist's proof' and signed by Edward Ardizzone in pencil

DESCRIPTION: The setting is an oak wood. A road leads away through it, curving to the left out of sight. Beyond
and through the tree canopy can be seen a church steeple. In midground left a woman and a child are
walking towards us at the side of the road.

EXHIBITED: SAC(125:AP)

SUITE XIII
YOUNG PEOPLE AND CHILDREN

Edward Ardizzone was fascinated by children and young people, he enjoyed watching them at play and at leisure. Because of his engagement with young people he was an excellent teacher who is remembered by his students with the greatest affection.

He had in his youth been a great lover of dancing, an activity he was able to record particularly well.[35]

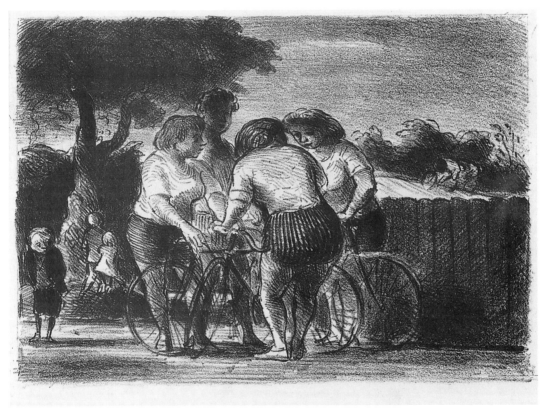

NAP 62

62

The Cyclists

Lithograph from a plate DATE: 1955
DIMENSIONS: 187 x 260
EDITION: 30, ledger 'A' reports an intended edition of 30 and 30 printed, 'plate here'
PAPER: Whatman white wove WATERMARK: Whatman mark on some samples
NOTEBOOK: SB17: several sketches of Paddington Recreation Ground cycle track and surroundings; SB20:05,06, pencil sketches
INSCRIBED: Numbered, titled and signed by Edward Ardizzone in pencil

[35]See the artist quoted in Paul Coldwell's preface (p15).

DESCRIPTION: A group of four girls with bicycles gossip, while to the left a small boy gives them a sideways, suspicious glance. There is a cycle track in background with some cyclists racing around it. The setting is based on Paddington Recreation Ground.

SEE ALSO: Paul Coldwell's preface (p5), and GW(156) which has a broad view of the Recreation Ground and the cycle track.

PRINTED: RCA

LITERATURE:

GW(39&41):

> Another meeting place for local life which constantly provided subjects was the Paddington Recreation Ground, off Elgin Avenue. It had a cycle track which appears frequently in Ardizzone's early work and there are cyclists, standing and chatting or bending over their handlebars with a fine display of back and thigh... In the centre stood an old half-timbered pavilion, round which the elderly sat with children playing at their feet, or sad-looking women pushed their prams. This was the scene which inspired the story for the artist's second children's book, *Lucy Brown and Mr Grimes*.

EXHIBITED: V&A(67); MG(03); WFA(36:26/30)

NAP 63

Here Comes the Copper

Etching with aquatint

DATE: 1952

DIMENSIONS: 145 x 178

EDITION: Not known, but the NG81 ctalogue entry suggests an edition of 6

PAPER: Whatman white wove

WATERMARK: Whatman mark on some samples

NOTEBOOK: SB01:66, possible study; SB05:74v, wash study

INSCRIBED: Titled and signed by Edward Ardizzone in pencil

DESCRIPTION: Three boys right run away from an approaching policeman who is walking with measured step from the left. He is wearing a large moustache and the old uniform with the high collar. A woman holding back a curtain watches from behind it. The image to the left is sketchy but the whole work is greatly enlivened by a patch of aquatint over the right background.

NOTE: At least two states exist. The 1st state has no aquatint, very few pulls exist

EXHIBITED: MG(07); NG81(79:1/6)

PRINTED: RCA

Here comes the Copper *Edward Ardizzone*

NAP 64

The Dance (Rock & Roll) (The Jive)

Etching with aquatint

DIMENSIONS: 134 x 207

PAPER: Whatman white wove

DATE: 1952

EDITION: 30

WATERMARK: Whatman mark on some samples

INSCRIBED: Some titled *The Dance*, a few titled *Rock & Roll*, all numbered and signed by Edward Ardizzone in pencil

DESCRIPTION: A jazz band plays on stage whilst students jive by the light from the stage in a darkened hall. This is a scene of vibrant energy, where the artist's superb grasp of anatomy has allowed him to capture the actions of the dancers quite wonderfully.

 Though dealing with young teenagers and a completely different subject, *The Bullies* (NAP 59) exhibits a similar exuberance and observation of stance.

SEE ALSO: Paul Coldwell's preface (pp10 &15)

NOTE: Titles vary from print to print

PRINTED: RCA

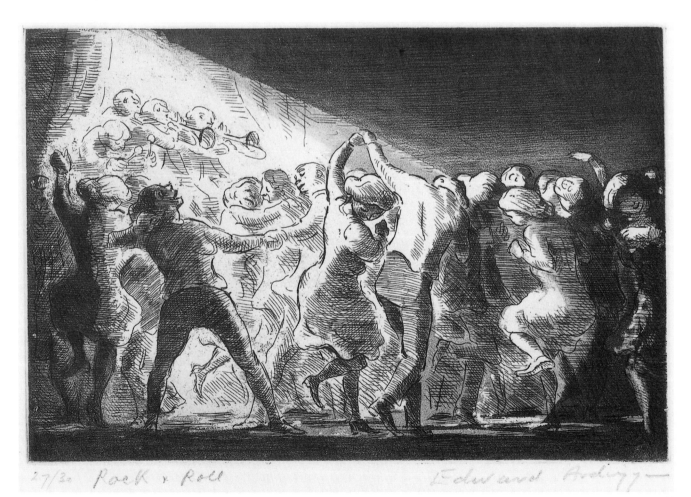

64

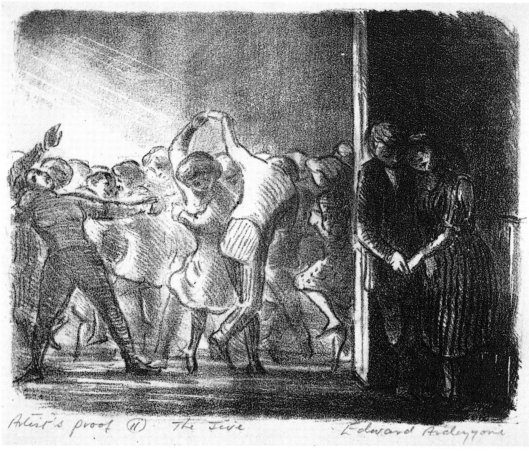

65

NAP 65

The Jive

Lithograph from a stone

DIMENSIONS: 190 x 245

PAPER: Whatman white wove

INSCRIBED: Numbered, titled and signed by Edward Ardizzone in pencil

DATE: 1952

EDITION: Not known

WATERMARK: Whatman marks on some samples

DESCRIPTION: This is essentially the same action as the etching *The Dance (Rock & Roll)* (NAP 64), almost as if another artist, with an identical eye, had recorded the same instant from a different angle. The viewpoint has moved in an arc round to the left and the dancers are seen brightly illuminated with light from that direction. Because of the etching, we know that it is coming from the stage but we might well have supposed this anyway.

In this work, however, the secondary action is quite different. To the right edge of the picture there is a partition beyond which is a darker area. A young man facing us is leaning against the partition and against him leans a young woman with her head on his shoulder. He is holding her left hand in his right.

PRINTED: RCA

EXHIBITED: MG(15)

66

NAP 66

The Fair

Etching with hand aquatint
DIMENSIONS: 132 x 139
PAPER: Whatman white wove
INSCRIBED: Numbered, titled and signed by Edward Ardizzone in pencil

DATE: 1956
EDITION: 4 in 2nd state, other states not known
WATERMARK: Whatman mark on some samples

DESCRIPTION: The scene is a fairground with many stalls. Two women and a little girl walk away from us looking at a stall to right. They have arms round each other's waists. In midground is a shooting gallery with men, seen from behind, leaning forward into it. There are several other figures in the picture, as well as a small dog in the left hand corner.

NOTE: At least 2 states exist. The 1st state has no aquatint, very few pulls exist
PRINTED: RCA
EXHIBITED: SAC(123:11/50); MG(11)

SUITE XIV
FANTASTICAL SCENES

Ted was lonely and unhappy at his boarding school and in his autobiography he wrote:[36]

> This unhappy situation drove me to take refuge in painting and drawing, a hobby already, but even more so now. I lost myself in hours of doodling, making up odd monsters, caricaturing boys and masters and inventing strange landscapes.

His excellent, self-taught grasp of anatomy allowed him to invent fantastical creatures. He used this to great effect in some of his illustrations for children's books. Here the centaurs look quite credible, but with an almost human and homely quality.

NAP 67

Centaurs by the Sea

Softground etching with aquatint DATE: 1953
DIMENSIONS: 125 x 180 EDITION: 30
PAPER: Whatman white wove
WATERMARK: Whatman 1952 mark on some samples
INSCRIBED: Numbered, titled and signed by Edward Ardizzone in pencil

DESCRIPTION: The setting is a rocky shore with sea to the left. There are mountains in the distance right. To the right, a bearded centaur holding a spear looks right to left towards us while rearing up on his hind legs. To the left, facing right to left, and with her hind quarters partly obscured by him, a comely female centaur stands among rocks at the sea's edge with her arms partially extended.

PRINTED: RCA

67

[36]*The Young Ardizzone*, Studio Vista, London 1970, p106

NAP 68

Centaurs Hunting

Softground etching DATE: 1953
DIMENSIONS: 125 x 180 EDITION: 30
PAPER: Whatman white wove WATERMARK: Whatman 1952 mark on some samples
INSCRIBED: Numbered, titled and signed by Edward Ardizzone in pencil

DESCRIPTION: In the foreground two centaurs holding spears stand on a promontory watching two others
hunting in the middle distance; the one on the right is galloping right to left whilst loosing off an arrow into
the distance. The setting is Arcadian, with mountains in the distance.

PRINTED: RCA

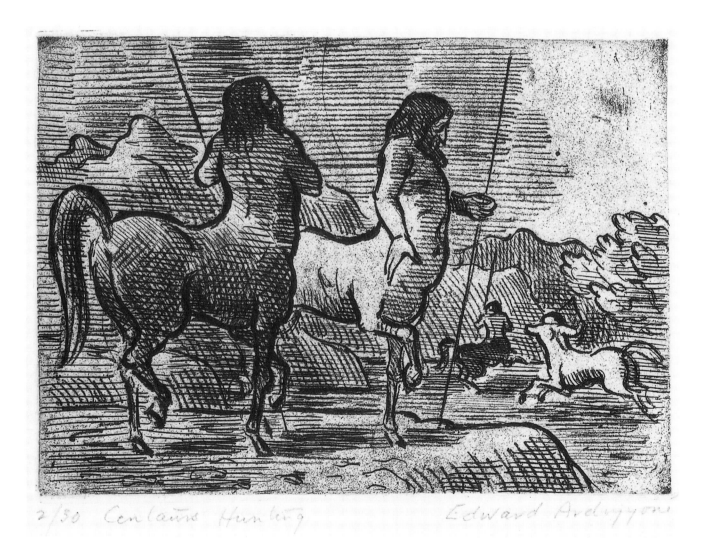

2/30 Centaurs Hunting Edward Ardizzone

68

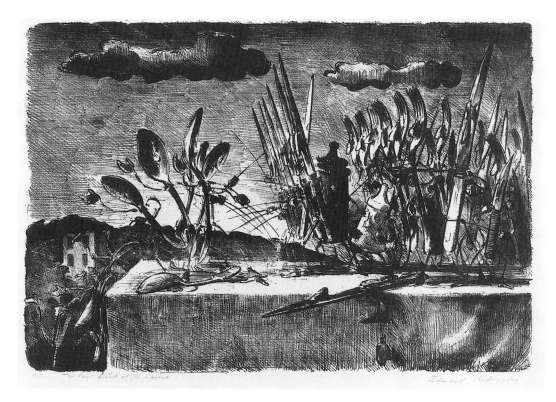

69

NAP 69

The Last Stand of the Spoons

Lithograph from a plate
DIMENSIONS: 360 x 530
WATERMARK: None seen

DATE: 1968
PAPER: Various
INSCRIBED: Numbered, titled and signed by Edward Ardizzone in pencil

DESCRIPTION: Despite the visual resonance with *Alice in Wonderland*, this is possibly the only work by Ardizzone that harks back to his experiences as an Official War Artist between 1940 and 1945. The battle takes place on a table top, beyond which is seen romantic, italianate landscape, reminiscent of those depicted in his travels in north-central Italy in the spring of 1945. The spoons are routed, and their leader, though fighting courageously to the last, shrugs in acceptance of the inevitable as he waves the world farewell. Among the opposing knives and forks, losses are light but no premature jubilation is seen. Discipline is being maintained till the last sword thrust.

 Ardizzone had been in the habit of staying with the front-line wherever possible, and his intuitive visual grasp of military attitudes is shown here in the stolid expressions in the lines, the canny expression of the pepper grinder, and the furtive demeanour of the salt cellar, who seems bent on some devious action.

 In the spring of 1942, Ardizzone had been part of the 8th Army pursuit into Tunisia. Later his friend and colleague Alan Morehead described the collapse of the *Deutsche Africa Korps* there,[37] where many of their number were literally pushed into the sea. Ardizzone was very moved by the account and the desperate plight of the spoons may have been based on it.

COLLECTION: Tate Gallery (P06009)
PRINTED: The Curwen Studio, proofed by Stanley Jones
EXHIBITED: V&A(74)

[37]*The Desert War*, Hamish Hamilton, London, 1965

SUITE XV
THE SECOND WORLD WAR

Edward Ardizzone had been a Royal Artillery Territorial before the war. On mobilisation, he was among the first to be recalled to the colours. Commissioned quite quickly, he had resigned himself to the business of manning anti-aircraft batteries around London for the rest of the war, when to his total astonishment he was appointed an Official War Artist. This was the start of an enormous adventure. In 1940, he joined the British Expeditionary Force in France, and was lucky to escape through Boulogne when the BEF collapsed in ignominy. He spent a year in the United Kingdom, painting the London and Glasgow blitzes, the Home Army and the Home Guard in training and the arrival of the first American troops in Belfast.

70

In 1942 he was sent to Cairo. Ted, a conscientious man, felt it his duty as a War Artist to be at the front and developed a habit of staying with front-line units whenever possible. The Army were not only extremely fond of this unusual character but admired him also, which gave him almost unlimited freedom of movement.

He was with the Rifle Brigade at 2nd Alamein, and stayed with the 8th Army during the bitter fighting that ended in the rout of the *Wehrmacht* in Tunisia.

After a rest in Cairo, he waded ashore during the invasion of Sicily, and stayed with the 8th Army through some of the bloodiest battles in the Sicilian and Italian campaigns. He was withdrawn from Italy to attend the invasion of Normandy, and then sent back to Italy for the brutal and frozen 1943-44 Winter Mountain Campaign in the north. Eventually he was sent with the 8th Hussars into Germany, where he witnessed the collapse of that country and the fall of Bremen. The first British soldier into Denmark, he was much lionised by the citizens of Copenhagen. He returned to England and was demobilised after spending six years to the day in the Army. In that time he had submitted an astonishing 401 finished watercolours, as well as 117 illustrations to war-related books. Most of the works are housed at the Imperial War Museum.

The following three works were commissioned by the War Artists Advisory Committee of the Ministry of Information. They were published and sold to the public by the National Gallery. The two following prints listed were printed at the Curwen Press and the third, the Curwen having been bombed, was printed at the Baynard Press.

NAP 70

Brigade HQ 1940

Lithograph, commercially printed DATE: 1940
DIMENSIONS: 368 x 456 EDITION: Not known
PAPER: Machine Glaze WATERMARK: None
NOTE: This is a reproduction of the eponymous work held at the Imperial War Museum (LD: 0118, NA: 008).
In my catalogue[38] It is placed in Phase II of Ardizzone's activity as an Official War Artist, *With the British Expeditionary Force, before the German attack,* from 30 March to 9 May 1940.

DESCRIPTION: A sentry with rifle at the slope stands foreground right in front of his box by the gates of a fine country house, seen behind.

LITERATURE: G&Co(319), listed
SEE ALSO: *Baggage to the Enemy* by Edward Ardizzone, John Murray, London 1942 (described p136)
PRINTED: The Curwen Press

[38]Ardizzone, Nicholas, *Edward Ardizzone RA (1900-1979), Commissioned Works of the Second World War.* See bibliography p136

NAP 71

With the 300th – On the Move

Lithograph, commercially printed
DATE: 1940
DIMENSIONS: 406 x 506
EDITION: Not known
PAPER: Machine Glaze
WATERMARK: None seen

This is a reproduction of *With the 300th – On the Move* in the Imperial War Museum (LD: 0129, NA: 022). In my catalogue[39] it is placed in Phase II of Ardizzone's activity as an Official War Artist, *With the British Expeditionary Force, before the German attack,* from 30 March to 9 May 1940.

DESCRIPTION: The location is northern France. Leading away into the distance is a road with a low house left and a canal running beside it right. Middle distance right there stands a substantial house surrounded by a park and trees. Going away from us up the road is a column of transport followed by a despatch rider on a motorcycle. In the back of the rearmost vehicle a soldier leers at a woman standing near the low house. She has two small children in hand, and she smiles back at the soldier. To the right of the column, a man, seen right profile, sits on the canal bank fishing. He is wearing an overcoat and a shallow bowler hat. He seems totally unconcerned by the column passing behind him. The spring sky is bright blue with some threatening grey, and the trees near the big house are not yet in full leaf.

INSCRIBED (on verso):

<div align="center">

With the 300th – On the Move
Edward Ardizzone
(War Office Artist 1940)
PUBLISHED BY THE NATIONAL GALLERY FOR THE MINISTRY OF INFORMATION
PRINTED IN ENGLAND BY THE CURWEN PRESS LTD.,
LONDON, E.13

</div>

LITERATURE:
GW(49):

> Some of the early war pictures of the two months Ardizzone spent in France in 1940 have a freshness which makes them outstanding, the lonely fisherman in his bowler hat sitting on the bank of a canal wholly unaware of the army convoy passing behind him.

SEE ALSO: *Baggage to the Enemy* by Edward Ardizzone, John Murray, London 1942 (described p136)
 G&Co(319), listed
PRINTED: The Curwen Press

[39]See p136

71

NAP 72

Shelter Scene

Lithograph, commercially printed DATE: 1941
DIMENSIONS: 655 x 990 EDITION: Unknown
PAPER: Machine Glaze WATERMARK: None
NOTE: This is an adaptation of the work *Shelter Scene, Tilbury,* held at the Imperial War Museum (LD: 0129, NA: 022). For reasons that are explained below, in my catalogue I have retitled the original *Shelter Scene, The Tilbury Shelter, Stepney* and have placed it in Phase V of Ardizzone's activity as an Official War Artist, *The Blitz,* from 22 September 1940 to 12 April 1941
INSCRIBED: (1) EDWARD ARDIZZONE – SHELTER SCENE (2) Published by The National Gallery

DESCRIPTION: This is a direct adaptation, slightly reduced, of Ardizzone's largest wartime painting measuring 890 x 1365.

The title is most misleading, because 'The Tilbury' was in fact a huge series of wine cellars under railway arches at Stepney. It did not start the war as an official shelter because, although it offered reasonable protection from direct hits, being above ground it was vulnerable to blast waves. The public had another view however: they quite simply occupied the place until the authorities were forced to take it over. A vast community settled in there, including many who had been bombed out. A micro-society formed and, inevitably, crime and vice followed. It was The Tilbury that fostered the widely-subscribed-to myth that the shelters, generally, were places of merriment and jolly junketing. In the IWM collection there are a number of drawings that Ardizzone made in The Tilbury. Henry Moore also visited there and made drawings later.

Many people mill around in a vast, vaulted, cathedral-like cellar. In the arched alcoves people are bedding down. By the wall midground left there is a grey tea stall. In the centre aisle, which leads directly away, groups of figures stand chatting. Foreground right a man is digging a pile of earth or sand. The fluency of Ardizzone's line sometimes gives people the impression that his work was insouciant. In the original, the still-visible perspective lines are most expertly and beautifully drawn out showing a high level of craftsmanship.

LITERATURE:

Angus Calder, *The People's War,* pp182-183:

> The most famous, or notorious, of all London's shelters was found under the Tilbury railway arches in Stepney. Part of a complex of cellars and vaults had been taken over by the borough council as a public shelter for three thousand people. The other part was the loading yard of a huge warehouse. The shelter was famous as a popular refuge in the raids of the First World War, and people flocked to it from a wide area. Communists encouraged the shelterers to overflow into the 'unofficial' part of the arches, where massive steel girders maintained an illusion of safety. This became the largest, and perhaps the most unspeakable of all London's shelters; as many as fourteen or sixteen thousand were estimated to use it on certain nights. Great stocks of margarine were stored in the 'unofficial' section. There was sanitation only for the handful of workmen usually employed there. Children slept among trodden faeces and soiled margarine; so did Indians, Lascars, Negroes, spivs, prostitutes and Jewish refugees. Parties of sightseers from the West End would make the Tilbury Arches the highlight of their tour of black spots. American Correspondents were taken there to shudder; though Negley Farson found its 'vital, impulsive life' oddly 'inspiring', and when Harold Scott visited it, 'A girl in a scarlet cloak danced wildly to the cheers of an enthusiastic audience; a party of Negro sailors sang spirituals while someone played the accordion.' 'Tilbury' became the spearhead of the agitation for a general improvement in public shelters which journalists and social workers began to conduct as soon as the blitz settled in.

The Times, 10 July 1941 (reporting the painting rather than the print):

> The third of the three, Mr. Edward Ardizzone's Shelter Scene, in which he has limited his sense of the comic so that his figures, while giving life to the picture, do not mar its impressiveness. This is a drawing that will gain much historic interest when the exact location of the shelter no longer needs to be concealed.

Excerpt from a letter from Ardizzone to EMO'R Dickey, Secretary to the War Artists Advisory Committee, from Edinburgh, dated 27 April 1941:[40]

> Do write & let me know what the Committee think of my big picture when it comes in from Styles.

[40]WAAC file GP/55/10:027, now at the IWM, Department of Art

Though I hold no brief for it, I have had my nose up against the beastly thing for 3 weeks and I am anxious to know its fate. I suppose my last batch of pictures are now framed and in the Gallery.

The Minutes of the War Artists Advisory Committee of the Ministry of Information. In the Chair, Sir Kenneth Clark:
Meeting No. 62 of 19 November 1941[41]
2, 3: Departmental reports, War Office
(i) Pictures for the New War Office canteens in the Whitehall building.
Recommended that 33 enlargements from subjects selected be provided as well as a small group of originals. ... It was suggested that Captain Ardizzone might usefully be asked to paint a decoration.

The matter was considered further at subsequent meetings but by Meeting No. 6542 of 10 December 1941 the minutes read:
1, 2: Matters arising out of the minutes
Item 6(i) of the 64th meeting
Reproductions for canteens
After reconsidering the committee's original choice, in the light of suitability for reproduction by lithography, the following new list was agreed upon:-
Stanley Spencer's 'Burners'.
Barnett Freedman's interior of a gun turret.
Paul Nash's 'Battle of Britain'.
Edward Ardizzone's 'Shelter Scene'.
It was hoped that other subjects would be produced in due course.

PRINTED: The Baynard Press
EXHIBITED: SSC(?); WFA(27); WCE(52)
COLLECTION: British Museum (1988-6-18-17; PRN: PPA8142 1988-6-18-17)

[41]*Op cit* p192

[42]*Ibid* p198

SUITE XVI
CINEMA POSTERS

Edward Ardizzone received two commissions to make cinema publicity posters. S. John Woods, (1915-97) the Advertising Director at Ealing Studios, had joined there from Fox Films in 1943.

I knew John Woods from childhood till the year he died. Coincidence found us both living in the small seaside town of Deal in Kent. I recall him with great affection.

Like Augustine Booth,[43] his turbulent and forthright manner made him enemies, which worried him not at all. Perhaps, because much of his working life was stalked by personal tragedy, he was prone to mercurial moods. He might move from mild grumpiness, to ranting rage, to placid charm, all in a matter of minutes. These foibles disguised a highly cultured man, one of great and subtle

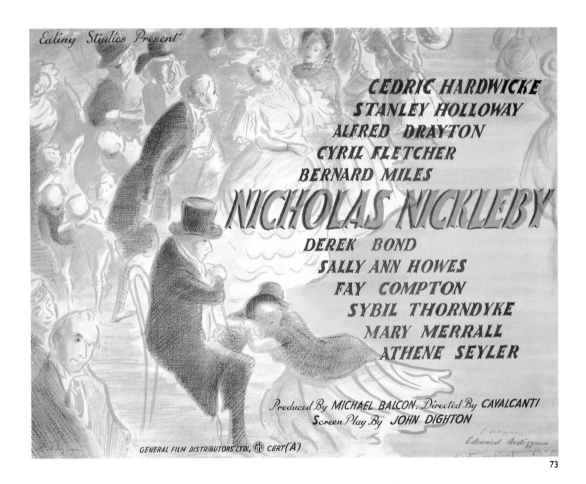

73

complexity, who got on famously with Michael Balcon, the Head of Production at Ealing, with whom he worked until 1959.

Woods and Ardizzone had known each other since the mid 1930s. Both at that time dwelt in Maida Vale, where they favoured, and met frequently in, the same pubs. Woods – an accomplished artist, designer and critic himself – had played a considerable and generally under-appreciated part in promoting British abstract art in the 1930s. He admired Ardizzone both as friend and artist, and did much to encourage his early career.

Woods was aquainted with most of his contemporaries and commissioned many of them. Barnett Freedman designed the Ealing Studios symbol, and both John Piper and Ronald Searle, among many others, designed posters. He designed several of the Ealing posters himself and was particularly adept in the tricky technique of combining photography with original art.

THE LIFE AND ADVENTURES OF NICHOLAS NICKLEBY

Made at Ealing Studios in 1947. Produced by John Croyden from a script by John Dighton adapted from the novel by Charles Dickens. Directed by Alberto Cavalcanti with cinematography by Gordon Dines. The film starred Derek Bond, Cedric Hardwicke, Alfred Dyton, Sybil Thorndyke, James Hayter, Sally Anne Howes, Jill Balcon, Cyril Fletcher and Fay Compton.[44]

Apart from the posters listed below, a trade press advertisement measuring 275 x 425 was made by letterpress. I have only ever seen one original copy of this, in the Print Room of the V&A (C17460.D). The subject matter is the same as for the poster NAP 73.

The colour separations for it, made on cartridge paper, also are held held at the V&A

E701-1-1980, black, hatching and lettering. The artist lettered the title of the film, the other text and credits are typeset

E701-2-1980, grey

E701-3-1980, yellow

E701-4-1980, orange

These separations are the only known surviving originals connected with this series.

NAP 73

Nicholas Nickleby (1)

Lithograph from color separations reproduced by photogravure
DIMENSIONS: 764 x 1016
PAPER: Machine Glaze
NOTEBOOK: 65v-69v, rough pen sketches, specifications and credit list
INSCRIBED: Signed by Edward Ardizzone on the plate bottom right
DESCRIPTION: Colours: red, yellow, grey, black
REPRODUCED: *Projecting Britain: Ealing Studios Film Posters*, p11[45]
PRINTED: Graphic Reproductions Ltd

DATE: 1947
EDITION: Not known
WATERMARK: None

[44]Source for information on both films: *Halliwell's Film & Video Guide 1999*

[45]David Wilson (ed), BFI, London, 1982, ISBN 085 170 1 221

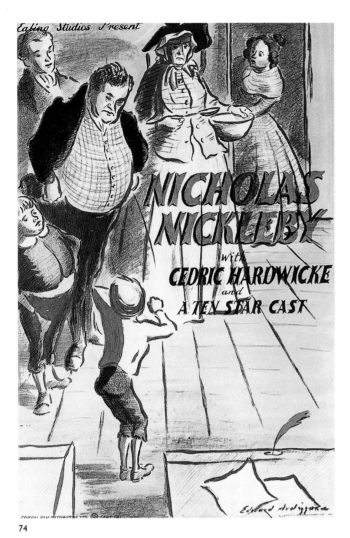

74

Nicholas Nickleby (2)

Lithograph from color separations reproduced by photogravure
DATE: 1947
DIMENSIONS: 744 x 587 (Double Crown)
 EDITION: Not known
PAPER: Machine Glaze
WATERMARK: None
NOTEBOOK: 65v-69v, rough pen sketches,
 specifications and credit list
INSCRIBED: Signed by Edward Ardizzone on the
 plate bottom right
PRINTED: Graphic Reproductions Ltd

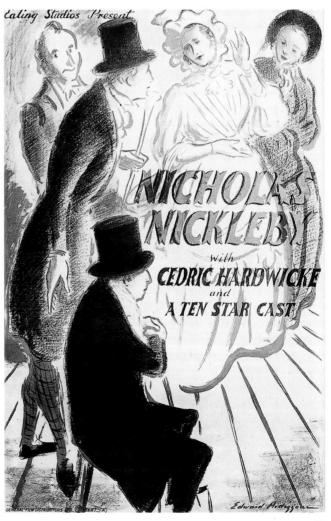

75

NAP 75

Nicholas Nickleby (3)

Lithograph from color separations reproduced by
photogravure
DATE: 1947
DIMENSIONS: 744 x 587 (Double Crown)
EDITION: Not known
PAPER: Machine Glaze
WATERMARK: None
INSCRIBED: Signed by Edward Ardizzone on the plate
 bottom right
NOTE: Though drawn in a distinctly different way, the
 subject matter is essentially a detail of NAP 73
PRINTED: Graphic Reproductions Ltd

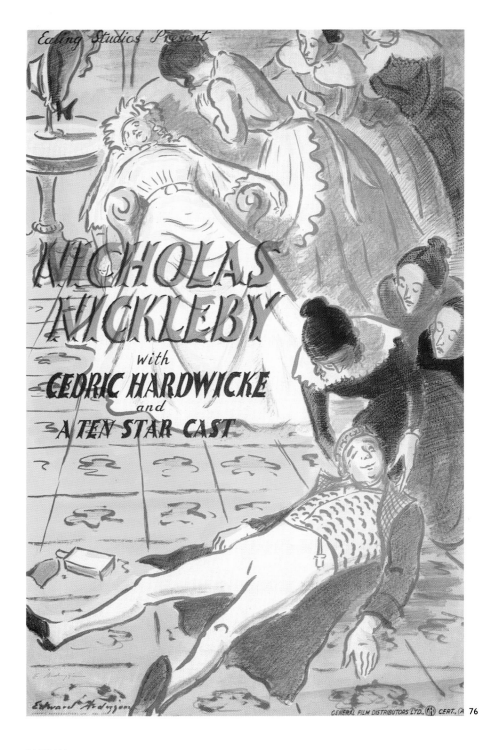

NAP 76

Nicholas Nickleby (4)

Lithograph from color separations reproduced by photogravure
DIMENSIONS: 744 x 587 (Double Crown)
PAPER: Machine Glaze
INSCRIBED: Signed by Edward Ardizzone on the plate bottom left
REPRODUCED: *Projecting Britain: Ealing Studios Film Posters,* p11
PRINTED: Graphic Reproductions Ltd

DATE: 1947
EDITION: Not known
WATERMARK: None

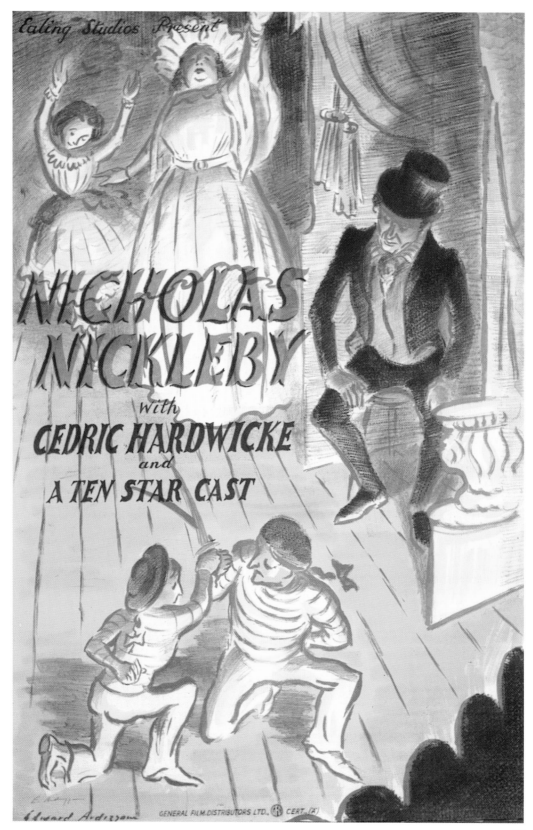

77

NAP 77

Nicholas Nickleby (5)

Lithograph from color separations reproduced by photogravure
DIMENSIONS: 744 x 587 (Double Crown)
PAPER: Machine Glaze
INSCRIBED: Signed by Edward Ardizzone on the plate bottom left
PRINTED: Graphic Reproductions Ltd

DATE: 1947
EDITION: Not known
WATERMARK: None

NAP 78

Nicholas Nickleby (6)

Lithograph from color separations reproduced by photogravure
DATE: 1947
DIMENSIONS: 1505 x 485
EDITION: Not known
PAPER: Machine Glaze
WATERMARK: None
INSCRIBED: Signed by Edward Ardizzone on the plate bottom right
DETAILS: Kindly provided by Mr Michael Caldwell of the British
 Film Institute
REPRODUCED: *Projecting Britain: Ealing Studios Film Posters*, p10
PRINTED: Graphic Reproductions Ltd

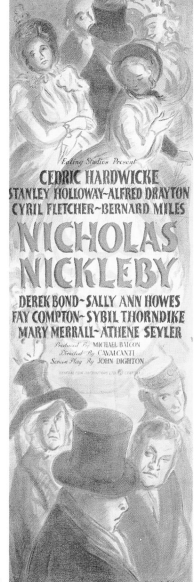

78

THE MAGNET

Made at Ealing Studios 1950. Produced by Sidney Cole from a script by T.E.B. Clark. Directed by Charles Frend with cinematography by Lionel Banes. The film starred Stephen Murray, Kay Walsh, William Fox, Meredith Edwards, Gladys Henson, Thora Hird and Wylie Watson.

As a designer, S. John Woods was more than usually successful in the sometimes awkward technique of combining photography with original art. He used this device in many of the Ealing posters both those he designed himself and those by other artists.

NAP 79

The Magnet (1)

Lithograph (offset) 4 Colour
DATE: 1950
DIMENSIONS: 747 x 496
EDITION: Not known
PAPER: Machine Glaze
WATERMARK: None
INSCRIBED: (1) signed on the plate 'DIZ' bottom
 right (2) Printed in England by Graphic
 Reproductions Ltd

DESCRIPTION: Colours: red, blue, yellow with black line
The work is presented as if the images were a number of pages laid on top of each other on a grey stippled background.

> A man threatens a boy with a stick, line drawing, red background
> A policeman tries to catch a boy whilst others run away, line drawing, green background
> A photograph of William Fox, blue background
> Ealing studios credit, brushed lettering, yellow background with chalk stipple
> Text banner, brushed lettering, red background with chalk stipple
> A man falling from a pier, line drawing, blue background

PRINTED: Graphic Reproductions Ltd

79

80

NAP 80

The Magnet (2)

Lithograph (offset) 4 Colour DATE: 1950
DIMENSIONS: 741 x 1004 (Quad Crown) EDITION: Not known
PAPER: Machine Glaze WATERMARK: None seen:
INSCRIBED: (1) signed on the plate 'DIZ' bottom Right (2) Printed in England by Graphic Reproductions Ltd

DESCRIPTION: Colours: red, blue, yellow with black line
 The work is presented as if the images were a number of pages laid on top of each other on a grey stippled background.
 A man falling from a pier, line drawing, yellow background
 A man threatens a boy with a stick, line drawing, red background
 A policeman tries to catch a boy whilst others run away, line drawing, green background
 A photograph of William Fox, blue background
 Text banner with credits, brushed lettering, red background with chalk stipple
 Ealing Studios and star credits, brushed lettering by the artist, blue background with chalk stipple

REPRODUCED: *Projecting Britain: Ealing Studios Film Posters*, p12
PRINTED: Graphic Reproductions Ltd

NAP 81

The Magnet (3)

Lithograph (offset) 3 Colour DATE: 1950
DIMENSIONS: 546 x 698 EDITION: Not known
PAPER: Machine Glaze WATERMARK: None
INSCRIBED: (1) signed on the plate 'DIZ' bottom right (2) Printed in England by Graphic Reproductions Ltd

DESCRIPTION: Identical in layout and content to (2) but smaller format

PRINTED: Graphic Reproductions Ltd

SUITE XVII
VARIOUS COMMISSIONED POSTERS

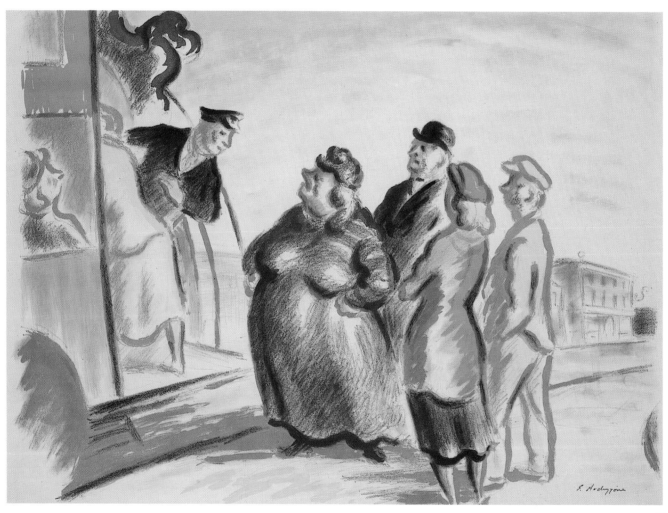

82

NAP 82

The Bus Stop

Lithograph, (poster-print), commercially printed
DATE: March 1938 (2nd series)
DIMENSIONS: 540 x 657 EDITION: Not known
PAPER: Pale cream wove WATERMARK: None
INSCRIBED: Published by Contemporary Lithographs Ltd London
DESCRIPTION: See LITERATURE below
PRINTED: Contemporary Lithographs Ltd
LITERATURE:
G&Co(317):

> For a full account of Contemporary Lithographs Ltd, see Antony Griffiths's article in *Print Quarterly* Vol. VIII, No. 4, December 1991. These prints differ from some of the School Prints and some other poster-prints in as much as they were original works in their own right and not lithographically reproduced images of paintings.

AAC(92):

> The Contemporary Lithograph the artist drew pre-war was surprisingly broadly brushed for an artist happiest at working on small scale, and showed a powerfully framed lady arguing with a conductor at the bus stop.

EXHIBITED: SSC, WFA(26, 'Sorry Full Up')
REPRODUCED: *The Spirit of the Staircase* foldout, RCA 1996; WFA(cover)
COLLECTION: V&A(Circ.201-1938)

NAP 83

The Railway Station

For image see next page

Lithograph, (poster-print), commercially printed DATE: 1947
PUBLISHED: J. Lyons Ltd, as No. 1 in the first of three series published between 1947 and 1955
DIMENSIONS: 712 x 978 EDITION: 1500
PAPER: Machine Glaze WATERMARK: None
INSCRIBED:

> THE STATION designed and lithographed by Edward Ardizzone. Published by J. Lyons & Co. Ltd. Printed by Chromoworks Ltd, London.

DESCRIPTION: The scene is a crowded station with a curving platform. The passengers stand under the ornate green awning like the ones that are still seen on some of the old Southern Railway's stations. At the extreme left edge a man glances left while to the right a man in a bowler hat leans forward to do the same A small boy standing with his mother also looks away left, as if anticipating the train's arrival.

In the centre of the crowd there is some luggage to the right of which, seen rear view, a young girl in a green coat and hat is holding up a hand to her mother. The sky is dull red: the light and people's clothing suggests cold weather, maybe autumn or winter. To the left of the luggage two women look suspiciously at the sky, suggesting that the weather is unsettled. Foreground centre right, a porter, seen rear view, is climbing up from the track to the platform. On his shoulder he is bearing a red tin trunk with an arched top.

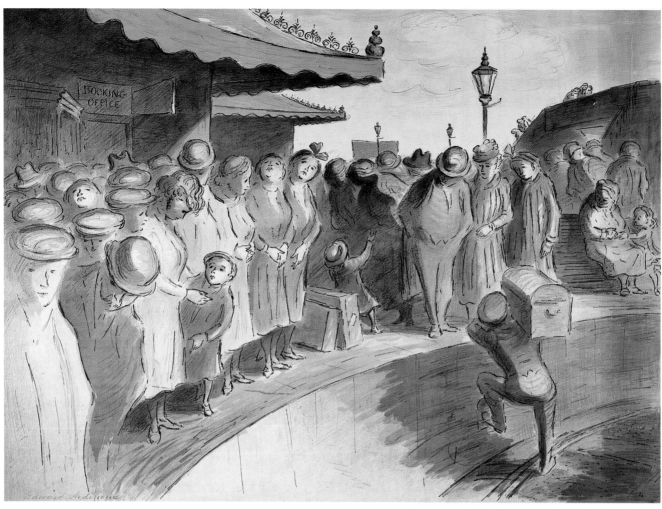

83

Behind him stand a smartly-dressed trio with at their centre a woman in a fur coat. To the extreme right there is a green slatted bench on which sits a woman with a little girl standing at her knee. Behind them there can be seen two groups of people crossing the footbridge over other tracks suggested in the background.

The nervous glances down the track and at the sky, the muted colours, the sense of tension in the foreground with bustle behind and the insouciance of the porter all combine, in different ways, to evoke the anxiety that is typical of such a situation.

This work is unusual for its use of pen for the major detail. Chalk crosshatching has been used to provide halftones and modelling.

PRINTED: Chromoworks Ltd

LITERATURE:

G&Co(321), listed

Carey & Griffiths, *Avant-garde British Printmaking 1914-1960,* (exhibition catalogue), BMP, 1990, p20:

> The Lyons series consisted of 16 lithographs commissioned in October 1947 followed by groups of 12 in 1951 and 1955. This catering firm used them to adorn its tea shops and restaurants and sold them over the counter.

COLLECTIONS: British Museum (1988-11-5-82; PRN: PPA8743); V&A (E690-1947)

NAP 84

The Wreck

Lithograph, (poster-print), commercially printed DATE: 1951

PUBLISHED: As No 17 in the 4th series sponsored by School Prints. The Artist's International Association (AIA) co-sponsored this series for the Festival of Britain the same year. The prints were marketed by J. Lyons Ltd.

NOTE: Robin Garton indicates[46] that this was also issued as an unsigned edition by Schools Prints in the 4th series, 1951

DIMENSIONS: 455 x 724 EDITION: Not known

PAPER: Heavy cartridge type WATERMARK: None

INSCRIBED: (1, bottom left) The Wreck by Edward Ardizzone. S.P.32 (2, bottom right) Distributed by School Prints Ltd., England (A.I.A. 1951 Lithographs).

DESCRIPTION: Colours: yellow ochre, vermilion, viridian, grey, black

This work is made with broad, brushed areas of solid colour overprinted with bold, thick crosshatching to add modelling and perspective. Fine chalk work has been used selectively to enhance detail.

There is a steep, shelving beach right, with frequent groynes running down to the sea. To the left, enormous breakers are about to crash on the shore, where at the edge of the beach five men are attempting to rescue a man who is rolling in the surf. The men seem experienced. Two of them are laying hold of the drowning man and appear to have got a line around him, on which the other three men are hauling to try to get the man onto the beach. To the extreme left a broken mast is sticking up out of the sea. On the beach there are various spectators, but most prominent is a standing woman wearing a red dress which, like her hair, is being blown back by the gale.

EXHIBITED: RAS(35); WCE(53); MBA(5)

LITERATURE: G&Co(323), listed

 Ibid:

 For a full account of the publication, see Mel Gooding's article in *Arts Review,* July 1980.

PRINTED: Graphic Reproductions Ltd.

84

[46]G&Co, p323

NAP 85

Shopping in Mysore

Lithograph, (poster-print), commercially printed DATE: 1955 (3rd Series)
PUBLISHED: J. Lyons Ltd, as No. 3 in the last of three series published between 1947 and 1955
DIMENSIONS: 728 x 980 EDITION: Not known
PAPER: Machine Glaze WATERMARK: None
INSCRIBED: SHOPPING IN MYSORE designed and lithographed by Edward Ardizzone

DESCRIPTION: Colours: Alizarin violet, raw umber, light red, grey, black.

This work is made from broad brush strokes, with only a few areas shaded with Ardizzone's characteristic chalk work.

The scene is a fabric shop. There are bolts of cloth stacked on shelves around the walls and to the right a door leads out onto the street, showing that the floor of the shop is raised above ground level. There are four women present, all of them sitting on the matting floor. To the left sit the two shopkeepers seen right profile, though the nearer one is turned away from us as we look over her shoulder as she presents cloth to the two customers. The younger customer sits cross-legged whilst she tests the fabric between the fingers of her left hand. Her companion sits behind and to the left facing us. She is holding up the edge of her sari to cover her mouth. There is a bolt of cloth in the foreground centre, and to the right of that near her knee are the foremost girl's sandals. Watching all this, a small boy with a cap on his head leans on the edge of the shop floor, with elbows forward. Behind him stand two men. The nearer one has glanced into the shop and has caught the eye of the woman who, modestly, is veiling herself.

LITERATURE: G&Co (321), listed
PRINTED: Chromoworks Ltd, London
COLLECTION: V&A (Circ. 36-1957)

85

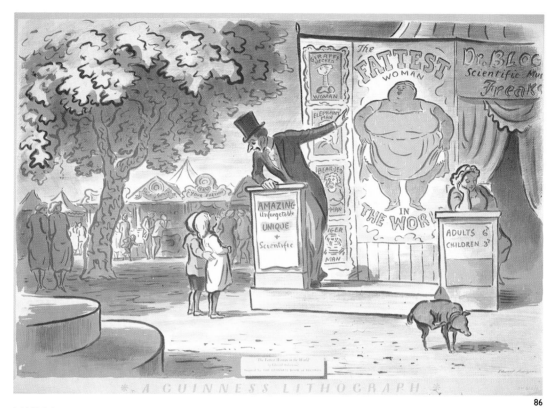

NAP 86

The Fattest Woman in the World

Lithograph, (poster-print), commercially printed DATE: 1956
PUBLISHED: Guinness Ltd.
DIMENSIONS: 480 x 735 EDITION: Not known
PAPER: Machine Glaze or similar WATERMARK: None
Signed bottom right by Edward Ardizzone on the plate in the drawing area
Inscription panel in picture, bottom centre: The Fattest Woman in the World : By Edward Ardizzone : Inspired
 by THE GUINNESS BOOK OF RECORDS
On bottom margin: * A GUINNESS LITHOGRAPH *

DESCRIPTION: The scene is a funfair, possibly that at Battersea Park. In background left are seen many stalls and
people visiting them, before which is an oak tree in midground. The foreground is almost deserted. To the
right of this in foreground is the stall of the Fattest Woman in the World, with her picture painted
prominently on hoarding. To the left of this a barker, magnificently clad in tails and a top hat, harangues his
audience, which consists only of two small children. The little boy has his arm round a little girl who stands
in front of him partially obscuring him. To the right a woman sits at the cash desk. She is turned away from
the barker and looks perfectly bored. In front of her a dog stands scratching its right ear with its rear paw.

PRINTED: The Curwen Press
LITERATURE:
G&Co(325):

> Information about the first series is scant and Guinness's own records lack a full complement of the
> prints, although they do have the artwork for a number of them. The assumption has been made that
> there were six prints in the first series, because it is known that there were six in the second series.
> Identification of the first series is, therefore, based on works which have come to light.

AAC(093):

> In the series of Guinness lithographs which the Curwen Press printed. By various artists, these had to
> take as their subject some aspect of the *Guinness Book of Records*. In Ardizzone's a circus barker drawing
> attention to the claims of 'The Fattest Woman in the World' is ignored by all but a couple of small
> children and a dog scratching for fleas – and possibly the dog has more important things on his mind.

EXHIBITED: SAC(121)
REPRODUCED: AAC(Plate 12a)

SUITE XVIII
MENUS FOR OVERTONS AND HATCHETTS

Overtons[47] Victoria restaurant was on the opposite side of Victoria Street to the railway station, beyond the bus station. It was a popular meeting place, having a seafood bar downstairs with a comfortable restaurant above, both of which were well known for their unusual half-moon windows.

Overtons St James's was at the top of St James's near the corner of Piccadilly. It did not have a separate seafood bar like the restaurant at Victoria and was generally more luxurious and formal. It specialised in theatre dinners.

Hatchetts, owned by the same company, opened later than the other two restaurants. It was round the corner from St James's in Piccadilly, and catered for the business community at lunch time and for theatregoers in the evening.

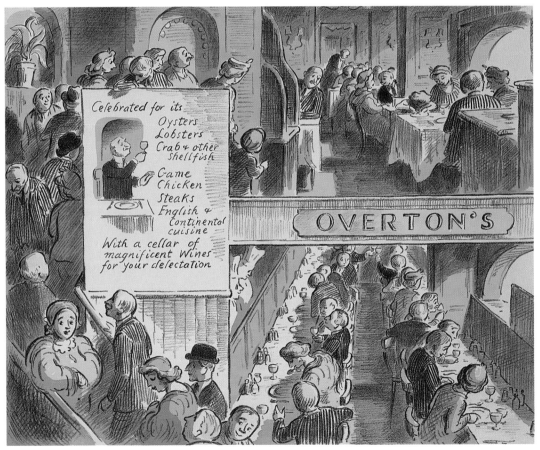

Celebrated for its
Oysters
Lobsters
Crab & other
Shellfish
Game
Chicken
Steaks
English &
Continental
cuisine
With a cellar of
magnificent Wines
for your delectation

OVERTON'S

87

[47]Although one appears on the Victoria menu, generally the three restaurants spelt their names without apostrophes, so I have adhered to their style throughout.

NAP 87

Overtons menu (Victoria)

For image see previous page

Lithograph (offset) DATE: *c* 1956
DIMENSIONS: 320 x 393
EDITION: Not known. There are an unknown number (perhaps twenty) of original proofs in circulation and family collections. These have delicate colour rendition and have no printing on the inside.
PAPER: Card WATERMARK: None

NOTE: This menu was in use continuously from the time it was produced until the restaurant closed in the mid 1990s. Successive reprintings appear in a number of formats, finishes and colour variations.

The original was the format mentioned above. A later version has the drawing split into two parts, each part being bordered in grey with a yellow border surrounding the whole. This leaves the two parts divided by a grey gutter. Later both drawings and borders were changed to conform with the new ISO size A3. Because this change is quite considerable, and because the new size is not directly proportional to the old, the grey and yellow borders were abandoned to prevent the drawing being reduced too far but the gutter remains. This has meant also that some of the edge areas of the original drawings have been lost.

Later printings of the metric version were printed on a cream card and the outside has a yellow underprint, both of which serve considerably to coarsen the colours. It has also a shiny cellulose finish added.

Later still, an A4 version appeared for use in the seafood bar, where it was thought to be less cumbersome to handle.

DESCRIPTION: Colours: black chalk line with yellow, grey, green and red washes

The drawing for both front and back is a continuous one, though both parts stand successfully when viewed separately.

The viewpoint is in mid-air somewhere above the bottom of the stairs, as if the nearer wall had been removed. This allows simultaneous views of the downstairs bar, the restaurant and all activities on the stairs. The upstairs is full and people are queuing at the top of the stairs left. In the centre a man facing us is giving a glance of recognition around the cash desk that is partially obscuring him and the table he is sitting at. He has caught the eye of a small boy who is standing with his mother holding her hand. She and the others queuing are partially obscured by a text banner which takes up the centre of the left half. One man facing us but looking away down the stairs is leaning his elbow on the top of the banner. Half way down the stairs the artist has portrayed himself rear view, and in front of him a little lower down, his wife Catherine looks straight out at us.

Downstairs at the front, people are seated, back-to-back at the bars that run down each side of the room. Those seated at the right are under the windows, those to the left face a low wall leading to the servery, where two men in chefs' hats are standing. To the back of the room, it seems a party has had to be split between the two sides, with the men to the left and the women seated under the window. Both sides have turned to speak to each other, and those at the rear are clinking glasses across the aisle.

NOTE: All lettering is by the artist
PRINTED: The Curwen Press
LITERATURE:
AAC(P93):
> Several superb menus for Hatchett's and Overton's, the plates for which are still in use today, were drawn on stone and transferred to plate in the 1950s and again carry an artist's originals into an unlikely area of ephemera.

GW(160):
> In the gastronomic vein there were also menu cards for restaurants, including one for Overtons, the fish restaurant by Victoria.

NAP 88

Overtons menu (St James's)

Lithograph (offset)
DATE: *c* 1956
DIMENSIONS: 320 x 393
EDITION: Not known. There are an unknown number (perhaps twenty) of original proofs in circulation and family collections. These have delicate colour rendition and have no printing on the inside.
PAPER: Card
WATERMARK: None

DESCRIPTION: Colours: chalk line with pale red and green washes

The drawing is a continuous one from back to front, being divided visually only by the fold, though both sides seen separately tell their own stories.

Front (right half): At the top there are two text bubbles with the hand lettered words Overtons and St. James's, one above the other and, below that left, the word menu in red.

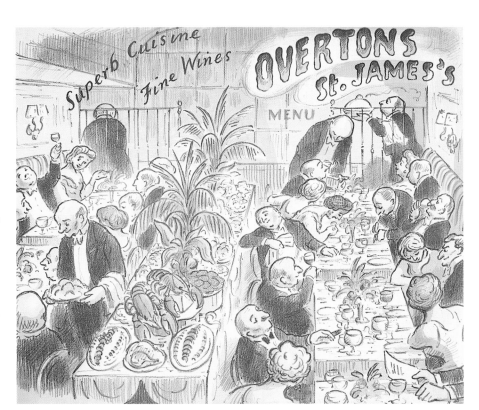

88

There are four tables with white cloths stretching away from us towards the rear wall. The cutlery, glasses and floral arrangements are very lightly but accurately drawn.

There are many people dining. Those sitting to the right are seated on cloth-covered banquettes and those to the left on chairs. Most are formally dressed. The people at the three tables furthest away may be all in one party, but those at the nearest table are probably not, because one of this party is wearing black tie whereas all the others are in white tie. A man right, of whom only the hands are in picture, is checking his bill.

At the end of the table left a waiter is bending over forwards serving wine. To the right and rear of the room, beyond a dividing rail, another waiter, moving right to left, is bringing in a covered dish.

A couple at the third table back are the only couple in the entire picture seen eating. A man sitting on the left of that table is leaning over the back of his chair as if trying to get attention from a waiter. This is the only visual link with the back of the menu when folded.

Back (left half): The whole of the right edge – the centre of the room – is taken up with a table piled with cold food. There are plates of salmon salad, a chicken and, prominently, two large lobsters. There are luxuriant potted palms placed along the centre of the table. Like the cutlery and glasses on the tables, the drawing of the food is accurate but deliberately a little faint so as not to draw the eye away too much from the diners.

Along the left wall are three tables with banquettes to the left and chairs to the right. To the rear there is a dividing rail behind which stands a portly man seen rear view. It is not certain whether this is a diner on his way to the cloakroom or, perhaps, a waiter preparing something. It could even be a self portrait of the artist.

Among the diners, a man left is holding up his wineglass to the light, and in foreground a waiter is about to serve a diner in the bottom left corner.

Inclined superimposed lettering across the top proclaims 'Superb Cuisine' and below it 'Fine Wines'

PRINTED: The Curwen Press
LITERATURE: See previous entry
EXHIBITED: WFA(32)
REPRODUCED: AAC(Plate12b); GW(160)

NAP 89

Hatchetts menu

Lithograph (offset) DATE: *c* 1958
DIMENSIONS: 320 x 393
EDITION: Not known

DESCRIPTION: Colours: blue yellow, red and black chalk

A stairway descending from a landing left to right is full of people waiting to be seated. Before the stairway and partially embraced by it is a table behind which, seen facing us, a chef is standing carving a fowl. The table is covered with food: lobsters and a partly carved ham. Facing the chef, a waiter dressed in tails is offering a plate.

In foreground there are three tables leading away from us with diners facing each other in profile across them. At the left, a woman seen facing us at the head of the table is being offered a plate by a waiter; another waiter is seen emerging from the kitchen door in the background. Behind her a green, square column extends to the ceiling, behind which a waiter is seen disappearing in the direction of the kitchen.

At the centre table the party is formally dressed. A girl left leans her elbow on the back of her chair and looks back over her right shoulder. To the right in foreground a man is holding up a glass of wine whilst looking back over his left shoulder to talk to a man at the table furthest right.

The stairway curls round so that the bottom of it faces us directly. A middle-aged man in a pinstriped suit is descending, purposefully, as though he were being called to a table.

At the top of the stairs there is a text banner, lettered by the artist.

NOTE: Because Hatchetts was open for a shorter time than the other restaurants, this menu is comparatively rare.
PRINTED: The Curwen Press

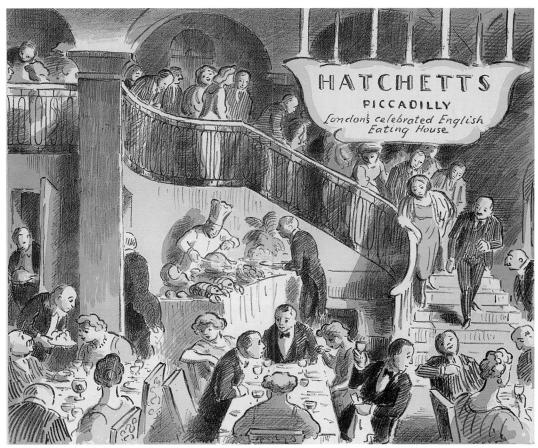

89

SUITE XIX
TWO EXHIBITION POSTERS

NAP 90

Poster for a London Group Exhibition

Illustrated on frontispiece

Lithograph (poster print), commercially printed
DIMENSIONS: 780 x 525
PAPER: Yellow ochre heavy cartridge

DATE: Between 1949 and 1954
EDITION: Not known
WATERMARK: None

NOTE: Edward Ardizzone was elected to the London Group in 1949, but had exhibited with them several times previously.[48]

DESCRIPTION: Colours: red brush and black chalk on yellow ochre paper

In foreground left, a woman, seen rear view, is looking at pictures on a flat which extends half way across the gallery. She is smartly dressed in a striped calf-length overcoat and a pillbox hat which has a prominent plume sticking up from the back of it. She has her head turned slightly towards us as she studies the catalogue held in her right hand. Her left hand is held up to her mouth thoughtfully.

To the far side of the flat and partly obscured by it, a man is standing studying something on the reverse. He is wearing a dark suit with a black bow tie. To the right of him, seen rear view, a woman in a red hat and coat and a man in bowler hat and striped suit are studying the exhibits on the far wall.

The far section of the room appears crowded, busy and bright, whereas the nearer one is much less brightly lit and the mood is quieter and more reflective.

PRINTED: Not known

NAP 91

Poster for the Royal Academy Summer Exhibition, 1969

Photogravure
DIMENSIONS: 763 x 509
PAPER: Heavy cartridge type

DATE: 1969
EDITION: Not known
WATERMARK: None

DESCRIPTION: Colours: Sepia line with pale pink and pale blue-green washes

It is doubtful that this is truly a lithograph. A suspicion of pencil underdrawing suggests that it is more likely a drawing using inks applied with brush and bamboo pen, a technique the artist did use very occasionally for larger-scale works. This work has been included, however, because it is very clearly executed in the lithographic idiom.

The scene is a happy one and full of bustle. The setting is one of the large Royal Academy galleries. On the far and left walls are hung the usual eclectic selection of works that would be expected at the Summer Exhibition: landscapes, two portraits and a large Venus with Cupid.

We see most of the visitors rear view as they crowd around to look at the pictures, but at the left edge a young couple are about to leave the scene. A man with thick curly hair and a moustache has his arm around the girl's waist with his left hand resting on her hip. She is pretty, blond and is wearing a pale, sleeveless mini dress. To the right centre, two women, one facing us and the other seen left profile, sit talking. To the right edge a little girl sits quietly hands on lap, and, behind her, seen right profile looking away out of picture, is a self portrait of the artist.

There are text banners at top and bottom. Both are enclosed in irregular shapes reminiscent of the speech bubbles found in many of Ardizzone's illustrations for children.

PRINTED: Not known

[48]*Catalogue for The London Group Centenary Exhibition*, Tate Gallery, London 1964, p3

91

BIBLIOGRAPHY

AUTOBIOGRAPHIES

Unusually for a visual artist, Ardizzone wrote well, in easy, lucid prose. Three autobiographical works are particularly recommended. All the printed works are copiously illustrated by Ardizzone. The recorded interview is of particular military interest.

Baggage to the Enemy (BA14), Peter Davies, London 1941
> Recounts Ardizzone's experiences with the ill-fated British Expeditionary Force in France, 1940. This profusely illustrated book was excused the blanket official censorship on accounts of the BEF because of its personal nature as a record.

Diary of a War Artist (BA161), Bodley Head, London 1974
> The published version of Ardizzone's illustrated war diaries: his experiences and travels in the Second World War, from the Invasion of Sicily until the end in Germany.

The Young Ardizzone: An Autobiographical Fragment, (BA151), Studio Vista, London 1975
> Ardizzone's early life in Edwardian England until he became an artist in 1926, copiously illustrated by the artist.

Artists in an Age of Conflict – Edward Ardizzone, recorded interview with Conway Lloyd Morgan, Department of Recorded Sound, Imperial War Museum, London, 1978, Acquisition No. 004525/05
> Shortly before his death, Ardizzone – still remarkably lucid – reminisces about his wartime experiences as an Official War Artist.

IMPORTANT RESEARCH WORKS

Alderson, Brian, *Edward Ardizzone, a Preliminary Hand-List of his Illustrated Books,* The Private Libraries Association, Pinner, 1974

Ardizzone, Nicholas, *Edward Ardizzone RA (1900-79), Commissioned Works of the Second World War.* The author's 1997 doctoral thesis which contains a catalogue raisonné of Ardizzone's work as an Official War Artist. This may be viewed by appointment at the library of the Royal College of Art or at the Department of Art at the Imperial War Museum.

Nudd, Kevin, 'The Illustrated books of Edward Ardizzone', *Book & Magazine Collector,* London, 6 June 1989, pp12-21, which lists most titles published later than Alderson.

White, Gabriel, *Edward Ardizzone,* The Bodley Head, London 1979 & Schocken Books, New York, 1979

COMPREHENSIVE BIBLIOGRAPHY

Presented chronologically by year then alphabetically, this is a large part of the bibliography I assembled for my doctoral thesis. It is larger by several times than any other available. Entries with a terminal asterisk do not mention Ardizzone directly but contain useful background information.

1931 Bury, Adrian, 'Oil paintings and watercolours by Edward Ardizzone at the Leger Galleries', *Saturday Review,* 15 August 1931

1932 Furst H, 'Edward Ardizzone – review of an exhibition at the Leger Galleries: London 1932', *Apollo,* Vol. 16, London, September 1932, pp136-137
 Stables, Gordon, 'Edward Ardizzone – review of an exhibition at the Leger Gallery', *Art News,* Vol. 31:9, London, 15 October 1932, p9

1935 Furst, H, 'Edward Ardizzone – review of an exhibition at the Leger Gallery', *Apollo,* Vol. 22 London, October 1935, p243

1936 Anon, 'Review of *Little Tim and the Brave Sea Captain',* *Manchester Guardian,* Manchester, 4 December 1936
 Anon, 'Review: *Little Tim and the Brave Sea Captain',* *Sunday Observer,* London, 13 December 1936

1937 Anon, Review of *Lucy Brown and Mr Grimes, New Statesman,* London, 4 December 1937

1939-45 Various, *The records and correspondence of The War Artists Advisory Committee, 1939-1945* (File GP/72)' Ministry of Information, London, housed at the Imperial War Museum

1939-46 War Artists' Advisory Committee, *Minutes of the War Artists Advisory Committee, London, 1939-46, housed at the* IWM

1939 Anon, 'Review: Edward Ardizzone at the Nicholson Gallery', *New Statesman,* London, 1 April 1939
 Anon, 'Review of *Little Tim and the Brave Sea Captain',* Unknown,
 Anon, Leader: 'Art in War Time', *The Times,* London, 11 October 1939
 Gordon, Jan, 'Review of Edward Ardizzone's 7th Exhibition at the Nicholson Gallery', *Sunday Observer,* London, 26 March 1939
 Newton, Eric, 'Edward Ardizzone in the Dickens Tradition: Review – Edward Ardizzone at the Nicholson Gallery', *In My View,* Longmans Green & Co, London
 Newton, Eric, 'Edward Ardizzone in the Dickens Tradition: Review of Edward Ardizzone at the Nicholson Gallery', *Sunday Times,* London, 26 March 1939

1940 Anon, 'Cameos of Flanders fighting', *Star,* London
 Anon, 'War Artists, salaried posts and commissions', *The Times,* London, 14 March 1940
 Anon, 'Mr. Ardizzone – A war artist's drawings', *The Times,* London, 23 March 1940

Anon, Stafford Gallery – 'War as I see it', *The Times,* London, 19 April 1940

Anon, 'National Gallery : First War Pictures', *The Times,* London, 2 July 1940

Anon, 'More War Pictures', *Manchester Guardian,* Manchester, 24 August 1940

Anon, 'Pictures by War Artists : Record of Historical Events', *The Times,* London, 24 August 1940

Anon, 'National Gallery : New War Pictures', *The Times,* London, 5 December 1940

Blaikey, Ernest, 'War Artists', *The Times,* London, 16 March 1940

Cooper, Douglas, 'War Artists Exhibition at the National Gallery', *Burlington Magazine,* VLXX No. 451, London, October 1940, pp128 & 129

Read, Herbert, 'Pictures of the War', *Listener,* BBC, London, 4 July 1940, Vol. XXIV No. 599, p22

Dowling, Henry G., 'War Pictures: Missing the Real Story', *Daily Telegraph,* London, 9 July 1940*

Gossop, R..P., 'War in Pictures: Opportunities Missed?', *Daily Telegraph,* London, 18 July 1940*

'H.K'., 'Official War Artists – National Gallery', *Jewish Chronicle,* London, 19 July 1940

Newton, Eric, 'Pictures of the War', *Sunday Times,* London, 7 July 1940

Newton, Eric, 'War Painters Again', *Sunday Times,* London, 11 August 1940

Newton, Eric, 'The Poetry of War: Fine Achievement of Modern Painters', *Sunday Times,* London, 29 December 1940

Richards, J., 'Edward Ardizzone', *Signature,* No. 14, May 1940, pp22-8

1941 'An Art Critic', 'War Pictures in Leeds: Work of British Artists', *Yorkshire Post,* Leeds, 10 September 1941

Anon, 'Pictures by War Artists: Records of Air Raid Damage', *The Times,* London, 20 January 1941

Anon, 'War Pictures – Exhibition in Glasgow', *Scotsman,* Edinburgh, 22 February 1941

Anon, 'Artists Depict a War Torn World', *New York Times,* New York, 1 June 1941

Anon, 'War Pictures at Castle Museum', *Eastern Daily Press,* Norwich, 19 June 1941

Anon, 'War Artists Paintings', *Belfast Telegraph,* Belfast, 13 June 1941

Anon, 'New War Pictures: Exhibition in National Gallery', *The Times,* London, 10 July 1941

Anon, 'War Artists Exhibition Closed for a Week', *The Times,* London, 30 June 1941*

Anon, 'New War Pictures: Exhibition in National Gallery', *The Times,* London, 10 July 1941

Anon, 'More War Pictures: And Some of the Official Artists', *Tatler & Bystander,* London, 15 October 1941

Cooper, Douglas & Freeman, Denys, *The Road to Bordeaux,* Illustrated by Edward Ardizzone, Cresset Press, London

Coote, Colin, *War Pictures by British Artists, Army,* OUP, London

'E.C.', 'Review of *Baggage to the Enemy*', unknown, London, 1941, p89

Gordon, Jan, 'Art & Artists', *Sunday Observer,* London, 2 February 1941

Newton, Eric, 'The Artist as Prophet', *Sunday Times,* London, 5 January 1941

Piper, John, 'New War Pictures', *Spectator,* London, 23 May 1941

Wheeler, Monroe (Ed.), *Britain at War,* Museum of Modern Art, New York

1942 Anon, 'New War Pictures', *The Times,* London, 23 January 1942

Anon, 'Recognition for War Artists', *World Press News,* London, 8 May 1942

Anon, 'National Gallery: New War Pictures', *The Times,* London, 5 June 1942

Anon, 'War Pictures Lost: Works of Famous Artists', *Sunday Observer,* London, 13 September 1942 *

Anon, 'War Pictures Lost', *News Chronicle,* London, 14 September 1942*

Anon, 'War Pictures Lost', *Birmingham Post,* Birmingham, 14 September. 1942*

Anon, 'The Lost War Pictures', *Manchester Guardian,* Manchester, 15 September 1942*

Anon, 'Exhibition of War Pictures: A Further Selection', *The Times,* London, 23 October 1942

Anon, *An Air of Peace,* Tate Gallery Archives, journal unidentified, London, 15 December 1942, Acquisition: MR Vol. V p69

Coldstream, W, *War Pictures by British Artists, Second Series, No. 3, Soldiers,* OUP, London Morton, J.B., War Pictures by British Artists, No. 2, Blitz, OUP, London

Seddon, Richard, 'Artists of Note', *Artist,* London, December 1942, pp89-91

1943 Anon, 'New War Pictures – National Gallery Exhibition', *The Times,* London, 3 March 1944

Anon, 'New War Pictures: Exhibition at National Gallery', *The Times,* London, 13 August 1943

Ardizzone, Edward, *Unpublished War Diary, Cairo and at Sea,* 1943, housed at the IWM

1944 Ardizzone, Edward, 'For the Children – How the Tim Books were Created', *Radio Times,* BBC, London, 9 July 1944

1945 Anon, 'Artist's Record of the War: Royal Academy Exhibition', *The Times,* London, 13 October 1945

Anon, 'Pictures of The War', *The Times,* London, 13 October 1945

Anon, 'War Paintings', *Manchester Guardian,* Manchester, 26 October 1945

Buckley, Christopher, *The Road to Rome,* Hodder & Stoughton, London

Charlton, Warwick, 'The Clerk who went to War', *Soldier,* Vol. 1, No. 7, 26 May 1945, pp4-5

W.A.M', 'Foreword', *An Exhibition of Drawings by Edward Ardizzone, Exhibition Catalogue,* IWM,London

1946 Richards, J., *Edward Bawden,* Penguin, London

1947 Ayrton, Michael, 'The Modern Phiz', *Strand Magazine,* London, 1947, pp78-83

1948 Blaikley, Ernest, 'The Lighter Side of War', *Studio,* Vol. 135, London, February 1948, pp48-51

1949 Gander, E. Marsland, *After these Many Quests*, MacDonald, London, 1949, pp147-8; 155-7

1951 Ardizzone, Edward, 'Visiting Dieppe', *Signature*, New series 1951, London

1955 Bell, Quentin, 'Edward Ardizzone', *Studio*, London, May 1955, pp144-147
Noble, Ronnie, *Shoot First: Assignments of a Newsreel Cameraman*, George G Harrap, London

1958 Ardizzone, Edward, 'The Born Illustrator', *Motif No. 1*, November pp37-44, reprinted in *Signal*, No. 3, September

1958 Anon, 'Review', One-man Exhibition at the Leicester Galleries, *Studio* 156:187, London, December 1958, p187

1960 Verney, John, 'Meeting Captain Ardizzone', *Compleat Imbiber*, London

1961 Anon, *Drawing for Radio Times*, The Bodley Head, London

1965 Coote, Colin, 'Introduction', *British Artists of the Second World War, Exhibition Catalogue*, Arts Council of Great Britain, London
Mahoney (Miller), Bertha et al, *Illustrators of Children's Books*, Horn Books Inc, Boston, 1965, pp. 268-269

1965 Moorehead, Allan, The Desert War, Jonathan Cape, London

1969 Calder, Angus, *The People's War : Britain 199-45*, Jonathan Cape, London, 1969

1970 Ardizzone, Edward, 'The Born Illustrator', *Signal* No. 3, The Thimble Press, Stroud Glos, September 1970, pp67-80
Chambers, Aidan, 'Ardizzone at 70', *Times Educational Supplement*, 16 October 1970, pp19-20'
Coleman, John, 'Pick of the Pics', *New Statesman*, London, 6 November 1970
Newby, Sonia, ''The Young Ardizzone', *Designer*, London, December
'Pooter', 'Ardizzone at 70', *The Times*, London, 15 October 1970
Rosenthal, T.G., 'Portrait of an Artist', *New Statesman*, 23 October 1970, p536

1971 Hughes, Shirley, 'Biography', *School Librarian*, June 1971

1973 White, Gabriel, 'Edward Ardizzone', *Introduction to the Catalogue of the 1st retrospective exhibition*, Victoria and Albert Museum, London, 1973

1974 Anon, 'Edward Ardizzone – Review of exhibition at the V&A Museum', *Apollo* (new series) 99:63, London, January 1974, p63
Anon, 'Oh What a Lovely War', *The Economist*, London, 25 May 1974, p145
Alderson, Brian, 'Review of Edward Ardizzone's War Diaries', *The Times*, London, 9 May 1974
Alderson, Brian, Edward Ardizzone, *A Preliminary Hand-List of his Illustrated Books*, The Private Library, Second Series, Vol. 5 No. 1, Spring 1972, The Private Libraries Association, Pinner
Lancaster, Osbert, 'Review of *Diary of a War Artist* by Edward Ardizzone', *Spectator*, 17 May 1974
Montgomery, Cara, 'Edward Ardizzone at the Victoria and Albert Museum', *Studio* 187, London, February 1974, p74
Watts, Janet, 'Ardizzone', *Guardian*, London, 9 January 1974
Wintle & Fisher, *The Pied Pipers*, Paddington Press, New York, 1974, pp35-48

1975 Winter, Gordon, *The Golden Years 1903-13*, Penguin Books, London

1976 Jones, C. & Way, O., *British Children's Authors*, American Library Association, Chicago, 1976, pp21-9
Hart, Dennis, 'Life in a Frame, Character in a Line', *Daily Telegraph Magazine*, No. 612, London, 3 September 1976, p.p. 32-8

1977 Anon, 'Edward Ardizzone – review of an exhibition at the Imperial War Museum, London, *Art and Artists*, London, March 1977, p34
Alderson, Brian, 'Picture Book Master', *The Times*, London, 19 December 1977

1978 Anon, 'An old fashioned artist', *Observer Magazine*, London, 12 November 1978, p91

1979 Anon, 'Foreword', *An exhibition of Edward Ardizzone, Exhibition Catalogue*, Campbell & Franks Ltd, London
Anon, 'London Day', *Daily Telegraph*, London, 20 October 1979
Anon, 'Edward Ardizzone', Obituary, *The Times*, London, 13 November 1979
Anon, 'Edward Ardizzone', Obituary, *Design*, No. 372:44, London, 1979, p44
Alderson, Brian, 'A Catchy Flair for Life's Absurdities', *The Times*, 10 December 1979
Gander, Marsland, 'Edward Ardizzone War Artist who created Little Tim', *Daily Telegraph*, London, 10 November 1979
Garland, Nicholas, 'Edward Ardizzone', *Daily Telegraph*, London, 15 November 1979
Hamilton, Alex, 'For Artists and Simpletons only', Obituary of Edward Ardizzone, *Guardian*, London, 10 November 1979
Herman, Robin, 'Edward Ardizzone Artist Dead', *New York Times*, New York, 9 November 1979
Hogarth, Grace, 'Ardizzone recalled by his publisher', *Sunday Times*, London, 2 December 1979
Mann, Andrew, 'Children's Books', *Spare Rib*, London, November 1979, p42
Rife, Mary, 'Edward Ardizzone', *Film News*, Vol. 36 2, April
Staghouwer, Judith, 'Het Gekras van Edward Ardizzone', *Bijvoegsel Vrij Nederland*, Vrij Nederland Kleurkatern, Amsterdam, 3 March 1979, pp26-36
White, Gabriel, *Edward Ardizzone*, The Bodley Head, London & Schocken Books, New York
White, Gabriel, Foreword to the catalogue to *The Scottish Arts Council exhibition*, Edinburgh,

1980 Bell, Alan, 'Two Scottish Arts Council Shows', *Burlington Magazine* Vol.122, London, February 1980, pp142-5

1980 Anon, 'Edward Ardizzone dies in London', *Juvenile Miscellany*, University of Southern Mississippi, June 1980, p2
Anon, 'Edward Ardizzone', *Manchester Evening News*, Manchester, 2 June 1980
Bell, Quentin, 'Fine Art for Kids', *New York Review*, New York, 18 December 1980
Hogarth, Grace, 'Edward Ardizzone 1900 to 1979, an editor's view', *Horn Book*, Horn Books Inc, Boston, December 1980, pp680-6

Mullaly, Terence, 'Ardizzone', *Daily Telegraph,* London, 9 December 1980

Packer, William, 'Edward Ardizzone', *Financial Times,* London, 26 July 1980

Waterhouse, Robert, 'Ardizzone', *Guardian,* London, 13 June 1980

1981 Driver & Briggs, *The Art of Radio Times – The First Sixty Years,* BBC, London, 1981, p60

Harvey, Anne, 'The Perfect Storyteller', *Times Litererary Supplement,* London, 27 March 1981

'Peterborough', 'Cottage Industry', *Daily Telegraph,* London, 19 February 1981

1982 Wilson, David (ed), *Projecting Britain: Ealing Studios Film Posters,* BFI, London, 1982, pp10-13

Lewis, Mel, 'A Touch of Ardizzone by the Sea', The Times, London, 21 January 1982

Murray, Andrew, 'Ardizzone By the Sea', *Middlesbrough Museums and Art Services travelling exhibition, Exhibition Catalogue,* Middlesbrough Gallery, Middlesbrough

1983 Anon, 'Insight into the life of a famous artist', *Gazette and Times,* Sittingbourne, 8 December 1983, p4

Booth-Clibborn, Edward, *My Father and Edward Ardizzone, a Lasting Friendship,* Patrick Hardy, London

Foss, Brian, 'It's not a Bad Life Sometimes – Edward Ardizzone's Drawings and Paintings of the Second World War', *IWM Review No. 2,* Imperial War Museum, London

Harries, Meirion & Susie, *The War Artists,* Michael Joseph Ltd with the Imperial War Museum, London

Morris & Radford, *The Story of the A.I.A.,* Museum of Modern Art, Oxford,

Ross, Alan, *Colours of War,* Jonathan Cape, London

1987 Raven, Susan, *Canvases of War,* unidentified cutting, possibly from a weekend supplement, 1987, pp67-70

Radford, Robert, *Art for a Purpose: The Artists' International Association,* 1933-1953, Winchester School of Art Press, Winchester

1984 Ardizzone, Edward, *Indian Diary,* Bodley Head, London 1984

1990 Bailey, Bel, 'Ardizzone – a distinctive flavour', *Bookdealer,* No. 932, London, 11 January 1990, pp5-6

Foot, M.R.D., *Art and War,* IWM with Headline, London

Spalding, Frances, *British Art since 1900,* Thames & Hudson, London

1991 McCormick & Perry (Ed), *Images of War,* Cassell, London

Sillars, Stuart, *British Romantic Artists of the Second World War,* Macmillan, London

1992 Devitt, Nial, *Edward Ardizzone,* catalogue 3, Nial Devitt books, Leamington Spa

Dawson, Eric, *Dawson's Army: from Libya to Lebanon: Memoirs of a Soldier Artist in the Second World War,* National Army Museum, London

Harrison, Charles, *English Art and Modernism 1900-1939,* Yale University Press, New Haven and London

1996 Kinnunen, Annika, *Edward Ardizzone – His 'Tim' Book Series and His Views on Illustration,* BA dissertation at City & Guilds Art School, London

CONCISE BIOGRAPHY

EDWARD JEFFREY IRVING ARDIZZONE (known, almost universally, as 'Ted')

16 October 1900 – 8 November 1979

This is based on Andrew Murray's biography in the Catalogue to Ardizzone's second retrospective which opened at the Scottish Arts Council Gallery, Edinburgh, in December 1979. The biography has been considerably expanded in the light of further research and personal knowledge.

1862 [Auguste Ardizzone, the artist's father, born at Bône, Algeria]

1876 [6 April: Margaret Irving, Ardizzone's mother, born at Ealing]

1900 Ted born October 16, in Haiphong, Province of Tonkin, Cochine-Française (French Indo-China). His father, though born in Algeria of Italian parentage, was brought up French

1904 [24 April: Catherine Josephine Berkley Anderson, his future wife born at Bombay, India]

1905 Ted arrives in England with his two sisters Elizabeth (Betty) and Lauretta (Tetta)

1905-13 Brought up largely by his Irving grandmother whilst his parents were on foreign service

1913-18 Attended Clayesmore School, where he meets Freddy Mayor

1918 Family house established at 130 Elgin Avenue, Maida Vale, London

1919-26 Works as a clerk in his father's firm, the Eastern Extension Telegraph Company (now Cable & Wireless plc), where he 'doodled a lot on his blotter'

Attends evening classes at Westminster School of Art under Walter Bayes and Bernard Meninsky. This was his only formal training as an artist

1927 To the horror of his father gives up work at the office to become a full time artist. Visits Austria and Italy with sister Betty

1928 Meets Catherine Anderson, whom he marries early in 1929

1929 Publication of *In a Glass Darkly* by Sheridan Le Fanu, the artist's first illustrated book

8 November: birth of first child, Christianna (later the model for *Lucy Brown*)

1930 First one-man exhibition at the Bloomsbury Gallery. A meeting with his childhood friend Maurice Gorham results in Edward Ardizzone's first drawing for *Radio Times*.

Around this time his brother David rents a house at Kingsdown, near Deal, later to be the model for that of Tim's parents in the *Little Tim* books

1931 Exhibition of oil paintings and watercolours at the Leger Gallery

December 1: birth of second child, Philip (later the model for *Little Tim*)

1932 Exhibition of oil paintings and watercolours at the Leger Gallery

1934 Exhibition of watercolours and drawings at the Leger Gallery

1935 Illustrates booklet *Game Pie* for Guinness

Exhibition of paintings and drawings at the Leger Gallery

1936 Publication of *Little Tim and the Brave Sea Captain*, the first of the 'Tim' books

Exhibition of paintings and drawings at the Leger Gallery

1939 1 September: called up to 54th AA Regt (TA), Royal Artillery

8 September: birth of second son, Nicholas

23 December: commissioned 2nd Lieutenant

Generally abandons oil painting, though a few (possibly three) post-war oils known

1940 27 October: appointed Official War Artist at behest of Sir Kenneth, (later Lord) Clark. Goes to France as War Correspondent to record the British Expeditionary Force

1940-42 Remains mostly in London – arrested as a spy for sketching in the East End of London

1941 [Auguste Ardizzone dies at Rodmersham Green aged 79]

Publication of *Baggage to The Enemy* – Edward Ardizzone's war experiences with the British Expeditionary Force in France, 1940

1942-43 North Africa

1943-45 Sicily and Italy, also Normandy landings and later, Germany

1944-45 First contributions to the *Strand Magazine*

1945 1 September: Relinquished commission, discharged from the Army

1947 Large coloured lithograph *The Railway Station* for J. Lyons Ltd

1947 Elected member of the Society of Industrial Artists

1948 Joins teaching staff of the Camberwell School of Art and Crafts, where he produces lithographs from the stone.

Exhibition of recent watercolours at the Leicester Galleries

Elected Fellow of the Society of Industrial Artists

Possible penultimate oil of students painting a nude at Camberwell

1950 Visits Anthony Gross in the Lot, France

1951 Visits Dieppe with his brother David and Barnett Freedman.

Exhibition of recent watercolours, Leicester Galleries

1952 Publication of *The Blackbird in the Lilac*, first book in collaboration with James Reeves

Commissioned by UNESCO to attend seminar for production of audio-visual aids in India and trains classes in the art of silk screen printing and other stencil processes

1952-54 The last known oil painting, *A Quiet Morning in the Bar*, painted for a so-far-unidentified brewery exhibition, [possibly sponsored by Ind Coope Ltd]

1953 Returns to London to carry out commissioned watercolour of the Queen's Coronation

Appointed tutor in etching at the Royal College of Art, where he produced several editions of etchings and lithographs from the stone and plate (to 1961). Illustrates series of essays by G.W. Stonier in *Punch*

1954 On recommendation of Sir John Rothenstein, commissioned to execute drawing of Sir Winston S. Churchill for presentation to him on his retirement by the Press Gallery of the House of Commons

1954-57 Designs several *Punch* covers

1955 Exhibition of recent watercolours and drawings, Leicester Galleries
Publication of *The Little Bookroom* by Eleanor Farjeon illustrated by the artist
Awarded the Carnegie Medal of the British Library Association

1956 Publication of *Tim All Alone*. First book to win The British Library Association's Kate Greenaway Award for the year's most distinguished work in book illustration
Awarded The Hans Christian Andersen Medal of The International Board on Book for Young People

1957 Publication of his article, 'On the Illustrating of Books', Private Libraries Association, Vol.1 No.3, July 1957

1958 Exhibition of recent watercolours and drawings, at the Leicester Galleries
Visits Western Ireland
Publication of his article, 'The Born Illustrator' in *Motif No 1*, November 1958

1959 Sir Colin Anderson commissions murals in first class children's nursery on the ocean liner P&O *Canberra*
Visits Dieppe again

1962 Exhibition of recent watercolours and drawings at the Mayor Gallery
[3 December: Ted's mother Margaret dies aged 86]

1963 Visits Menton, S. France

1965 Exhibition of recent watercolours and drawings, the Mayor Gallery
Visits Greece

1966 Purchases cottage in Kent, at Rodmersham Green, where his parents had lived previously
Visits the Cevennes, France

1967 Designs Birthday Greetings Telegram for the Post Office

1968 Visits Australia, exhibition at the MacQuarrie Galleries, Sydney

1970 Elected to the Royal Academy of Arts
Exhibition of recent watercolours and drawings at the Mayor Gallery to coincide with the publication of *The Young Ardizzone – an Autobiographical Fragment*
Publication of Brian Alderson's *Edward Ardizzone, A Preliminary Hand-List of his Illustrated Books* 1929-70

1971 Awarded the CBE

1972 Leaves 130 Elgin Avenue for good

1972 Publication of *Tim's Last Voyage*, the final 'Tim' book

1973-74 *Edward Ardizzone, A Retrospective Exhibition*, at the Victoria and Albert Museum

1973 Visits Australia to attend art seminar at University of New South Wales, Sydney, and to visit his son Nicholas, then living in Sydney

1974 Publication of *Diary of a War Artist*

Elected a Royal Designer in Industry

1975 Exhibition of watercolours, the Mayor Gallery

1975 Exhibition of drawings and doodles, New Grafton Gallery
Buys a house in Deal, Kent

1976 Breaks his leg and this leads to a period of inactivity

1978 [16 April: granddaughter Hannah Ardizzone dies of cancer aged 13]
[27 April: son Philip dies of kidney failure aged 47]
[1 May: James Reeves dies]
[6 May: Enslin Duplessis, dear friend and talented amateur artist dies]
[28 July: Son Nicholas returns to live in England]
Exhibition of complete set of watercolours and drawings at the Mayor Gallery of *Ardizzone's Hans Andersen*

1979 Publication of *Edward Ardizzone* by Gabriel White
Last major work, the illustration of *A Child's Christmas in Wales* by Dylan Thomas
Thursday 8 November: Edward Ardizzone dies at his home in Rodmersham Green
14 November: Edward Ardizzone's requiem mass at the Church of the Sacred Heart, Sittingbourne, burial in the churchyard of the Church of St Nicholas, Rodmersham

1979-80 2nd retrospective – Scottish Arts Council exhibition *Edward Ardizzone*, SAC Gallery, Edinburgh 8 Dec-27 Jan, touring: (see p34)

1981 Mayor Gallery exhibition *Edward Ardizzone, Lithographs and Etchings*, (details p34)

1982 Middlesbrough Art Gallery Exhibition *Ardizzone by the Sea*, 4 Sept-2 Oct, touring: (see p34)

1992 [10 February: Catherine Ardizzone dies at Rodmersham Green]

1998 Wolseley Fine Arts exhibition *The World of Edward Ardizzone*, London, 4-22 Feb, (details p34)

1999 The London Institute, Camberwell College of Arts exhibition *Running Away to Sea*, London, 26 Oct – 11 Nov.
The P&O *Canberra* murals were shown on land for the first time, (details see p35)

2000 Wolseley Fine Arts exhibition *Edward Ardizzone – A Centenary Exhibition*, London, 2-26 February, (details p35)

2000-2 The London Institute definitive exhibition of Ardizzone's work as a printmaker *Edward Ardizzone (1900-79) – Etchings and Lithographs,* opening at Pallant House Gallery, Chichester, (13 October 2000-14 January 2001); then touring: The London Institute Gallery, (19 February-22 March); National Library of Wales, Aberystwyth, (7 April-26 May); Victoria Art Gallery, Bath, (2 June-28 July); Hull University Art Gallery, (1 October-2 November); Wakefield Art Gallery, (17 November-6 January 2002); D.L.I. Museum and Arts Centre, Aykeley Heads, Durham, (2 February-12 March); Royal Museum & Art Gallery, Canterbury, (March-April 2002)

ALPHABETICAL LIST OF PRINTS

INDEX